THE SILENCE OF FALLING SNOW

KRISTJANA GUNNARS

COACH HOUSE BOOKS, TORONTO

first edition

Published with the generous assistance of the Canada Council for the Arts and the Ontario Arts Council. Coach House Books also acknowledges the support of the Government of Canada through the Canada Book Fund and the Government of Ontario through the Ontario Book Publishing Tax Credit.

LIBRARY AND ARCHIVES CANADA CATALOGUING IN PUBLICATION

Title: The silence of falling snow / Kristjana Gunnars.
Names: Gunnars, Kristjana, 1948- author
Identifiers: Canadiana (print) 20250232634 | Canadiana (ebook) 20250232928 | ISBN 9781552455081 (softcover) | ISBN 9781770568693 (EPUB) | ISBN 9781770568686 (PDF)
Subjects: LCSH: Gunnars, Kristjana, 1948- | LCSH: Grief. | LCSH: Husbands—Death. | LCSH: Buddhism. | LCSH: Art.
Classification: LCC BF575.G7 G86 2025 |DDC 155.9/37—dc23

The Silence of Falling Snow is available as an ebook: ISBN 978 1 77056 869 3 (EPUB), ISBN 978 1 77056 868 6 (PDF)

Purchase of the print version of this book entitles you to a free digital copy. To claim your ebook of this title, please email sales@chbooks.com with proof of purchase. (Coach House Books reserves the right to terminate the free digital download offer at any time.)

Truly, we have so little time to love, to give, to do penance.

– Francisco Fernández-Carvajal, *In Conversation with God*
(*Hablar con Dios*), Vol. 4, Pt. 1; Ordinary Time Weeks 13–18

PART ONE

I bought the seed of a fig tree and planted it. Soon it began to sprout and grow so I bought several more seeds and planted them. They too have begun to sprout and grow. I have plans to get more. Soon I will need to build a greenhouse.

 – From the journals of a Norwegian fig tree grower

Three vehicles

Three thousand realms

Ten thousand things

This is a story. It is a story about someone accompanying another to the last gate. The last gate we have to go through and the last train we have to board. I sometimes imagined such a gate as a half-open place, dark and earthy, where someone waited above, in a maroon robe and wearing sandals, holding a sceptre, with a golden-haired angel floating above each shoulder. Something important and even majestic.

But perhaps it is just a story about a white butterfly that flies beside you when you are walking on your journey. You do not know where the butterfly is headed or what it is saying, or why it is flying in such an irregular way. But it is there, and you are walking and flying together.

The Turkish writer Elif Shafak says the opposite of goodness is not evil; it is numbness. When you tell a story, you can maybe punch holes in

that wall of numbness. We do not have real enemies. Any Buddhist will tell you that. We have enemies who are under illusions. Who have anger and apathy in them. Anger and apathy are our enemies.

Shafak asks, When all else is said, are we building walls or are we building bridges?

There are both walls and bridges in this story. There is a train as well. And a platform. But I did not want to be the last passenger, alone on a waiting platform, everyone else gone. In this story, we were like two people waiting together, only a few minutes together, in the waiting room. We would never have enough time to tell each other everything.

Even if there is no one at the gate, or at the station, no wise man in a pointed hat holding up a large, impressive book; even if I am alone in the end, I still have a small story. And, with time, I have a bird's-eye view of everything as I drift away into the future.

For some reason the one I was accompanying to the end fell in love with silence. I do not know why. His story is not my story to tell. His story belongs to him. But I was there as a witness and meanwhile I was also living through a story of my own. I could not go into that silence with him. It was his private silence, and the small sound of the brass bell was so slight I could barely hear it.

Where I live now, in a tiny room, so small you can just step inside and stand still, there are two boxes filled with old photographs. Those were taken at a time when photos were prints. I put them away and never looked at them again. There was no reason to. I knew the boxes contained images of Bologna, Italy, in all its terracotta warmth, interesting feasts in Italian sidewalk restaurants, and pictures of parks and ships at sea.

Since then I have accumulated hundreds of images taken with a digital camera. They are on the computer and the phone. These pictures

just accumulate. I like taking weird pictures that don't say anything: a pattern in a piece of pottery, a snowdrop on a branch, a sheet of ice, a dead leaf hanging from a fence post. Those pictures I do like looking at. They are small moments of reflection, perfectly framed to be the split second of time that they are.

But when it comes to pictures that are supposed to be 'memories' of events – get-togethers, dinners, occasions, even happy ones – I do not like to look at them. I am not sure why, but those pictures do not make me happy.

I learned that every day millions of images are generated by artificial intelligence. These images are referencing other images in a circular loop. They do not refer to the world we live in, with its heavy material, but to other digital images, indefinitely coalescing them. The number of images created like this will probably quadruple every few months until all the images we see will be self-referential. We will no longer see the world as it is. The images will reveal nothing, be about nothing except themselves and their own networks. They will not remind you of anything.

The Italian philosopher and theologian Giorgio Agamben, in his book *Studiolo*, when talking about the painting *Blanket and Bedcover* by Sonia Alvarez, mentions the problem of seeing things as they really are from the angle of art. This painting is effective precisely because it is just a picture of a blanket and a bedcover, exactly as they are. There is no 'meaning' there except what we create ourselves in our own imaginations.

This thought is contrary to what seems to come naturally to being human. We tend to think we can 'read' nature or see mysterious signs in natural events. See 'meaning' in objects. Maybe we can and maybe we do. Maybe we are just blind to what is right before us. Maybe not.

At the same time, Agamben says every painting is an icon. What is depicted in the painting – any painting – is not just a representation, but is the thing itself: every painting is actually what it represents – contrary to the proposal of René Magritte's *The Treachery of Images*, which shows a pipe that it declares is not a pipe. What is it then? Even in things as they are, something is present to which we need to pay attention. Something else is always present. How do we 'read' such images? How do we even read texts?

I am reminded of a story in the Pāli Sutras in the foundational text of Buddhism, which is the Pāli Canon, relaying the Buddha's words: that we in our lives are like a dog on a leash that is tied to a pillar or a post. We go running around this post in endless circles that cross eons of time. There is no discernible beginning to those circles and there is seemingly no end to them either. They are the circles of what they call *Samsāra*. Every circle is another life. This will not end until we learn to pay careful attention to things as they are. *Careful attention.*

It is said that for human beings there are eight worldly conditions. We live in them like a fish lives in water. They are opposites, binaries. 'Gain and loss; fame and disrepute; praise and blame; pleasure and pain.' That is how they are termed in the Pāli Canon, which is said to repeat and explain the words of the Buddha.

But these worldly conditions are deceptive, and they are felt and experienced only by the 'uninstructed worldling,' as is called the person who has not thought about the human condition on a deeper level. For those who have thought more deeply, for the 'instructed,' these oppositions do not exist. The one is the other. All gain has loss in it. With fame also comes disrepute. With praise there is a great deal of blame as well. And pleasure itself is not alone; pleasure means we are also very close to pain.

These so-called opposites take turns. The boundary between them is fragile. So thin, you can almost see through it. Like a sheet of thin ice on a body of water. The ice glistens when the sun shines, but you can see through it.

It may not be too much to say that in the universe of *Form*, everything is changing all the time. We are filled with thoughts and emotions that waft across our sky like clouds forming, rain falling, sunshine breaking through. We think and feel things that are all illusions. We are acting out of our conditioning. Everything we have seen, heard, learned, and everything that has happened to us, where we have lived and whom we have met and been with: all of these have created the person we think we are.

But that is not who we are. That is just what happened in the course of our lives. If we try to shed that conditioning, we will find it is very hard and it will take a long time. That is because we are shedding not just the accumulated baggage of our own lives, but also thousands of years of civilizational conditioning. Of course it takes a long time.

As I think this, so long after the events in this story, I wake up to experience the sweet smell of rain after weeks of dry heat. The forests have been bursting into flames almost spontaneously. The smoke has filled the air all over the continent. But today, the air is rich and spicy, sweet and pungent, with freshly fallen rain.

On just such a day, long ago now, the phone rang. I picked it up and he was on the other end. He was calling me from Rome. He was giving a paper at a conference there and it was one of those times when we were in separate places, for I was in our home in Canada's rainforest. 'You have to come here with me,' he was saying enthusiastically, almost breathlessly. 'This place, there is so much I want to show you. We need to

come here together someday. You need to see the Palazzo della Cancelleria, the great Renaissance palace, and Michelangelo's marble Bacchus in the Museo Nazionale del Bargello, and his marble Pietà in the Basilica of St. Peter in the Vatican, they are never really seen unless in person, and the Tempietto, built on the site of St. Peter's crucifixion, which is really a martyrdom in search of the perfect form.'

Then it was only a couple of years later that we did end up going to Italy for a while. We had a small apartment in Bologna. A studio inside a courtyard with a mimosa tree in the middle and cobblestones in the patio. We were near the university, where I liked to walk in the dark lanes between the buildings thinking: This is where Dante Alighieri, or Durante di Alighiero degli Alighieri, the great thirteenth-century poet who wrote *La Divina Commedia, The Divine Comedy*, once walked. I stepped on the cobblestones cautiously, thinking maybe Dante Alighieri even stepped just where I am stepping now.

PART TWO

Imagine a raft on a river. You are on that raft,
and you are steering it to the other side.
The raft is not a day of your life, or a week, or a season.
That raft is your whole life.

One morning when the crystal dew was still on the grass and the pink lotuses were in bloom, the young man Gautama resolved to renounce his inheritance to the kingdom of which he was a prince and go to wander in the forests. He preferred to live like the holy men did at the time. When he announced his departure, everyone was sad: his family, his friends, the townspeople of Kapilavatthu. The birds stopped singing, the lotuses folded up and withered, and the trees remained barren and bore no fruit.

When the day of Gautama's departure arrived, the pure white horse Kanata, who was born on the same day as the Buddha, began to neigh loudly to wake up the people so they would stop the Buddha from leaving. But he was too late because Siddhartha Gautama was already stepping quietly through the thicket around the palace walls until his form disappeared among the leaves.

It can happen that in the deep darkness, when nothing comes to light and there is no way out of an enclosed labyrinth, it can happen that you wake up. Not immediately, not spectacularly. But slowly, in an unfolding, like a rose. Soundlessly. You did not know it was happening, and then one moment you find you are awake. You do not know what awakened you or what you are alert to. You just know the night is over, even though it is still dark. There are stars in the winter sky. There is snow on the ground.

It was not a waking up to knowing something. Not in the least. It was a *not knowing*. To not know and realize you may never know. This kind of awakening is really a dawning sensation of accepting a non-knowing.

(13)

Because everything is too large. The firmament is not a firmament. It is space, and space is too vast.

There is also very little that can be done. So little, it is almost nothing. But maybe in that nearly nothing there is a minute centre where a small step can be taken. It will be very small, almost the smallest flake of snow as it floats down to the ground. But even there a thought, a movement, a turn could happen. It is true, in among all the things we do not know are true, that a small turn in an insignificant time and place could alter the trajectory of whole planets.

I noticed that this idea of only being able to affect the outcome of things in small steps – what he, who is at the centre of this story, called 'mouse steps' – is reminiscent of the Austrian-British philosopher Karl Popper's idea of finding solutions bit by bit. He called it 'piecemeal engineering.' That was the best I could do, I knew already at the start. There could be no big fixes, only piecemeal engineering.

But I also thought the bits and pieces, random and accidental and insufficient as they had to be, could be gathered together with the needle and thread of Gautama Buddha. The four boundless states, as the Buddha called them: they are the threads of *love, compassion, empathetic joy, equanimity.* If I had to do this work and make the world coherent in an otherwise incoherent universe, tie together the loose ends flying all over, there was really only one way to do it. With the four threads of the Buddha. These are tough threads. Not everyone can find them.

I often wondered why practitioners of Chinese ink-and-brush paintings never tire of painting bamboo. Bamboo trunks, branches, leaves. Over and over again. I asked my Chinese painting teacher about this, much later when I set out to learn this art form: Why always the same bamboo motif? She said the bamboo is not just a beautiful plant. It is as if made for the Chinese brush. But that is not the only reason.

The bamboo is symbolic of how we should *be*, from a Daoist standpoint, and from the world view of Chan Buddhism. How should we be? I asked her. The bamboo, she told me, is gentle and graceful in fair weather. But it is strong and resilient under adversity.

We need to be supple, adaptable, firm, fresh, and vigorous all at the same time. Like bamboo. We also need to have in us 'the sweet melancholy of the rustle of its leaves.'

The way of life and the way of thinking they call 'Buddhist' are based on the teachings of Gautama Buddha. This way is also called being on the Path. The Path is referred to as the Diamond Way. In the Diamond Way, everything happens so slowly you can hardly tell it is happening. But that is because everything is also happening very quickly. Too quickly for us to see where it all has gone.

Even though things are happening with great speed, it feels like there is nothing. As if time has stopped. Perhaps it has: perhaps time has lulled and the clouds are waiting. In this story, I was waiting. Yet it is not clear to me what I was waiting for. Waiting for waiting to stop and time to start again. I was keeping quiet inside the diamond vehicle. A snow-drop of ambiguity. A Winter Palace.

I was reminded of something the Japanese artist Makoto Fujimura said about waiting. When a vessel breaks it is glued back together with gold in a process called kintsugi. The gold filling highlights the imperfections of the broken vessel. This is such a common metaphor now that you see it everywhere. But Makoto said something else about this kind of repair: the tea bowl needs to be repaired and it will be glued back together with gold so the cracks will show as beautiful lines. But it will not be repaired right away. The bowl will stay broken for a long time, in a pile of ceramic pieces, before it will be put back together.

A long time means generations. Several generations may pass before the bowl is put back together. It takes a long time for trauma to heal. If you break, you will not be able to put yourself back together right away either. It may take a whole lifetime. It may take more than that.

Makoto Fujimura called the waiting in this kind of time, the time it takes for trauma to heal and the time it takes to learn the work, he called it the need to learn to 'behold.'

I decided then that this was my time to *behold*. My time to behold a world being put back together. Just like a large ceiling rotunda in a great Roman cathedral, all in a mosaic of broken bits and pieces. The broken pieces are rearranged to show the sun like a red fan blistering above a procession of supplicants in blue clothing, making their way toward a giant bubble of cyan-blue sky filled with stars.

When he received a sudden and unexpected diagnosis of a terminal illness he had no inkling of but that left him unusually tired, we decided to return to Oslo from Canada. We packed in haste and departed the house within twenty-four hours of that unhappy meeting with the doctor. The whole time we were preparing to fly home to his native Norway he had a stunned look on his face. It is the same look Giorgio Agamben talks about when he is writing about a fresco panel from Pompeii, *Achilles Surrendering Briseis*. Agamben notices all the men in the fresco are gazing as if in a state of speechlessness and shock, wide-open eyes and pensive lips in 'stunned, silent dismay.' He calls this 'the gaze of ancient man.'

Here too it was noticeable to me as we packed our bags quickly and arranged our schedule and whom to meet where and when to catch ferries and flights – the whole time he had that 'gaze of ancient man.'

To get to the Vancouver airport, we had to do a lot of driving, and then take a ferry across the sound to the city, and then drive again. A friend took us to the ferry terminal and another friend was scheduled to pick us up on the other side.

The ferry terminal in Horseshoe Bay had a long covered walkway where foot passengers proceeded from the boat to the street on the other side. This time, when we made our way along this above-ground tunnel, with its makeshift aspect and open-air windows, the walk was interminably long. He was already weaker and had trouble pulling his suitcase, so we walked slowly. The walkway suddenly felt strange to me. It dawned on me that now even very familiar things were going to seem strange.

The walkway's brown concrete floor and grey walls and smell of wet tin seemed exaggerated. The village of Horseshoe Bay outside offered glimpses through the walkway openings of cars and people rushing to their destinations. People were there in groups and in lines and the newly built tall structures on the hillside stood guard as if we were in some newly formed panopticon. Even the ceiling of the walkway seemed teeming with busyness: people in flowing robes, people being privately tortured, people being consoled by other people, and in the middle of it all, I thought I saw Adam and Eve being expelled from a place that had a great, twisted tree in the centre.

The two human beings ran away in their shock and misery while the angels gathered around the tree trunk and shouted after them.

We did manage to set up shop in Oslo, Norway, and we spent just over three months dealing with what was happening to him as best we could. Those were extraordinary months. At that time I could live on air. I could sleep on clouds, walk on dust. I needed nothing material. And there was nothing in the material world that needed me. I could go my way unseen.

I did of course eat, sleep, and walk, since I too am human. I subsisted on a diet of one item, though. All I ate was shrimp. They must have come from the Varangerfjord in Finnmark, the most northerly part of

Norway, where the water is clear as crystal and the shrimp develop slowly in the cold sea. Every evening in the 'blue hour,' on my way home after a day at the hospital with him, I stopped at the Rema store in Vinderen and bought a bag of fresh shrimp and took them home to my flat in Haakon den Godes Vei. The shrimp lie in piles in a freezer box at the grocery store in their white containers with tentacles sticking out in all directions and small, black beady eyes, dead to the world.

But in the Varangerfjord, where they came from, the Northern Lights reflect their various shades of green and gold in the glassy black waters, and the world glistens with magical light.

On some level I may have felt that with this food I might internalize the Northern Lights myself, and my body would glow in the same way they do, the lights above shifting and turning in a vast space of blackness.

Perhaps I was relying on an age-old prescription for faith. Having faith, even when you are not sure what you are putting your faith in. It may be God, or the Way, or some wisdom you have heard that remains in the back of your mind like a shadow, not quite discernible. You just know you have it. Something invisible to even you.

Makoto Fujimura once quoted the Bible when he said, 'Faith is the substance of things hopeful, the evidence of things unseen.' Maybe faith is simply hope. With his art, Makoto had this ambition to 'bring people back home.' But where, I had to wonder as I made my way in furry boots and winter coat through the snowy street with my bag of shrimp, where is home?

There is a story in the Pāli Canon about how Gautama Buddha tried to explain the 'Path' or the 'Way' to his listeners. To find out how to go about things the right way and not get lost or end up in the wrong place at the wrong time.

Think of a traveller, he said, who has just come from the village of Najakāra, which is not far away. You ask this traveller how to get to the village and he will tell you the way because he knows it. He knows it because he is from there and has just left there.

It is the same with the life we live. If we take instruction from someone who knows how to get to the right destination, because that person has come from there and knows the way, we can confidently go on. We can find the way to the brahma world, as he said. But if we take the advice of someone who does not know the Path because he has never been on it, we will end up lost.

A film made in 1957 by Ingmar Bergman, *Det sjunde inseglet*, or *The Seventh Seal*, takes place during the Black Death epidemic in the Middle Ages. The film shows a medieval knight playing a game of chess with Death, who has come for him. The seventh seal was opened in the Book of Revelation, and at that moment, heaven went silent for half an hour. God went silent.

It is a Scheherazade thought. Only if you keep playing will you stay alive, just as in *Alf Laylah wa-Laylah*, or *One Thousand and One Nights*, that collection of Arabic folk tales, only if you keep telling stories will your life be spared. But in *The Seventh Seal* the knight is betrayed and Death wins the game.

In this film there is also a picnic of milk and strawberries. The knight Block holds the bowl of strawberries, freshly picked in the Swedish fields, lying in a bed of pure white creamy milk, raises it, and says, 'This is enough for me.' Fresh strawberries and milk are the equivalent of freshly brewed tea in a Korean tea bowl, which you may find in a Japanese tea ceremony. Every movement made, every word uttered, every object on the ground means something.

I think of this film sometimes when I walk in the freshly fallen snow. Especially at night when the moon lights up the crystals and they blink and glare in turn. I can assure Mr. Bergman, now that I know: Death does not play chess.

Sometimes I think of what the fourteenth-century German mystic Meister Eckhart once wrote, that God called himself a word, which means all his creatures are full of words and every creature, every person, is a book.

Instead of a game of chess, I would rather liken Death to a train. This train speeds one way on a designated track. You ride on it one time only. Once you get on board you will not get off.

Somewhat later in life, when I was researching the writing of Anglo-German writer W. G. Sebald, I came across the statement in the 2007 film by Thomas Honickel, *Sebald. Orte.*, that Sebald greatly resented death because he felt it was very unfair.

PART THREE

It is not a new habit to measure historical events against what I was doing in my own life at that exact moment. The older I get, the more possibilities there are of this measuring and aligning.

One year when I was a child, a thick dark cloud covered the sun for many months. I lay in my bed with paratyphoid fever, half-conscious only sometimes. The rest of those months there was nothing. I remember nothing. Only occasionally did a little light break through a brief opening in the clouds. I saw faces, then I saw nothing.

At that same time, in the same year, the young Dalai Lama was invited to a theatrical event in Lhasa, Tibet. But he was told he could not bring his security or his protectors with him. The plan was to abduct him after the event, but the news got out so this did not occur. A week later, he escaped Tibet by making his way across the Himalayas in Nepal to India, like so many after him.

It is a habit among Buddhists everywhere to string up little flags with prayers written on them. The prayers fly away when the wind blows and the prayer flags are wafting and swaying. All the small prayers go floating in the wind to new destinations.

We know we are on a path of some sort as we go through life. Usually we think we are making our own path and heading toward a destination of our own choosing. But I can see that is not right. Life may be a path, but what about this did I choose?

When something unexpected happens, we think it is a detour of some kind. This is not the main road. This is not where I thought I was

going. But I can also see now that there are no detours. The path in life is always the main road and there is no destination.

This was not something I was thinking much about until I found myself in our small rented apartment on Haakon den Godes Vei in Oslo looking out the window onto the barren trees and snow-covered rooftops of the brownstone and wood buildings on the other side. The sky was grey and white and shrouded everything from view because the snow was coming down thickly.

So this is my Path in life. Clearly one thing causes another as we go on, but sometimes you wonder whether these causes and effects are predetermined before you even go there. Since one thing follows another, all of this seems inevitable. But once this outcome is accepted, it is best to just settle in with it. Make the best of it.

So I went to the Plantasjen garden centre nearby. I liked going there because they had plants that were green and healthy, and greenery is good for the soul, I hear. I wandered around the space and looked at the flowering blooms, sometimes smelled them, even felt them among my fingers.

I bought six bulbs of hyacinths. The lime-green leaves were already sprouting from the mushroom-coloured bulbs and the white wrinkly flowers had already unfolded. On some of the plants the top flowerlets were still in tight clusters, the outer leaves just beginning to unlock. I put them all on the windowsill facing the street. Behind them the nondescript look of an Oslo winter day acted as a backdrop.

If you have to wait, I was thinking, then just settle in with it. It is better not to push against what you know you have to do. For that the hyacinths gave me some comfort.

So it came to the business of medicine. The question of medicine is so intertwined with this story.

There are so many ideas about what constitutes medicine. In Canada I have so often encountered the medicine bundle: a rawhide pouch, sometimes with beads, containing herbs and grasses Indigenous people on the Plains carried with them. Sage, sweetgrass, tobacco, cedar, lavender. Roots, a stone pipe.

The medicine bundle also has spiritual value. Every item inside the pouch has significance. If one of the items is exposed to the open light, a special song is sung. You cannot just give such a bundle to someone. There are strict rules and a ceremony is required. There are inheritance guidelines.

Medicine is also a mystery. If you take the mystery out of it, the medicine may lose its power. I often thought about how we have done exactly that in medical history. All we have now is 'medication' for this and that. We have pills, injections, solutions. But we do not have mystery or magic in what we take when we are ill. We were collecting such pills for his condition, and a strict schedule for him taking them, but there was no special quality to these pills. Nothing to hold on to and find hope in, really, because we already knew nothing would work.

There is another kind of medicine bundle: one made of words and imaginative worlds. The American speculative-fiction writer Ursula K. Le Guin wrote an essay on 'The Carrier Bag Theory of Fiction,' where she says a work of literature, a story, is a collection of things that has the function of a medicine bundle. A story need not be about the predatory journey of a hero. A story can be a collection of healing words. A collection in a container: the container of the book, or the bag, or even the home itself.

Another way of looking at such a method of storytelling is mentioned by Jonathan Culler in his essay 'On the Negativity of Modern Poetry,' which is about the poetry of the French poet Charles Baudelaire, who Culler said ushered in the poetry of the twentieth century, that a story can also be made up of the contents of a huge desk: 'glance sheets,

verses, love letters, legal papers, romances, locks of hair wrapped in receipts,' and so on. A jumble of different random things kept in a certain place. They are not 'healing' words or things so much as they are an attempt to gather the fragments of a life that is always on the verge of disintegrating. Such a collection is also an attempt at 'confronting an endless series of memories that cannot be integrated.'

Or, as I have thought in relation to where the memories gathered here all started, in a box of photographs that have been thrown together by chance.

Sometimes I prefer to think of all writing as a kind of text that is written in 'the alphabet of the stars,' as the French poet Stéphane Mallarmé has worded it.

Because the words seem to come from far away and often appear indecipherable, even to the one who has written them. Just as it is with the American poet Walt Whitman, who wrote in his famous book of poems *Leaves of Grass,* 'I believe a leaf of grass is no less than *the journey work of the stars.*'

As to the analogy of the speeding railroad, and the concept of the Path in Buddhism, everything was happening very quickly and yet things were exceptionally slow. So slow it was almost as if nothing moved.

My husband was on that fatal train. I was keeping him company as far as I could go. I was also organizing this journey of his; all the while he was withdrawing. From me, from everyone.

He had medicines given to him by doctors and pharmacists. There were at least twenty different pill containers with white lids on them. Each one had to be taken at a different time of day or night, in different sequences. Some were not allowed to overlap, some had to be taken before meals, or after meals, or with food. Some on an empty stomach. It was a mathematical labyrinth.

I arranged the containers in order, on a shelf inside a closet. There were little labels on the front of each to remember what was to be taken when. I had a system that worked. But those pills were just there to reduce the severity of symptoms. The real medicine lay in closing the cabinet door. That was so the house would not feel like a pharmacy.

It was not a good measure to stumble on a vial of medication when your gaze was on its way out the window and into the white, snowing sky. It was better to forget about those mundane little things. There was something much bigger to consider.

What they say was not lost on me, in the Buddhist texts, in the talk among the Lamas and Rinpoches and Zen masters, all of them: the only real medicine we have is compassion.

Under the circumstances, what was highlighted for me was the surety that we were not really going anywhere. We had no destination. The point of everything was not the destination after all. Not where we were going or how quickly or slowly we got there. Instead, it was, and is, about how you go.

They call it a 'Path,' and how you take your Path is really a question of how you are living. How are you living? I did not know how to answer that myself. Except to go from day to day, see the sun rise and then see the stars in the sky.

At Christmastime I bought a big star made of twigs with lights on it. I got it at the garden centre Plantasjen. When I returned home I hung it from the ceiling right above his favourite chair, where he usually sat and studied his laptop computer. So whenever I looked over, I saw him seated, head turned downward, and a lighted star above his head. That simple twig star might as well have been a whole ceiling fresco by Pinturicchio of St. Joseph and Mary seated beside each other dressed in

Persian blue and scarlet, surrounded by gold, encircled by a whole host of saints decorated around them.

I did not realize then that this Christmas star above his head was an image that would stay with me.

This journey we are on, it is best to remember what it is so there will be no unnecessary expectations. The journey we are on is not 'a walk in the park.' It will never be 'a piece of cake.' Nothing is. So long as we are breathing the air, we are inside something we have to endure.

This is what I reminded myself of as the sky began to look too bleak. Which it did. Often. The cloud cover seemed too thick and stayed too long and the air was too white. But pleasant times were not something we could in any case take as a given.

I often think how we have been led to believe that we should have it easy. It must be the culture we are in, with all its modern paraphernalia. Things intended to make it easier for us. But those easy things become a false facade. In reality, things are not easy. We got to thinking any kind of pain or heartbreak is an exception and we deserve better times. But, actually, pain and heartbreak are no exception. They are the rule. We just do not remember that.

To make the hours pass more tranquilly, while these kinds of thoughts floated up to the surface in my mind, I made jewellery pieces out of stones and beads. It was a hobby I engaged in at the dining room table. Colourful glass beads put together in special, eye-pleasing combinations. There was something soothing in that. Maybe also something meditative in the repetitive action of adding beads together on a wire.

For this reason, the reason that suffering is not an exception but is the rule, the Buddha himself, so I am told, said to his listeners that they

should think of themselves as very sick people trapped in the world of life. All he was for them was a simple physician.

The healing is something you have to do yourself, he assured them. But he can show you the way. How to do it, if you care to hear it.

They should have listened carefully to his instructions. So much later in history, 2,500 years later, it has become clear that 'caring' for something, anything or anyone, is much more complex than we thought. The caring is the medicine. The caring and the receiving of care is what is on the Path itself.

'Care' is sometimes aligned with the word *curare*, which is a South American poison derived from a plant. The toxin has been a treatment in anaesthesia to paralyze a patient, but it is so dangerous that it is hardly ever used. The truth about caring for someone and something is that it is also dangerous. That applies to caring for the Earth as well.

To care, to cure, to curate. I thought a lot about these ecocritical concepts since they came crashing into my life in such a personal way. Then I thought, if I could pick up the pieces that lay scattered about when our personal lives blew up, if I could pick up the pieces and put them back in some curated fashion, in words inside a manuscript, would it be worth doing? Would that too be dangerous? Would it be, as the French writer Patrick Modiano says in his novel *Paris Nocturne*, that various memories, hidden for a long time and laid to rest, would come back and 'rattle me,' he wrote, 'like a time bomb'?

'Cure,' 'heal,' 'care.' It's dangerous and troublesome, as Donna Haraway says in her book *Staying with the Trouble: Making Kin in the Chthulucene*, but you have to continue with it. Keep going.

'Industriousness' is also one of the precepts of Buddhism: to keep going, working, even though you cannot be attached to the outcome. You are alive, and since you are, you need to keep going and do the work.

When I was a very young woman, married for the first time, I began my own journey. It was a very distinct turn, a noticeable beginning of something. I left my parents' house and they were unhappy to see me go. I literally walked down the street, away from the house, and in turning back for a last look I was thinking: *I am sorry. But I am on my own raft and I have to go now.*

We moved to a small place in Eugene, Oregon, where we studied and started a home. At that time there was a new kind of pour-over coffee pot that looked like a chemistry glass. In fact, it was called Chemist in the Kitchen and was all glass with a wooden cover in the middle, tied with leather string. I bought this coffee maker, which became so emblematic of something important that I kept it with me all my life. As often happens, that old implement came back into fashion many decades later and you could buy it in almost any coffee store.

The important thing I wanted to remember was that it was in those months in Eugene, while daily life was churning on, that I had what I felt was an awakening. It was really just the fact that I bought in passing a book titled *Tao Te Ching* and read it. But this reading on the foundations of Daoism, which took place in the solitude of my own private hours, made me see something that had been lurking behind a cloud and now emerged the way a cloud is drifted away by the wind. Behind the cloud there is a blue sky.

Later I went on to read books on various kinds of Buddhism and Taoism. Eventually I amassed a small library of such books.

That learning had both good and bad effects. In the good, it gave me a grounding, which only got stronger the more I acquainted myself with the observations on life I found there. There was something else besides what I thought of as my home in the world, a small island in the North Atlantic. Everyone who comes from Iceland feels grounded. There is a magnetism to the environment there that penetrates forever. But here I found something else, something aerial.

I thought of it as the earth and sky. I found the sky.

Another good is that it helped me understand my own mother, who was for some reason hidden from us. I came to share many things with her and I never got a chance to tell her. My mother once told the story of meeting someone new who happened to mention how she loved the work of the Indian poet Rabindranath Tagore. At this my mother burst into tears. Here was the first person she had met with whom she could share her own love of Tagore's writing, something she had been keeping in her private heart and about which no one knew anything.

On the bad, though, this learning made sure I too would be invisible for the rest of my life. People would see me, but they would not be able to truly see me. There would always be misapprehensions that I could do nothing about. I would go through life like a blank slate onto which people projected many of their phantasms, their desires, apprehensions, and even nightmares.

It was a little bit like coming to a hotel and there is no one at the desk. You are in the building, you know you will stay for a while, but there is no one to check you in.

This is what they talk about when they talk about the 'self.'

Talking about the 'self' is like talking about something invisible. This is how you can walk on snow without leaving a trail.

PART FOUR

The Buddha became enlightened as he sat under a Bodhi tree. That tree became revered as a great spirit tree.

One time Emperor Asoka wanted to take the Bodhi tree to the island of Lanka. On learning this, a branch jumped off the tree by itself and into a bowl of water, where it rooted itself.

But first it had to become enlightened. So the branch flew off to the Himalayas for a week-long spiritual retreat. When it came back, it boarded a ship for Lanka, and when it got to the island, it jumped into a bowl, where it flourished and grew.

I am told the Bodhi tree is a wish-granting tree, and it has four deities: Venu, Valgu, Sumanas, and Ojupati. They shaped the tree perfectly for sitting in its shade. Other trees were seen respectfully bending to the Bodhi tree. A great number of snakes came with flowers to offer the Buddha. While he meditated underneath its branches, the forest went silent out of respect. Even the wind did not blow and the leaves of the trees did not rustle.

When the Buddha touched the earth with his finger, the earth trembled.

Such are the stories.

On New Year's Eve, we pulled two chairs to the window and watched the fireworks over the city of Oslo. Lights from the lampposts and from windows of the buildings along the street lit up the white snow. The sky had been Persian blue earlier, a special hue I hardly ever saw. Establishments where people went to eat and drink were open and lit up, and yet the streets were strangely empty. The green benches along the sidewalks that stood up from the snowbanks were themselves covered with more snow. There were no cars in the street either.

The world was white and strangely silent. I remembered it was the Russian painter Vassily Kandinsky who once said that white is the colour of silence.

Earlier in the evening people ate turkey or lamb and drank wine, beer, aquavit. During the day people had wandered about the streets lined with colourful red, green, and yellow houses in the shopping districts downtown, where the streets were lit up with lights crossing from building to building and from windows of shops and lanterns on the top floors.

At midnight there were fireworks from Furuset Park and from the harbour and city hall. Those lights in the sky could be seen from anywhere. People lit fireworks from their own backyards and soon the whole skyline was aglow with red, green, blue, yellow, purple, unfolding in layers, clouds of light. We sat in silence and watched. We stayed for a long time, after the display was over, and looked at the city lights. We did not speak because there was really nothing more we could say.

Maybe we were both reminiscing about the life we knew we had lost. What was gone forever. We could grieve the loss even before it was entirely lost. Perhaps as we sat side by side in silence watching the fireworks in the distance over the houses, perhaps we were grieving the future.

We could say what Gautama Buddha said when he talked about his life, before he understood the meaning of it all. He said he was given all the pleasures available to a human being: 'I had three palaces, one for the rainy season, one for the winter, and one for the summer.'

He had everything in this world anyone could want. But then he chose to have nothing. Making such a choice seemed incomprehensible at that moment.

So many people advise you to try to take something good from a bad experience. They will say, 'Something good has to come from this.' The sentiment is understandable. It is also universal.

In Buddhist circles it is even a kind of precept. There are explanations that sound wild and extraordinary to a Nordic ear. Such as: The good thing is you are burning off the bad karma. You will never have to experience this again. And if not in this life, you have burned off the bad karma so it will not happen in the next life.

People who suffer try hard to say something good about it. Many even say they are thankful because they have become wiser. I had heard the arguments. None of them were ringing true to either one of us. I could see nothing good. Other than the fact that we were getting to see life as it really was, removed from the many illusions we allow to persist.

And yet, at that moment, watching the fireworks where people were incomprehensibly celebrating the new year, we were not feeling that bad. Not just then.

In his book *Transcendent: Art and Dharma in a Time of Collapse*, Curtis White mentions 'transcendental style,' which also has a good-from-bad idea in it. There are three movements, according to film theorists: First there is the 'everyday,' the world of stasis from which you start. Then the interruption of 'disparity' is introduced, which presents a break in the smooth surface of stasis. 'Disparity' forces into the story a moment of decision, a decisive action that needs to be taken. The third movement is also 'stasis,' but it is a new situation. The disparity has not been resolved, but the original 'everyday' has now been transcended.

Somehow if in the moment of necessary action you are prevented from taking that step – that decisive action you are called upon to take – it will feel like you do not exist. You will end up resigning yourself to an endless sadness where the mutilation of life as it was continues to occur without resolve.

Often it is the customary that prevents us from moving on. The customary is what we are accustomed to doing and saying in any situation. The habits of mind we have inherited and continue to propagate. If the customary is not adequate to the situation you are in, and if you cannot step outside it, you are trapped in 'dark karma.' You are trapped in a cave.

I was reminded of the old art-school advice that it is necessary to break your habits of mind. You need to grapple with things you are not familiar with, to always challenge yourself. Do the opposite of what you are comfortable doing. If you are a quick worker, try going slow. If you jump to conclusions easily, try thinking things over. If you are a perfectionist by nature, try to stop before the work is perfected. Try anything that will stop the force of habit from owning you and everything you think and do. Habit and custom cannot help you.

It is very popular to give – and get – the advice that you should 'be yourself.' But it will be hard to know what that self is. You will be peeling off layers for some time, and then you will not know what is inside.

Those thoughts were not always in the forefront of my mind. I was too busy looking after things. Trying to get things to work. I had been doing that for decades and for the most part I succeeded in getting things to work. But there was a cost to operating wholly in other people's productions.

It dawned on me way too slowly that I was in the position of the enslaved. I did not own myself and I did other people's bidding. Not just sometimes, but all the time. If I were to ask myself, *Do I want to be doing this?* I would fear the answer. If the answer was no, I was already so deep into my effort that there seemed to be no way back.

Sometimes you cannot think this way. Life throws such a stone at you that any thoughts of self or going another way are blocked. At such times you need to deal with that stone and put aside alternatives. That is what was happening to me those months in Oslo. All questions had to be put aside for later.

This is later.

I also remembered the advice against complaining, which I had heard so many times. How you see your situation depends on your mind. We can always find a reason to complain, and we can always find a reason to be happy or even joyful. It was the American writer Henry David Thoreau who said in *Walden, or Life in the Woods*. 'However mean your life is, meet it and live it; do not shun it and call it hard names. It is not so bad as you are. It looks poorest when you are richest.'

There is irony in everything. 'The faultfinder will find faults even in paradise,' he said.

＊

Most nights when the dark had set in and all of Oslo was quiet, I stayed up in silence. The traffic had died down and only the occasional car could be seen winding its way to the intersection down the street that crossed the train tracks and led up the hill into the neighbourhoods behind Rema grocery. Windows on houses were lit dimly and there might be a few stars in the sky.

At such times I lit a candle on the table. In my wanderings about town I bought a candleholder, a patterned basket which when you put the candle inside and lit it, would cast strange shadows on all the walls. When my small candle glowed at night and the patterns on the walls around me and on the ceiling showed up, I was somehow comforted.

Light is not a trivial matter in the life of the world. Light has always been central to all religions and spiritual aspirations. Candles, bonfires, electric lights, the sun, the stars. We navigate by these lights because the darkness is so thick.

I thought of that fact often: the fact of light, the part it plays for us. But not because I was being theoretical or reflective. As I looked at the candle glowing inside the basket, I felt guided somehow. In reality, I had no other guide to see me through what was unknown territory. Just this small light, flickering in the night.

Soon I felt the day and the evening were unfinished if I had not had my meditative moment with the candle lit. It became a necessity to have that time. Like a prayer of some sort that was not a prayer. It was just a passing time inside a labyrinth of darkness.

I remembered that the Buddha told his listeners that there are four kinds of light in the world. The four lights are: the light of the moon, the light of the sun, the light of fire, and the light of wisdom.

As for wisdom, the light of wisdom, the match that lights it is very hard to accept and adapt to. That wisdom all starts with letting go. Not clinging, not to anything. As Gautama put it, that letting go is being able to say to yourself: 'This is not mine, this I am not, this is not my self.'

To get a grip on the slow-moving whirlwind I found myself in, I thought of what was called the 'resultant path.' When you imagine you already are where you want to be. If you need wisdom, you imagine yourself already wise. When you want to be calm, you think of yourself as already calm.

So I did. The candlelight was helpful for that, as it made me focus on where I wanted to be. In a strange way, that focus made me want to be where I was. The distance between now and some other time and place had shrunk to nothing.

It is said that negative emotions make illness worse. A big point was made of this by the Canadian psychoanalyst and trauma expert Gabor Maté, especially in his book *The Myth of Normal*, but it is common knowledge. And yet people forget this. Because illness itself brings out many emotions, some that were hidden, some overtly there all the time. Emotions get stronger when you are ill; you become more sensitive.

My husband instinctively knew this, or his body did. He told me he did not want to visit with anyone who was too emotional. Any kind of drama or strong emotion was disturbing to him. He had his own reasons and I did not question them. So I kept everything as balanced and harmonious as possible around him. We were also silent much of the time. He did not have much to say and he did not want to talk much.

Sometimes a relative or friend would call and want to visit with him. I would ask him if he wanted that visit and if I could say yes. Most often, in fact almost all the time, he said no. I could not let that person in. The emotional range of that person was somehow wrong for him. So I had to say no.

This put me in a strange position because I could not tell the relative that he did not want to see them. I could not say, 'Your emotional range is too strong,' or 'Your energy is wrong right now,' or anything. There was really no excuse available except just to say no. Even if I tried to explain that he was not well enough to see anyone, whoever was calling tended to think they were an exception and it was really me who was locking them out. I ended up being seen as an unfriendly gatekeeper. This was difficult. But I took it on, the blame. The ill feeling needed to go to me, not to him.

I sometimes thought of the practice of *tonglen*, a giving-and-taking ritual in Vajrayana Buddhism where the healthy one breathes in the dark smoke of the ill one and so takes the illness to themselves and frees the ill one. Then one breathes out the clear, untainted air of healing instead. It is just a metaphor of some kind. An idea that has become a practice. It is thought of as putting the other ahead of the self.

Visitors were a sensitive and fragile area in our life at that time. Not a little energy was lost in just dreading visitors who might wish to come and having to negotiate everyone else's plans and desires. At the same time, there was a certain anticipation, a waiting for someone. Someone else: I was in some way expecting a visitor who never comes.

There were times I had to do things to try to curb the pain of the increasing isolation that was growing around me. To walk in the crusted snow and the delicious sunshine. To breathe the fresh air. To light a candle. Anything.

I did not know whether he was aware of any of this. But by the end of it all, I realized his awareness was much broader than I imagined. Actually, I think he knew everything and he was equally sad. But at this time it was impossible to have emotional discussions with family.

He really only wanted to see three people: his two grown children and myself. His focus was distinct and he knew the limits of what he had energy for. It is the kind of wisdom we are given at the end. A kind of farewell package from beyond. In the final analysis, you learn to know yourself.

He had grown into the kind of selfhood that sometimes only occurs too late. The self that allows you to slip easily through life. To hold off the encounter with people when they ask for it or press for it. Instead, it is you who chooses the moment: when to talk and when to act. You alone, for yourself.

PART FIVE

It often occurs to me that the distinction we make between medicine and religion is a false distinction.

We believed in the treatment of medical doctors who gave him medications and instructions, who created meal plans and exercise plans and told him to follow them. At the same time, we did not believe in them. We knew there was nothing they could do to help him except to treat some symptoms, and even then the symptoms and side effects persisted.

It was as if going to see medical doctors in the hospital, waiting in the hallway and going in for a consultation and deciding on options, whether to take chemotherapy or not, and in what order and for how long – it was as if this was all theatre. None of it would make any difference.

It was all ritual. Maybe it provided hope. Maybe it was just something to do.

Nonetheless, it was inevitable that we would be asked to appear before some authority at the hospital to discuss possible treatments. It was like a rehearsal for an alternate reality where treatments were possible and there were cures available, while everyone knew there were none. But we did as requested.

We made our way into a large room in the hospital where medical staff sat and stood, some with papers before them, some with screens, some consulting with each other with puzzled looks on their faces. No one looked our way. There was some kind of downcast shame in the air, as if they all knew this was theatre. A ritual we ought to go through for the betterment of mankind.

They placed a row of seats in the middle of the room, one chair for each of us. We came in a group, including myself and family members.

He sat in the middle like Thomas Aquinas in his intellectual authority, wearing his blue jacket and white shirt. We flanked him on both sides like the sibyls, leaning over attentively to hear what he might decide, or else saying words to each other in low tones. But everyone knew he was the decider; he decided what was true, what was heresy.

Before us in a chair facing us was a doctor asking if he might agree to chemical treatment that may or may not lengthen his life. The argument he made was reasonable and spoken to us gently. My husband turned to me and said, 'The doctor makes it very tempting to say yes.'

Maybe the sky was blue that day. Maybe the snow had stopped falling. Maybe everything was for nothing. But he agreed. I was thinking that if we were all of philosophy, theology, dialectic, and grammar, bolstering the doctor's argument, Aquinas would inevitably triumph over the rest of the heretics in the room. No matter what his argument would be.

Fig trees are not usually grown in Norway. They require warmth and humidity, and in the north it is too cold. But some growers cultivate them in greenhouses, mainly for horticultural interest.

I have never met such a horticulturalist, but I once saw parts of the journals of one fig tree enthusiast. He had studied the matter: he talked about Brown Turkey, Celeste, Black Mission, Kadota, Adriatic – varieties he enjoyed.

But everyone knows about the Bodhi tree, a fig tree native to the Indian subcontinent. They call it the sacred fig. They call it *Ficus religiosa*, because Gautama Buddha sat down under this tree in Bodh Gaya and came to an awakening there while he was meditating.

They say the fig tree grows very fast once it starts. The sacred fig has leaves that are shaped like hearts and the tree is a symbol of wisdom and spiritual growth. As it has been for thousands of years.

Sometimes when I made my way to the plant nursery at Plantasjen on my daily walks, I thought about trees. Everyone has a tree, it seems, every culture. A special tree.

It is said that sometimes the Bodhi tree has been regarded as a symbol of Gautama himself. Therefore people have been seen to conduct rituals at the foot of the fig tree. There are offerings of various kinds of gifts, such as money, spices, betel leaves, incense, flowers, butter lamps. Sometimes the roots of the tree are watered as if they were the feet of the tree. They may even be watered with milk.

In Canada I had a neighbour who was a fig tree enthusiast. He was from Italy. He spent most days in his garden, growing varieties of fruits and vegetables and trying to scare away the rabbits that were proliferating everywhere and nibbling on his produce. But the figs came, dark and purple and sweet, and when they did there were so many of them he had to give some away. Occasionally I would come home to find a bag of figs by my front door. The first time I tasted them I was surprised. The taste was so exceptionally good, I do not think it could be surpassed.

I have a memory from years before of one of our outings to the country-side of Norway. We stopped at Store Ringheim, an old country estate from the 1600s in Voss, where they gave us coffee and had chairs on the lawn to rest from the sun. Before it became a hotel and before there was a restaurant there, the Flor'n.

I understood there were Viking grave mounds on the grounds. It is said that when the Black Death was over, the Church took the property for its priests and widows.

He sat under a tree in the shade, in his white slacks and short-sleeved cotton shirt. It was summer. It was a European oak tree with a thick and twisted trunk, a tree that spread its winding branches and leaves over a wide grassy area. Lime green and grass green. The sun was shining, he

was smiling. We had no knowledge of the future. It was one of our many weekend outings.

When I came to think of it later, the oak tree is a special tree of the north – the tree of Thor, the god of thunder. For that reason it is called the thunderstorm tree.

Knowing the future is not one of the gifts we have been given in our baptismal ceremonies, whatever form they have taken. Our various rituals of becoming human. But there is always a suspicion that we know what will happen anyway. It is one of the many things we cannot explain. We have it on instinct, on a sense of premonition.

I have sometimes wondered at a fresco painted in 1481 or '82 by Cosimo Rosselli that is in the Sistine Chapel. It is a picture of the Last Supper, usually painted with all the disciples lined up along an elongated table, with Jesus in the middle. This is when he tells them about the wine and bread they need to be mindful of in the future.

But in Rosselli's painting, the table is crescent-shaped, covered in a white cloth. The disciples are sitting on one side facing the viewer, but Jesus is sitting alone on the other side, with his back to the viewer. There is only one goblet on the table and it is standing in front of the central figure of Christ in his dark drapery. In front of him, however, and behind the twelve on the other side, are three panels that look like windows. One panel shows the Agony in the Garden, the second panel shows the arrest of Jesus, and the third panel shows the crucifixion of Christ.

The viewer knows what Jesus knows and the disciples do not know. There is the future, laid out before us, which we already knew before we saw the painting. The future in such paintings is already inscribed into the painting itself. It presents itself as a statement on fate and how destiny is already inscribed into the cosmos before we ever appear in it.

For a while I was reading the work of the German sociologist Ulrich Beck, who created the term 'risk society.' In his book *World at Risk* he notes how it is understood that you cannot even be alive without some risk. Everything you do, every decision you make, entails risks. And then, risk is simply catastrophe that has not happened yet. There is going to be a catastrophe and you know it. But you hope the disaster will be put off.

The way I interpret this is that life is catastrophe. When I looked at the situation we were in, I reminded myself: There is nothing unusual or even unexpected here. It was always only about the timing.

When catastrophe happens, it does not necessarily come in a sudden explosion of things. Sometimes it does: when there is an earthquake, a tornado, a tsunami, or war. But most of the time, the catastrophe of living itself happens slowly. It is like an unfolding.

Then you may gradually lose your bearing. What they call your lodestar, your guiding light. You have to exert yourself to keep your eye on that light or you will lose it.

When we lived in the countryside near Oslo, close to the Swedish border, we usually went on small trips on weekends. We would drive somewhere on day trips or else stay overnight in some new place. Often our road trips and wanderings took us into Sweden. We traversed Sweden from Umeå to Karlstad to Göteborg, Växjö, Karlskrona, Kristianstad, to Malmö, and from there across the Öresund bridge to Copenhagen. That epic bridge with its cables gave the feeling of a giant sailing ship hovering high above the blue waters. As you soar upward, it feels as if you might continue into the azure sky and be gone forever.

When we were travelling in Sweden, I had the feeling of having been freed from something more constricting in Norway. Some sense of enclosure, which now was opened up and we were let out.

We stopped in Helsingborg one time and looked at Elsinore, Kronborg Castle, across the sound. There you take a twenty-minute ferry to Denmark

in the afternoon ocean mist. For a moment as we stood by the seawall I wanted to move to Helsingborg. It was just a passing thought as I suddenly felt at home there. We walked through town and I stopped at some of the glass displays on the walls of buildings showing real estate for sale.

Later I wondered whether this kind of whim was really a signal that was telling me to get out of Norway. Maybe I had a premonition. Things will get difficult. Perhaps it is true that we get lots of warning before challenging times arrive. Not just one warning, but many. The warnings come again and again in many forms – as apprehensions, synchronicities, even outright invitations for you to be somewhere else. But we don't receive the signals. Most of the time we are signal-blind.

There are guiding principles in Buddhism I can tell you about. Otherwise it may be unclear why we did things the way we did.

They are called 'the six perfections,' and they are ways of being that make up the right way. The Way, as they say. The Path to take so you will not get lost.

Generosity. It is better not to be stingy or to keep things close. Better to share with others and to give away rather than to keep.

Discipline. It is better to keep your markers, the ones you have created for yourself, and stay within them. Not to let your principles fall apart or you will have to start all over again.

Patience. Whatever is unfolding will do so in its own time. You cannot rush it and you are not entitled to demand the universe operate on your personal timetable. Learning how to wait is a good thing.

Exertion. Work hard. There is no reason to hold back on what you can do while you can do it. Nothing happens if you do nothing. It is better to move the wheel on, help it turn.

Meditation. Take the time to stop and let everything sink in. This is when you can practice not being attached to the outcome of things. It is better to learn to let things go, even before they are gone from you.

Wisdom. This is the hard one and the one most in dispute. What is wisdom? In Buddhist circles it is knowing that you are not what you think you are. You are probably not even You.

But of course wisdom also consists of the first five perfections. The last one holds all the others the way a lotus flower holds itself before it unfolds.

Some say those who live by the six perfections are 'stream enterers.'

There are also 'three poisons.' It is clear these three can poison everything. *Ignorance, passion, aggression.*

In Buddhist circles, when they say ignorance they mean not being mindful of the six virtues, or not adhering to them. This could mean you are impatient and lazy, without discipline and generosity. Maybe it means narcissistic or self-obsessed. All the things we associate with bad character, pretty much universally.

They also mean it is toxic to be overly emotional and to let emotions govern everything. There is a lot of debate about what that means. Some say emotions lead you to follow your instincts and that is good because reason alone cannot always be true. What is true for you. But emotionality and the attachments that come with it tend to be toxic – mostly to the self.

And aggression can come in many forms. Not just physically, but there is also emotional aggression, psychological and even intellectual aggression, none of which bear good fruit. They just alienate others and isolate the self. There is even spiritual aggression, when preachers howl at you and admonish you. And also manipulate you.

All of these are toxic and we know it. When we feel pushed around or when someone tries to overtake our own mind with theirs. What they call gaslighting, another form of aggression.

There are so many things that can go wrong. So many false turns one can take. I thought of this often, especially in the early morning when dawn seemed far away still and I was up awaiting another difficult day. I told myself I would adhere to what I knew was true that day.

I also told myself it would be all right to take it just one day at a time.

By accident I came across a picture of a lotus flower just about to open its petals in bloom. The petals were white but tinged red at the edges and tips, a maroon red. The stalk and leaves were bluish green, spread out and folded over themselves, showing a brownish pink underside. One bud was still closed, yellowish green on the outside and the tip all red.

I decided to paint that flower. I painted it exactly as I saw it, including all the veins and folds and nuances of colour. This was a picture of a lotus seed that had lain dormant for a thousand years. When it was planted and brought back to life, it flowered anew.

I hung the finished picture in my home so that every day I would see it and be reminded that everything once living can also come back and live again. Usually we feel when something alive is gone it is gone forever. But I have heard it said that like all that has ever died, we need to know that it never died; it simply shines somewhere else.

Where I live now, I drive past a building complex hidden in a forest of some kind on 32nd Avenue. It is on the corner and there is a sign that says 'Tree Seed Centre.'

This is where cones and seeds of Canadian forests are kept, analyzed, processed, and stored. The seeds and cones are used for reforestation when fires and logging have removed the trees on the mountains and hills. It is also a research centre where types and species are studied.

The Tree Seed Centre is also a storage vault in case of a catastrophe. As time goes on, the prospect of a tree catastrophe becomes more and more real. We have reached a point where forest fires burn every summer

in Canada, larger and larger areas of forest, in every province, denuding the mountains and hills.

The most famous seed vault in the world is probably the Svalbard Global Seed Vault in Svalbard, Norway, on the island of Spitsbergen. They call it a backup facility for the world's crop diversity. They have duplicates of seeds kept in seed banks around the world. It started with Nordic plants but later became international. There are over a million crop samples stored there. They say those samples are from thirteen thousand years of agricultural history.

The seeds lie dormant in the vault. At any time, they can be brought back to life. With diligence and exertion, a global will and faith.

I often think, if we try, we can make life go in a circle.

It is well-known that the lotus flower is thought to be sacred. Not only by Buddhists but also Hindus, and it was even sacred in ancient Egypt. This is because it can grow clear and fresh out of dark and murky water. The lotus flower symbolizes rebirth, and in Buddhism it represents the Path to greater wisdom.

The lotus flower is also a traditional medicine. It can cure many illnesses – of digestion, inflammation, skin ailments.

What you can remember with the lotus flower is that what is good can come from something bad. Adversity can also be a ground for beauty and goodness. We have only to let it happen. Not by resisting adversity, but by going through it. By non-resistance.

If I had to remember things like this during those months in Oslo, I had plenty of pointers around me. It was really only a matter of paying attention.

Every day I took a walk in the fresh winter air around the neighbourhood or I took the tram downtown and wandered about the busy, cheerful

streets. The tram system is called the Trikken and it has lines and electric trams that run all over the city. I boarded at Vinderen and got off at Majorstuen and then walked down Bogstadveien into the downtown. I passed the Royal Palace and grounds on the way and many cafés, restaurants, and shops. The streets were always full of people walking, having coffee, shopping.

Some landmarks began to stand out for me: the Deli de Luca kiosk, the Ark bookstore, certain clothing stores. Then of course the famous Litteraturhuset and art galleries. Eventually I got to Karl Johans Gate, the main drag of downtown, the Stortinget Parliament, and nearby the Oslo Domkirke. The Neo-Roman architecture that remained in the city was invariably daunting to me: the large columns standing guard before a government building with secret blackness in the shadows behind. The stone structures stood there like another version of the Parthenon in Rome and I had the sensation that if I waited long enough, Hadrian himself would appear on the front steps.

At the time it escaped me, although I can see it now, that I also passed by the Canadian Embassy every time. At one point in my saga of these months I was so perturbed and confused about what to do that I wrote to the Canadian Embassy to ask for advice. They wrote me back and were very kind. I think it was just the kindness itself that helped, and it did not matter whether or not there was anything substantial they could do for me. I was reminded that kindness alone is often enough.

On one of those trips I was wandering in Frogner and went into a side street where I looked across the street and saw a sign for a 'Perlebutikk.' After a moment of readjusting my language focus, I realized it was not where pearls were sold, but rather beads. I went inside to see if I could find supplies for making jewellery.

The shop had an alluring interior. The owner travelled extensively in Nepal and Tibet and had on the walls various ornaments and hangings from that part of the world. I queried her and she told me many things about where she got her material and about her travels. After listening

for some time, I went around her bins full of beads and stones and picked out as many as I thought I would need. Some were a beautiful Persian blue, and I chose them with black and gold fixings. I went home with the bag of supplies, feeling satisfied I had found a supplier.

For the next few days I organized the round stones and got the tools out on the dining room table. At night I spent many hours creating necklaces. They were beautiful and satisfying, although it was entirely unclear to me who would use them or when, if ever. But that did not really matter. It mattered that I could spend this time because it was also a time of meditation. In a strange way, making things in your hands becomes a springboard for reflection and calm.

Every now and then I picked up a heart-shaped pendant. There was an abundance of heart pendants in all the boutiques, often decorated elaborately. I usually picked a metal or wired pendant. I did not know what I would do with them, but I liked the look.

Eventually the hearts joined the bead malas and rosaries I had picked up over time as well. I did not use them, but it was a form of collecting. I put them in a box and sometimes opened the lid and examined them. Rosaries of all kinds, usually just acrylic, and beautiful malas in black onyx or tiger eye. The box of hearts began to grow as well.

On reflection it occurred to me that in Tibet, the mind is not considered to be located in the head. The mind is in the heart. I read this in a book by an anthropologist, Sara E. Lewis, titled *Spacious Minds: Trauma and Resilience in Tibetan Buddhism*. There is talk of the 'heart-mind.' This feels natural to many. I was beginning to think of things that way too. The whole concept of 'mind' is altered and it begins to feel less like a machine and more like that which contains spirit as well as thought and reason and feeling.

Perhaps it is also true that you do not just think with your brain. You think with your whole body.

PART SIX

We planted fir trees and junipers on the property where we lived in Canada. A whole line of fir trees along the long driveway and a series of junipers along the back. At first the saplings we put down seemed confused. They remained scraggly and small in their new soil – orphans all in a row. But there was a very large, very old fir tree at the end, with twisted trunk and heavy branches that leaned out over the driveway and surrounding hill. After a couple of years it was as if the 'mother tree' had managed to connect with the little ones and told them it was safe to grow, because suddenly, as if by explosion, all the little saplings started to grow very fast and they became handsome young trees.

He was very good at gardening, and he could lift heavy bushes and trees and move mounds of soil. He worked hard on the property. He often bought flowering plants in pots from the nursery that were about to expire, and in the course of a few weeks brought them back to life. Soon the front of the house was awash in blooming potted plants: lilies, hydrangeas, geraniums. Black-Eyed Susans near the grass. Chrysanthemums.

After he was gone and I returned from Oslo, I sometimes drove to the village and bought a sandwich at the kiosk and an orange juice, took them home, and had my lunch on the front porch. It was quiet, the sun was shining, the branches of the trees he had planted waved a bit in the light breeze. I watched them in their spaces: the little forest we made. It was our own private forest, something we got to put there ourselves, back to the land that had given us a great deal of pleasure in our life together.

It is a common conceit among Buddhists, especially Tibetan Buddhists, that the mind is the entire sky. The emotions you feel that obscure and often direct your thoughts are really the clouds passing by. They will disappear, maybe replaced by other clouds that will also go away. But it is good to remember that behind those clouds there is a clear blue sky: that is your mind behind the drapery of emotions.

I sometimes think of this allusion, this image. During that winter in Oslo, I do not remember a sunny day at all. Every day seemed thick with cloud and dark. But there were sunny days, I am sure there were. I just do not remember them.

But what is that clear blue sky? When I think of how the Buddhist way of dealing with difficult emotions exposes this notion of blue sky, it is well to remember that emotions come with a story: a narrative we have told ourselves. How we frame everything.

But we do not really know the stories. We like telling them; they give some comfort in a world of *unknowing*. But our narratives are also clouds passing by. We can just as easily create a new story and replace the old one.

What is true, in this way of thinking, is that there is no story here. In order to 'see the light,' which is not a coincidental verbal construction even though it is a cliché, it is necessary to abandon the narrative that surrounds us. Leave the story out of it and then see what is left.

Sometimes what we do and think is so habitual, so much a part of our everyday, that we think it is 'natural.' It is the idea of *habitus*, or *doxa*: possibly so trivial we do not even see it. But many small things we take for granted pile up and become a large mountain. Possibly a mountain of impediments.

This seemed especially true in our present situation, which was filled with expectations and unexamined 'truths.' If you are sick, you need a

doctor and you need medication. Certain things are necessary and other things are to be avoided. As clear as day. When we laypeople deal with difficult medical issues, we defer to the experts. The medical experts now own the situation and we are bystanders. Even those who are sick, the 'patients' themselves, are bystanders to their own illness journey.

This is now commonly understood to be a problem. Yet when you are inside this problem, there is nothing else you can do. If you were to take another route, you would be highly suspect.

I had many ideas running through my mind about possible alternatives to what seemed to me a bleak way of ending a life. Many medications, routines, schedules for taking them, with adverse side effects, visits to the hospital and long waits, sorry hospital environments with sad people, machinery, white and blue walls, and the clanging of metal. People rushing in panic.

I could not suggest something else because it was not me who was sick. I followed the wishes of him who was, but he no longer had the imagination to think of another way. So I waited with him in the dreary hospital corridor, hour after hour in sorry silence. Sometimes we talked, but he was no longer interested in subjects or even private matters. He was somewhere else, and over time he seemed to be further and further away.

I have read in books on ecology and biodiversity that in China, the landscape was denuded of a great deal of its biodiversity by the mid-twentieth century because, even though there were mystical stories of individual trees that people passed around, this did not extend to whole forests of trees. There are travellers who say when they are in the Chinese wilds, as Daniel Capper phrases it, 'where mammal, bird, and insect sounds should be abundant, yet there is no noise, only an unsettling silence.'

That is what I found in these months in Oslo as well. Where there should be life and activity, joy and abundance, there was only an eerie silence.

Perhaps it is also the silence of ordinary life. Just ordinary life.

The French philosopher Jacques Rancière wrote an essay on the Norwegian playwright Henrik Ibsen, included in his book *Aisthesis: Scenes from the Aesthetic Regime of Art.* Ibsen, to him, wrote a kind of 'drama without action' and displayed the 'drama of ordinary life.' This was for some reason a revelation to European theatregoers in the nineteenth century. The dramas take place inside rooms, and characters 'cross the threshold to bring messages from the outside.'

Otherwise, the voices of the soul can only 'make themselves heard in the silence of doors and windows.'

The Korean artist J. Park does not work with silence but with noise. He analyzes the noise of cities and machines and industry, creates digital images of that noise until what he sees are pixels and dots. Those pixels and dots are enlarged even further and he finds there are intricate patterns inside what seems like chaotic noise: the hum of machines, the grinding noise of industry. He recreates those dots and lines onto surfaces, with sheets and acrylic paint, and with video and photography.

He says he has created 'dot storms' and 'space waterfalls.'

When we pare down sound, cut it and edit it, we make signals. What we have removed is then noise. But in J. Park's mind, the things we remove and cut out have value. Sounds we refuse to hear, that we think of as 'noise,' are also full of signals.

*

There was a furniture and design store across the street from our building. It was in a red brick building, two storeys. When you walked in, there were tables and furnishings arranged around a staircase in the middle. Downstairs were more furnishings and accessories. Everything in there was cutting-edge design with a country style to it, all extremely tasteful.

I liked to go in there now and then to look at things. There is nothing quite as beautiful as good Scandinavian design, and this was a kind of epicentre of Nordic craftsmanship.

A lot of this design was simple and functional. There was an air of Zen about it all. And yet, Norwegian design has never quite forgotten how indebted it is to the forests and mountains, and you got a hint of the cottage feel as well. Raw wood, rough linen, exposed light bulbs. Decorative objects that were simply found: natural things like shells and pieces of wood.

I bought a chair there. It was so beautiful that I wanted it at home. We did not exactly need a chair, but the furnishings of our rental were nothing special. I wanted to bring in something more, something in excess. An item that would be uplifting in some way. It was a rather large chair and clumsy to lift, but I actually carried this chair across the street and up to the apartment. Through sheer force of will – when you find strength you did not know you had.

Now I could sit next to him, since he always occupied the only easy chair there was. We could be side by side, or we could face each other as I read to him.

It seemed time slowed down to a trickle. A snail's pace. We were caught in a bubble of timelessness where nothing moved. It took a great effort to make things happen. We were at bare survival stage where the only real question was how would we make it through the day.

It was strange to be in this kind of space at a time in history when everything is defined temporally. Modern life 'moves on,' we all 'go forward,' we 'develop' at a pace that is either rapid or slow, but it is a pace. Fast is more. Being slow is being less. We were much less, we were nothing, but in that extended moment there was so much depth – the kind of depth you do not see when you are running forward.

There have been studies of refugees, migrants, people without homes, that show there are certain exaggerated kinds of time that are experienced. There is 'waiting time' for those caught in the in-between: not able to return, not able to go forward and settle anew. This was a feeling that I experienced in our situation in a slightly different way: not at home, but in a temporary rental, caught between having to be there and needing to go home. I was trapped in waiting time.

There is also what is called 'empty time,' when things are not fulfilled. What needs doing cannot be done and yet it still needs doing. Then there is 'overscheduled time,' when too many things to do pile into one another and they cannot be completed because they are too many. Too many institutional forms to fill, lines to stand in, numbers to wait for, transportation issues to sort out, all on top of each other. This comes with a great deal of urgency.

When it comes to waiting time, there is waiting for nothing, waiting for the slow clock, for sleepers to awake, for evening to come. Then there is 'institutional waiting time,' where you do your waiting in an institution, like a hospital hallway or a doctor's office or a bureaucratic foyer where documents are supposed to be cleared. Institutional waiting time makes everything worse because it is so brutal. Symptoms, agonies, apprehensions are magnified – it is as if institutional waiting rooms are designed to kill the waiter.

In those places it is impossible to exercise the kind of patience you can perfect in quieter places, like at home, where you can fill a bowl with warm water, light a candle, and wait in a more tranquil way. But we tried. We exercised patience as well as we could.

There is yet another kind of time that is different from all the rest. It is the time you spend doing something for another. You do it as a gift. It could be called 'giving time' – when time is a gift you give to another.

There is also an exaggerated experience of 'speeding time.' Of a need to move quickly with everything so you can get on to the next thing. Sometimes I caught myself in the futility of this kind of hurrying. When I was doing mundane things like putting gas in the car, or picking up food, or walking across a parking lot, I realized I was rushing. I did not know why I was in such a rush. I had to remind myself: Slow down. You are not in a hurry. Take your time.

Take your time.

The Italian philosopher Franco Berardi once said that it seems time is accelerating. But, in fact, time actually *is* accelerating and it is always accelerating faster. Time continues to speed up unnoticed, he said, until you discover one day that something is out of joint. Some rupture has happened.

As if to confirm this thought, on the news one day it was reported that the Earth had lost a leap second for the first time ever.

I was reminded of something the Scottish sociologist Andrew Ross wrote in his book *Real Love: In Pursuit of Cultural Justice*, about so-called 'velocification.' We are addicted to 'the principle of accelerated life.' We need to see ourselves going faster all the time. But when acceleration is combined with scarcification, a strange culture of 'time scarcity' emerges. Capitalism, Ross advises, 'needs to manufacture scarcity; indeed, it must generate scarcity before it can generate wealth.'

Meaning, things can only become valuable insofar as they are scarce. He mentions Ivan Illich's book *Energy and Equity*, where Illich talks about 'the exchange value of time.' Time is a commodity, according to these thinkers, and commodities are exchangeable. To add value to time, it needs to be made scarce. *We have so little time.* This leads to a new form of class society, where some people's time is assumed to be more important than others'. Some people's time is also more 'valuable' than other people's time.

This is what they call 'the cult of acceleration' and it affects all aspects of society. An example is the lightning speed with which finance moves around the world. The faster things move, the faster the depletion of

Earth resources happen. Modern society is in the business of 'speed production' and 'the production of scarcity,' which go together.

This development, says Ross, is incompatible with the temporality of the intellectual – the thinker, reader, poet. Thought has a slower momentum than digital machines; patience is antithetical to acceleration and information technology. But our addiction to speed is rooted in the anxiety of being left out. Being left behind and alone. We think we lose nothing material in our pursuit of speed – nothing except our time. But we lose more than time. There are invisible costs, and now I also think we lose our ability to think. We lose thinking itself.

I could feel more succinctly how I had been browbeaten into such anxiety now that I was being forced to stop altogether. Caregiving is not a fast-moving pursuit or project. Everything goes very slowly, and it goes more slowly all the time, until it completely stops. You have to adjust your own rhythms to a whole new scale – even hand it over to another's rhythms. Time in our case had taken on gigantic proportions: everything was about time. How much time could we have? It became imperative to slow down everything simply so we could have more time.

I remembered how the German philosopher Martin Heidegger proposed another view of time. There are five characteristics to time in his analysis. For one, time is ecstatic. Then, time has a limit. Third, time does not pass and it does not stand still either.

Most curiously, time is subjective. The idea that time needs to have, as a fourth characteristic, a sensibility – both reason and spirit. Finally, time is personal and has a personal direction. Where you are going is not where I am going. The experience of time, it would seem, is different for each one of us.

It sounds as if time has become animate. That time itself has feelings and desires and predilections.

Despite how strange that sounds, there is a peculiarity about time that is hard to come to terms with. Time, a lifetime, seems flexible: stretchable, bendable. Not nearly as mechanical as we have been led to believe.

I am reminded of an essay I read by the American medievalist Lynn White Jr. titled 'The Historical Roots of Our Ecologic Crisis.' He wrote that 'the most monumental achievement in the history of automation [is] the weight-driven mechanical clock.'

Such a clock is a mechanical timepiece powered by the gravitational pull of heavy weights slowly falling down. The weights are on a chain wound around a cylindrical drum. The chain is fitted into a toothed ratchet wheel and then a main wheel and then a centre wheel and then an escape wheel and a pinion wheel. The teeth of the ratchet wheel assure that the chain can move only one way and cannot go backwards. All of this has a suspension spring from which the pendulum hangs.

After about a week, the weights need to be pulled back up. A winding mechanism allows the clock keeper to raise the weights again and start a new cycle.

Aside from being a thing of beauty in and of itself, the weight-driven mechanical clock is rich as a metaphor. It is a clumsy attempt at measuring time, which is otherwise so fluid we lose track of it. But it is also an elegant sculptural object that moves and clicks.

I am reminded of the incense clocks that date back to the tenth-century Song Dynasty in China and were used in Japan and Korea as well. This clock has censers that hold incense sticks, often powdered incense, that burn at specific rates. So specific you can count minutes and hours and days by their burning. These also have weights that fall off at set moments, and they drop onto a platter with a little click. The incense sticks might have different fragrances, so different hours would have their own scent.

I seemed to recall a weight-driven mechanical clock in the living room of our home when I was a child. It was an antique clock, elaborately carved with a glass door in front. The door would be opened and inside was the pendulum rod and bob, and the two brass weights hanging on their chains.

Every week or so I remember my mother, who was the keeper of the clock, opening that glass door and pulling down the weights to reset them for another week. The heavy clicking of the clock in an otherwise quiet room became for me a sign of 'home.' You were not at home unless that heavy clicking sound was there, and then perhaps a gong would sound on the hour.

When my mother reset the clock and pulled down the chain that held the brass weights, and I watched her from the doorway, she looked to me like a Delphic sibyl with her head in a blue scarf, reaching up to pull down her scroll of wisdom.

PART SEVEN

On National Day in Norway, which is the seventeenth of May, people come out in their fineries and national costumes, their skirts and vests and blouses, sometimes with capes and hairbands and holding signs and flags. They come down the street in huge crowds in every village and hamlet and town. There are thousands in the city centre in Oslo, and the predominant colour scheme of red and white is striking. They march in procession.

We spent that holiday in various places in the past, sometimes downtown. I always had a sense of unreality about these processions. People step out of themselves. They become members of a mystery that is ultimately cheerful. To me they might as well be a procession of angels dressed in white, dark blue, and crimson, slowly floating down the main avenue with their golden halos around their heads, holding sceptres, swords, and crosses instead of flags, moving toward some undefined centre where the saviour, in the personage of the king in his scarlet drapery, will speak to them all about the value of life. Everyone has stepped out of time.

The curious observation about time that strikes me often is that every person is going through a different time. Not everyone has the same time; we only think so because there are clocks that 'tell time,' and the whole system functions according to clock time.

But clock time is 'able time.' Many people have difficulty doing things by clock time. Some people take longer to do things because their bodies are different. They are made of different material, somehow. They have a different kind of clock in them.

This became more and more clear to me as our ableness drifted apart during those months in Oslo. I was more and more mechanical and

clock-adjusted in order to get things done. He was less and less so. He needed much more time to do the simplest things. Walking down the hall eventually became a chore that must have seemed like hiking up a mountain. He needed more time. For everything.

Even though I am recording a certain kind of 'narrative' of a certain time-space and condition, I am also trying not to solidify it all in a fixed story. How to keep this recollection from becoming solid even while it is being put into words is a kind of koan to solve. Because this 'story' both is and is not. This did and did not happen at the same time, and what was happening did so on several levels, not always harmoniously so either. The practical level, the emotional, the psychological, the theo-retical, even the spiritual levels, all bounced against each other like balls in a box. They were almost impossible to control, and sometimes I had to just let them bounce around and try not to be rattled by it all.

I tried to just let the snow fall. Thick, fluffy flakes floating down of their own accord and falling wherever it was most convenient to land.

The Irish-American artist Sean Scully said, 'It's not the survival of the fittest. It's the survival of all.' He also said of being a painter: 'I am a nurse.' He said he was trying to make the world better by making art.

The British painter Dan Perfect had a sign in his studio that said 'Always know where the exits are.'

The American artist Ed Ruscha said, 'It's always cloudy out there.'

I collected these sayings because they meant something to me. Often in an oblique way. Making art, writing books, nursing a patient: they are more or less the same thing. I did agree that Modernity has been staring itself blind at Darwin's idea of letting only the fittest survive. If you are not fit you can be dispensed with. That is what nature does. But I think: Even if you are not fit, you deserve to survive.

I also did not know where the exits were in this situation. In fact, it had already dawned on me that there were no exits. Did I forget something? Did I overlook something on the way here?

As to exits, it was clear as soon as we heard about the nature of his illness that this was going to continue until it reached the end. There would be no stopping this once it had begun. The rest of our time together would be composed of observing the wheel turn without being able to put the brakes on it.

I was reminded of the idea of the turning of the wheel in the bigger picture: the unfolding of history. That it cannot be stopped once it has begun. In the Pāli Canon I noticed this was said about the first teaching of Gautama in the Deer Park to the five monks: once he gave his first teaching, the wheel of the Dharma was set in motion and it would roll on without end.

There is such a thing as the 'theory of constructed emotion' in the world of sociological and cultural thought. That is, people's emotional experiences tend to differ from culture to culture. There are things we are supposed to feel, or expected to feel, and then what we do feel or think we feel or expect ourselves to feel. There are public and private emotions; institutional and domestic; family emotions and individual; different ways of feeling about things depending on how educated or learned you are. There are also religious emotions and how different religions deal with normal human emotions differently.

When people ask you, 'How do you feel?' it comes as no surprise to me that it is sometimes difficult to answer that question. How should I feel? What is the proper emotion for this circumstance? Am I a good or a bad person for feeling a certain way in a certain situation? There are judgments, both public and private, both by others and the self. In any case, how can I even express how I feel at any given moment? My answer

would have to be long and include many descriptives in a row.

I cannot tell how I was feeling. I think my emotional life was on hold, just like my entire life was on hold. At the same time, I was comparing myself to him, who had almost no life at all anymore. Who was I to have a feeling about myself when he had it so much worse? Logical and real. There was nothing exceptional about this state of non-feeling, of not allowing my feelings to be there.

I knew well enough how these things are handled in Buddhist circles, and it seemed natural to me to do the same. Here it is not advisable to allow excess. Not excessive grief, excessive joy, excessive anxiety. Those overabundant feelings are not helpful. It is better to be stable. No matter what is happening, to maintain emotional stability.

If the situation cannot be changed, there is no point in creating an outcry. Caught in a circumstantial trap, such as we were, it is better to try to transform your relationship to that circumstance. Reframe how you approach what is happening and how you think of it.

I did not have to think about that much because it seemed to happen organically that I adjusted my inner life to the reality I was in. I read about the samurai warrior who is loyal to his lord to the end, and it made sense to me. Maybe what I was feeling mostly was just that: loyalty. The times he was in the hospital and I stayed with him most of the day, sometimes the nurses did not understand why I did not go away. How could they? They were in a different world.

Perhaps it was easier to be 'loyal to the end' knowing the end would be there soon.

There is a poetic saying in Buddhist circles concerning the lotus that grows from the mud. The mud is harsh but the lotus still grows into a rich flower.

Life itself, once it takes hold, is *like the wind the net cannot catch.*

There were times when reality did not seem fixed. One moment he was in his chair writing on his laptop goodbye letters to everyone he knew. The next moment he was lying in bed sleeping. He was very tired most of the time. But even though he was gone from his chair, I still saw him in the chair, sitting there. I did not see him the way you see things when you look at them, like you see a coffee pot or a vase in front of you. But I saw him in another way that I could not articulate. He was still there, in the chair, even though he was gone from it.

This kind of sensation continued, long after everything was over. I could not account for it. He had already split somehow into his material self and an immaterial self that would stay, go with me wherever I went, and that could be found in certain locations, and that came and sat beside me when I was writing or painting or just meditating. For years. I thought maybe it would remain like this forever.

❋

There is lot of confusion about that kind of splitting when it comes to Buddhism. It appears that in Zen, there are 'two minds' at work simultaneously: the thinking mind and the observing mind. And yet, the thinking mind cannot be disassociated from what it is thinking. The thoughts of the 'self' are floating there without anchor, because the self itself is an illusion.

But most people have the experience of both being in the midst of something and also observing it at the same time, as if they were not in it. Thoreau wrote about it this way: 'I am conscious of the presence and criticism of a part of me, which, as it were, is not a part of me, but a spectator sharing no experience, but taking note of it.'

The part of you that is not part of you – that must be what continues when the other part is stuck in its material chains. There were always two of you.

I have also heard of this splitting going three ways. You can be thinking; you can be below thinking; and you can be above thinking.

The Japanese Zen master Dōgen Zenji, who founded the Sōtō school of Zen in Japan, said, already back in the thirteenth century, that there are actually three minds. There is the joyful mind, the caring mind, and the great mind.

One afternoon, several years after our last stay in Oslo, when it was raining hard on the silver birches outside my home where I now live, the sidewalks and alleys shimmering wet and the sky heavy and cloudy, I was relaxing in my reading chair with a magazine. It was not usual for me to browse through magazines, but this one had been deposited in my mailbox as a promotion. I took it in because it contained an interview with the British writer Zadie Smith.

Smith was talking about the self. About 'authenticity,' and how she is skeptical of that concept. She does not think she is 'authentic' herself, the article said. The 'self' is a 'moving target,' she said, and cannot be pinned down: 'the "real you" is very hard to identify, because it changes constantly.'

I thought, if there are two of you and both of you are moving targets, maybe there are many more of you. Maybe this so-called 'self' is a universe of orbiting stars.

Because of the lack of a 'fixed reality' in my mind, and because time was taking on different dimensions, such as inside time, outside time, walking time, waiting time, this account of our months in Oslo cannot be any kind of historiography or even memoir or recollection. That assumes everything is certain and all you have to do is either remember it or find the facts. I can certainly look at a map of Oslo to remind myself that the nearest street was Rasmus Winderens Vei, but the essence of our experience, his and mine, cannot be delineated that easily.

If I do not describe exact feelings or give an exact chronicle of events, perhaps I am simply exercising the only agency I have now and had then: the power to refuse to give a description of feelings or events. If I write a memoir that is not a memoir, I am still writing. You could call it an 'anti-memoir' or even 'anti-writing.' It does feel like this something is really nothing, and yet nothing is also something. This is the vocabulary of Buddhism. Knowing that Buddhist language has been helpful in this instance.

For many years after I returned home and our experiences in Oslo were over, I could not talk or write about any of it. There was a huge block, a big stone, keeping all that apart from even me in my own mind. But after returning to the language of students of Buddhism, I found a small crack. Just a tiny space I could dwell on, and little by little that part of my life began to reveal itself. My memory was no longer guarded by those demonic gatekeepers you see in the Buddhist temples – many of them, each one more grim than the next, standing in threatening postures with weapons in hand, swords or knives, grimacing, feet apart as if ready to pounce.

In academic vocabulary, there is something called an 'anthropology of refusal.' That is when scholars study what people refuse to do rather than what they actually do. A great deal of cultural information can be found in refusal. In my own mind, I had a feeling of refusal much of the time, but I was not sure what I was refusing to do, or what I am now refusing to write. Maybe it was just suppressed anger. Maybe it still is – but I doubt it.

If Samsāra is an illusion, it seems like a conundrum that industriousness is even necessary. If what we are after is not worth pursuing in the final analysis, then what is the point of it all? But that is not the way to think. The point is that we still have to go on living, and to live there are many necessary obligations. And life itself is worth everything, just for itself. However it appears, in whatever guise.

There is also another way to think of these things. It is said that in Samsāra, we begin to suffer and accumulate negative energy from our suffering. This energy requires food, which is more negativity, so it takes more negativity into itself to become strong. The stronger it becomes, the more negativity it ingests, and we feed it all the time, until a person is so full of anger, hate, violence, that it has overwhelmed all positivity and taken over the mind in the form of mental dysfunction and depression.

What such a person needs to do is clear all that up. Go on a healing journey. Begin with one step and let that negative energy dampen and diminish until the imprisoned angel inside you is set free.

These are all words and stories. But somehow we have to talk about what is happening inside us. This way of saying it makes just as much sense as any other way of describing suffering.

It is said that when you go on such a journey of clearing out negative stuff from your mind, you will find it disquieting, if not downright frightening. That is because you do not know where you are going. You will need to embrace not knowing in the process, and that is difficult for everyone. It is much easier to 'know' everything than it is to accept that you do *not know*. But shedding your negativity also means shedding the things you think you know and all the talk in your head. It means letting the voice in your head be silent for a change.

As far as I could see, there were at least two different kinds of negativity to think about. One was the negative thoughts and emotions that work to destroy life, which is what the Buddhists are always trying to remove. The other is a negativity that seems to exist as a shadow of our positivistic world, which is what the mystics talk about.

It seems many believe there is another world parallel to ours, a shadow world alongside ours. It is the negative of our positive world. It is a world that moves side by side with ours.

That other world holds all the secrets. It is a universe of secrets that for us is sealed off and full of things we do not understand.

The American artist Josh Smith once said that the whole history of art is an illustration of depression.

Maybe it is not so much depression as it is sorrow. The history of Western art is a long illustration of sorrow.

Sometimes that identification is overt and clear. I am thinking of religious art, especially depictions of the Madonna. In Renaissance art it seems the figure of the Mother Mary was invented specifically to be able to picture human sorrow.

She sits with her child in her lap, head leaning to one side, face expressionless, eyes downcast, as if she knows there is nothing she can do to alleviate the sadness, the distance, the oncoming catastrophe in her heart. She is wearing a cobalt-blue cape that covers her head. Her tunic is rose-coloured and her fingers are unusually long, as if she is trying to protect the child in spite of the inevitable. She tries to protect the unprotectable, and she knows it.

Human sorrow may be a fundamental part of being human – even what makes us human in the first place. We are capable of sorrow, and therefore we are capable of contemplating true reality.

It was the English poet Andrew Marvell who wrote in the seventeenth century a poem titled 'Eyes and Tears' where he says:

Ope then mine Eyes your double Sluice,
And practise so your noblest Use.
For others too can see, or sleep;
But only humane Eyes can weep.

PART EIGHT

On one of my daily walks around Oslo I stopped in a small bookstore called Ark, on Holmenveien. I browsed in all the different sections: it was one of those old-fashioned neighbourhood bookstores where those who lived in the area came regularly to find new reading material – the kind of bookshop that is now being replaced by big-box and online retail.

On impulse I bought a biography of the painter Edvard Munch. It was in Norwegian, as were all the books there, but fortunately I did read the language. I was not sure why I bought it; it was an old biography that had been reissued, and it was a psychological portrait of the life of Munch, *Edvard Munch, Nærbilde av et geni*, by Rolf. E. Stenersen. *Intimate portrait of a genius.*

During the many outings we went on in and around Oslo over the years, we had seen pretty much every painting by Munch available to the public for viewing. When we were in the old Munch Museum in Tøyen, the permanent museum dedicated to his work – which has now been replaced by a swanky new thirteen-storey museum on Edvard Munchs plass 1 in Bjørvika – I remember feeling quite sad. His subjects were dark and fraught. He was obviously a disturbed soul. After all, his mother died when he was very young. His sister died of tuberculosis when he was a teenager. Later his brother also died.

Melancholy, showing a disturbed man, hand to cheek, walking along the shore of some place like Sandvika, a lone rowboat tethered to the dock behind him. The colours dark green and brown and grey. Or *Self-Portrait with the Spanish Flu*, showing a man in a chair by his unmade bed, blanket draped over his knees. He is looking at the viewer with that surprised mouth that has become so famous, a signature expression. Then of course *The Scream*, one of the most famous works of art in the world, with the bloody sky and the disorderly river and the iconic skull-like face between two clutching hands, screaming at the viewer. I came out of the museum feeling dreary. Death and sadness, dark colours,

anguish – all these portrayals on canvas that have left an indelible mark on the Norwegian soul. He painted the same scenes over and over: he copied himself. Often it would be a picture of a moment, nothing special about it, nothing going on. But in the end, it would be most significant. It is a memory, and the memory is not new until it is old. It is both empty and full at the same time.

My husband and I had many conversations about those paintings. One time when he was in the hospital, a young nurse had learned that he was a professor, so she came to his bedside and told us that she had written her master's thesis on the psychology of Edvard Munch and she based it on this particular biography. She even brought an old hardcover copy of the book to lend to him. He thanked her but said he would not take it just now.

Here I was with a new edition of the same book, quite by accident. I took it home and we decided I would read it to him, in short sections each time so as not to tire him out. But it became something he looked forward to every day. We set up our chairs to face each other and I read the next chapter. He listened with great interest. After each reading we discussed what was happening in the life of poor Edvard. These readings were the last thing we got a chance to do together. Our last adventure. When we finished the book, we both felt sorry there was no more.

Later, very much later, I watched a BBC documentary called *Art of Scandinavia*, narrated and hosted by the art historian Andrew Graham-Dixon. While the images and photographs were lovely and the text was well-written and -narrated, the clichés about Scandinavia and its art were too frequent. The men of yore were heavily bearded and stocky. They 'knew about nothing except waves and trees' so they fashioned Viking ships out of wood that look like an upside-down onrushing wave. He went to the Borgund Stave Church and said it was a 'higgledy piggledy' building worthy of a Hansel and Gretel fairy tale. People, especially artists, were by nature miserable, melancholy, and dark. And then, neither Finland nor Iceland was included in his 'Scandinavia.'

But he did say one thing that rang true: the people in Munch's paintings all seem locked in their own isolated worlds, even when they are seen in the same room together.

We have only one guarantee in this world: things change. Change turns out to be the fundamental nature of reality. Nothing stays the same. Often we want things to remain as they are, 'forever' as we like to put it. When things are going well and we are happy with our lives. But we cannot control the fact that our lives will change.

That thought was strong with me at this juncture in our lives. We had a good life together in a place we enjoyed. Nature was close, the sea was close, we had friends around, but also friends in the animal kingdom: a certain family of robins that came every summer to scrounge on our lawn; a certain family of bears that checked on us regularly to see if we had new bird feeders up; goldfish in the pond that were becoming very much like people; herons that hovered when they could; snakes that appeared among the rocks; eagles on the top branches of the tall cedars, piping at us; hummingbirds that visited our flowers at all times; owls that landed on the telephone wires and stared gloomily; coyotes lurking in the bushes when we took long hikes; deer that seemed to think they lived there and looked at us astonished when we appeared.

It seemed like this picture of existence was there to stay. But one day he visited the doctor, who sent him for an X-ray, and then for an MRI, and within two weeks we got an eviction notice. He and the doctor stood in the doorway of the doctor's office and he asked, 'Is it bad?' And the doctor said, 'It's as bad as it can be.' We learned he had at most three months left on this earth. It was such a surprise that when we got in the car we simply looked at each other with the kind of astonishment I had seen on the faces of the deer. It hit us like a sudden ocean wave: the life we had built up over the last sixteen years was about to go down the drain.

It was of no comfort to me that change is the foundational precept in Buddhist thought. 'Everything changes' seemed like a cliché, and a bad one at that. And yet, as the months wore on, I began to think this universal truth has a good side. When things are going badly and there seems to be no hope, then it is good to remember that this will change, just like everything else.

In fact, I think we have made a hell out of the idea of permanence. Permanence – when we are stuck in a reality that will never be different – is also a kind of horror. We need to know it will be different later. Without the knowledge of change, there is no adventure. Nothing to look forward to either. Nothing to dread. No reason to try to be a little wiser about everything.

When asked about the nature of reality and human life, I recalled, Gautama Buddha said it's all like a dream. Imagine someone having a dream where there are lovely calm lakes, beautiful green parks, verdant flowers in bloom swaying in the breeze, sunshine touching your shoulders softly. Then the dreamer wakes up and all that was in the dream world is gone.

The suggestion has often been made that dream and reality can switch places, and when your life ends you wake up.

As if to illustrate that idea of dream and reality, I sometimes think of a painting that was created in 1526–27 for the altar of the church of San Salvatore in Lauro in Italy. The painter was Parmigianino or, in full, because names were long then, Girolamo Francesco Maria Mazzola. The painting is *Vision of St. Jerome* and it eventually ended up in the National Gallery of London since it was oil on panel, therefore portable.

The painting shows St. Jerome in the bottom right corner, lying down, asleep with his arm covering his eyes and a red cloak covering half of his naked body. St. Jerome is dreaming, and in his dream he sees

John the Baptist, which fills the bottom left of the picture. The half-dressed John is very alert, kneeling on one knee, holding a pole or staff in his left hand and with his right arm and finger he is pointing to the upper half of the picture. The whole of the upper half is taken up by the seated Madonna in her violet shirt and dark blue dress, and in her lap the child Christ is leaning against her. They are both looking out to the right of the frame, and behind them are the rays of light emitted by the haze of heaven.

Here John the Baptist is also dreaming, but he is awake, so it is a waking dream. In his lucid dream vision, the Madonna and child are the most prominent aspect of the whole painting. They are the reality. St. Jerome, who is the only 'real' personage in the picture, is out of commission and sleeping in the dark, while the visionary John is in an anticipatory position.

So reality, what is real, is entirely interior: reality itself, this painting implies, is a dream within a dream, or a waking dream inside a sleeping dream. And reality is not only an interior rather than an exterior world: it is not even your own interior. Reality is someone else's interior.

But Gautama said life was so short it could be likened to a 'lump of foam' floating down the river Ganges. The foam dissipates as it floats along. It has no substance and is just dancing on the surface of the flowing water.

In another comparison, he likened our lifespan to the big drops of rain that fall in autumn. When the drop hits the surface in its fall, a water bubble appears and bursts on the surface of the water.

The American clay artist Liz Larner makes clay sculptures that are really broken plates. Like tectonic plates, but human-sized. They are uneven, full of debris, and they are broken in two. The two halves are drifting away from each other, very slowly. So slowly you cannot see it happening.

She said that to be an artist is to be someone who can change her mind. She said she did not want to feel obligated to do the same thing over and over.

I recalled a day in April when I took a drive to the end of the peninsula that comprises the town of Tsawwassen in British Columbia. I had seen a road winding from the highway to the shore and I wanted to see where it would lead. So I drove to the end of the highway and took a sharp turn southwest. The road meandered for a while and ended at the private property of a waterfront condominium complex. I turned around, but as I headed back, suddenly two young eagles were flying in front of my car, so close their wings almost touched the windshield. I rounded the corner and saw more eagles ahead, so I parked the car and got out to look.

Above me and above the trees of the roadside forest were hundreds of eagles. They flew in circles at various altitudes, some very high up, some so low to the ground you could see the light in their eyes, the black and mother-of-pearl blue in their wings, the saffron in their beaks. They had something in their sights I could not distinguish. I had never seen so many eagles assembled in one place before.

I stood for a good while watching. A woman further down had also gotten out of her car and stood by the roadside looking up as if angels were descending, and further up the road a photographer was aiming his long zoom lens at the assembly overhead as if to capture the arrival of aliens. I imagined this crowd of eagle wings that cast a shadow on the ground where we stood – I imagined this a scene out of the creation of Adam, the shadow of tens of dozens of large black and brown wings to be the huge wing that encompasses the figure of the creator with outstretched arm and a hundred angels crowded inside the wing's shadow like baby seraphim, all floating in circles above our helpless footed selves.

The Icelandic artist Ragnar Kjartansson put together a work of art titled *No Tomorrow,* based on Vivant Denon's novella, *Point de lendemain,* which in turn was based on the canvases of Jean-Antoine Watteau. The work required eight dancers and eight guitars, a choreographer, and a composer, and they worked on this for several years.

In this work, there is no development or message or point. It is going nowhere. Some figures in jeans and T-shirts with guitars milling about, singing and strumming. Kjartansson said his work was really about nothing. An ode to 'nothingness.' His theory was that since we live in a world that is overloaded, nothingness becomes significant.

I remember a Masolino fresco in San Clemente from 1428, broken into three panels. One shows St. Catherine of Alexandria disputing and debating with a number of scholars. She is wearing black; they are in all pastel colours. The second panel shows the torture of St. Catherine. There are large wheels being turned by labourers clutching big cranks. Perhaps she is being torn apart. The third panel shows the beheading of St. Catherine. She is on the ground and the executioner is holding, high in the air and about to strike, the knife that will separate her head from her body. Above is the blue sky with one angel floating in it.

But curiously, even though St. Catherine is in a scholarly debate, her listeners are attentive and she is composed and calm. Even though she is being tortured, she is perfectly at ease, as if nothing is happening to her. And even though she is being beheaded, the knife is forever held aloft and will never come down. In all three panels, it seems Catherine herself is not really there.

Martin Heidegger said that the more a work of art 'thrusts itself into the open,' the 'more cleanly it cuts its ties with humankind.'

We travelled between North America and Norway regularly. On one of my trips back to Norway from Canada, I flew from Amsterdam to Oslo with the national soccer team. I did not know the players were on the plane, but they must have been coming back from a mighty conquest on the soccer field. Maybe they had won the European Cup.

When we landed in Gardermoen Airport, we all filed out of the plane and went through customs. As we came out of the double doors that opened automatically to where the public was waiting to pick up passengers, we encountered hundreds of people filling the airport hall. As soon as we walked out, this crowd burst into song and sang in full-throated harmony, just like a well-rehearsed choir. In fact, they were well rehearsed, and they were welcoming the soccer team home.

The singers and other people were dressed in all manner of winter clothing: red coats, blue jackets, white headgear, scarlet boots, ochre knitted scarves, striped skirts. They sang, and behind them the large windows showed pale winter hills and scattered trees and strange dark clouds floating in pieces across the slightly yellow sky.

He stood among all those people, in the front, with hands in pockets and a big grin to greet me. I sent a choir to meet you, he said.

Anger, sadness, joy, laughter, like all other emotions, are just clouds passing by, shielding the big blue sky we know is there. If you are angry, do not say, 'I am angry.' Say: 'At this moment, anger is passing by.' Or say you remember that 'I am never angry for the reason I think I am.'

So I tell myself over and over again in the dark hours of the night when all else has settled down for a few hours and the city is quiet. All that glows are the tiny lights I have strung up by the doorway. They are lined up on a wire that hangs down the side of the wall and onto the floor. They give just enough light to see, but not enough to overwhelm the spirit and take my thoughts in other directions where they do not want to go.

The dim lighting helps me concentrate. I have a feeling there is something I need to concentrate on, but I am not sure what it is. I feel a little

bit like the Zen student who has received a koan to ponder. The answer is not going to come easily, if ever. At the same time, it has dawned on me that somewhere in the recesses of my mind there is an answer – not just for this koan, but for all koans. Could it be?

There is another koan I once learned from an elder who had retired to a cabin in the country by himself, where he spent his days in the garden or in the workshop carving wood, or else just sitting in a chair by the window smoking a pipe.

If you meet the Buddha on the road, he said, how do you greet him?

The British sculptor Antony Gormley has said he would like to view the body as 'a found object.' His sculptures have for the most part been based on his own body, cast in other media. He calls that his 'second body.'

It is said that Gormley studied Buddhism, wherein he found that the human being has access to numerous bodies. He also says that the body, like the sculpture, displaces space. It also displaces time.

Shortly after we moved into our small apartment in our last three months in Oslo, while he was still able to go around town and get things done, he told me we needed to go to Oslo city hall to look after some documents. We went downtown and into a large brick building with two huge square towers. That was city hall, which was officially put into use in 1950, right after the war. It had taken at least thirty years to get it done after the initial design was put forward in 1918 by the architects Arnstein Arneberg and Magnus Paulsson, who won the competition for the design.

The curious fact about this building is that it was built with red brick. Not the usual red bricks, but rather larger ones that were in use in the

Middle Ages. Perhaps that was to tie the complex to medieval history, since the whole city of Oslo burned town in the 1600s. Another curious fact is that the architects changed the design after it was accepted, made it more 'Functionalist,' and they added two towers. The 'twin towers' of Oslo. One tower is sixty-three metres tall; the other is sixty-six metres.

It was of interest to me as well that one of the towers has in it a set of forty-nine bells that ring out every hour, every day. It is the largest carillon of bells in the Nordic countries. The largest bell weighs 4,000 kilograms and the smallest 14 kilograms. The bells are played by a carillonneur who gives live concerts every Sunday. Famously, one of the bells, cast in 1949 and weighing 1.4 tons, went out of tune. The bell is tuned to D# and is out of tune with the rest of the carillon. So it was taken out and placed on a steel string over Honnørbrygga pier, where people can play it for themselves.

Sometimes, as the Danish children's writer Hans Christian Andersen might attest to, an ugly duckling might magically be turned into a beautiful swan.

Apparently people get married in the 'Munch room' of city hall, where Munch's painting *Life* looms over them. People also get the Nobel Peace Prize in the main hall there. The whole building is saturated with works of art, and people come to see them as they would to a museum.

But we did not come as tourists; we had business to take care of. We were in the administrative offices, and he dealt with the clerk while I waited. Afterwards he wanted to find a place to sit down, since he tired easily, and have a cup of coffee. We located a small cafeteria where we were the only customers. We took a table by the window overlooking the street below and had a view of the hallway where people passed by on their way to and from different offices.

But being city hall, those hallways were full of social 'luminaries': politicians, judges, actors, writers, famous people. He was enjoying himself pointing out to me who was who as people went by. He told me their stories, since he knew the city gossip from a lifetime of Oslo living. Many of the stories were dramatic, some scandalous. We laughed.

We were sitting on plain plastic chairs, but they might as well have been the red velvet high chairs of the Wedding Hall of the Piazza del Campidoglio, and we might as well have been surveying the *possesso*, the triumphal procession with horses, soldiers, cannons, trophies, and war booty and all the accessories of temporal power at our feet.

It seemed at that moment so natural for us to be there, in town having coffee and telling stories, that we forgot our real circumstance. We had for a moment stepped out of our shell and had started thinking everything was all right and we were just fine and the world was continuing as usual after all.

PART NINE

When theorists debate the nature of reality, those debates go on indefinitely. Therefore, as Richard Gombrich writes, in the *Cūlamālunkyā Sutta*, the Buddha enjoined: 'Let's start with suffering: that at least is real … Our problems are urgent, and irrelevant theorizing is as silly as refusing to receive treatment for an arrow wound until you know the name of the man who shot the arrow.'

It was a very big surprise to me that Norway turned out to have a Christian Fundamentalist undertone. Since I was used to the easier mores of Iceland, and the much easier mores of Denmark, I assumed Norway would be similar. Individual freedom of choice and self-agency would be sacrosanct in all areas of life: how and where you live, eat, get educated, put together a family, whom you spend time with, whom you vote for, how you choose to live and die. But I had long ago, on my first sojourn to live in Oslo with him while he was still working, accepted the contrary fact that when I was in Norway, I might as well be in a completely unknown place, where there are strict social and behavioural mores and where foreigners are not endured.

And yet, it was also in Norway that I found the deepest, most solid and good and wise people I had ever encountered anywhere in the world.

So it was in this last stay in our small rented apartment while we waited for fate to take its course. I have heard that adversity teaches us things we need to learn. That is a fact we invariably refuse to accept when it comes. This horrid experience has nothing good in it. Not for me and certainly not for him or any of us closest to him. I did not accept that, as Buddhists like to say, I could take this adversity 'onto the Path.' Bring these months into the Way I needed to travel and learn from.

But during the course of my bureaucratic headaches and struggles with the system, I ran into many teachers. I encountered them everywhere, even among those whom I figured were not my friends. And among the friendly – those who loved him and wanted to help and were empathetic. And also from complete strangers. I had become aware I could meet my teacher anywhere.

Therefore it was not exactly a surprise that the lawyer who helped me sort out the business of our Canadian marriage certificate was one of those teachers. He took the time to meet me in a small boardroom in his downtown legal building. He did the work of contacting the Canadian Department of Foreign Affairs and exchanging documents and getting them back to me quickly and efficiently. But more than that, he took the time to talk with me.

He was one of my teachers. He taught me not to lose patience. Not to despair. To hold on to a belief in the goodness of people, especially when it was hard to do so.

We had already decided to go back to Norway before we got the dreaded doctor's report, suspecting we might get bad news. It took us only twenty-four hours to get the tickets and pack and we were on our way. We had friends who dropped us off at the ferry, and other friends who picked us up and dropped us off at the airport. People had lined up to help. But when we got to the airline ticket counter to check in, we discovered that my passport had expired. I could not go. So he went on alone in his shock and misery while I stayed behind in Vancouver to renew the passport. This required me to wait three days, and I stayed in a hotel downtown.

Those were three difficult days. It was as if a giant hand had come out of the sky to say, *Stop! Don't go!* I did not think of it that way just then, but in retrospect it seems the universe was trying to deter me. But I was not free to stay. I was not free to abandon him or leave him to others. Nor did I want to. Even though we think we are free, much of the time we are not. And curiously enough, when she discovered our predicament, the ticket agent at the airline counter started to cry.

While I waited I walked around town for fresh air. I visited a walk-in clinic because I was experiencing a 'trauma reaction' that consisted of a sore throat, and I thought I was getting sick. In the hotel room I fainted. But I did get my passport after waiting in the passport office the required time, and I got a new ticket and was on my way to Amsterdam and from there to Oslo. I made that trip almost unconsciously, as if I were rehearsing a script I knew all too well.

Meanwhile he had been picked up by his grown children, who kept him in their home and took care of him. They were flying around town in their car, looking for a doctor for him. It was extremely hectic, but at that time he was still able to run around. When I arrived, we took lodgings downtown until we found our little apartment. Doing all that took the last of his energy, because soon after he was not able to go places. We got there, it seemed, in the nick of time.

I have since pondered the nature of freedom a great deal. It is said the ultimate freedom is to be able to choose your own way. To be able to choose how to live, where and when to do things, what to think about anything, whom to be with. Your life, your choice. Perhaps you will make enemies in the process, but then it is well to remember that even the best people in the world, the best people in history even, have all had enemies. For so many reasons, there are those who will not like your choices. You cannot hold it against them. They have their reasons, their own lives to live, and they have confused their own choices with yours.

It is well understood in Buddhist circles that you cannot change other people's characters. You need to let them be who they are. And you will be who you are. They do not have the authority to make changes to you either. So you practice what they call 'detachment,' a much-used and much-misunderstood word for something that is very important.

He was not a 'Buddhist.' Neither was I, although I had more direct experience with Buddhist circles where I had lived. I had read more of the literature. For a time I joined a Dharma group and once a week

spent the morning meditating, listening to the Rinpoche speak, and socializing with the others in the group afterwards during tea.

Then again, there is really no such thing as being a Buddhist anyway. Buddhism is not a club you join; there are no initiation rites to go through or certificates to be had. Buddhism is an understanding. A realization, and a life practice that comes out of that understanding. There are no 'real' Buddhists or 'fake' ones. There are just people who are honest and who are not, those who have integrity and those who do not, and some who are more performative than others.

There are just people who are more or less toxic. The objective of Buddhist thought, it sometimes strikes me, is to learn to know how not to be toxic.

It is easy to confuse the idea of Buddhism with the idea of 'religion.' Buddhism is not something that asks of anyone to have blind faith in any scriptures, dogma, or revelations. Rather, Buddhism is an approach to life that relies on curiosity, investigation, and the evidence of personal experience in order to assess the validity of an idea.

There are three basic things that determine a person's merit, the Buddhist teaching goes. These three are: *giving, moral discipline, meditation.* Those are not just words.

As for giving, I read in the Pāli Canon that the Buddha said there are five gifts. When you *give*, you give from faith, you give respectfully, you give at the right time, with a generous heart, and you give without denigration.

That is, it is necessary to have faith that the gift will be good. It is also necessary to respect the person you give to, so it is not a gift of pity or condescending charity. You give without prejudice, so your gift is not selective to who you think might be worthy of it. It is also necessary to give without demeaning the one who receives your gift.

There is a fresco by Fra Angelico in the Vatican Palace in Rome, dating back to the fifteenth century. It depicts giving in the tradition of Christian theology. One panel shows St. Sixtus handing over the Church treasures to St. Lawrence. The giver is kneeling in his rose-coloured robe before a man in a long, light blue dress and a pointed hat, who is receiving the treasures with a hand of blessing on the giver. Another panel shows St. Lawrence, who now has no hat but a halo around his head instead. Lawrence is giving alms to the poor, who are gathered around him in various degrees of disability. One is on the ground, another is holding a baby, a third is missing a leg.

The bag from which Lawrence is taking his gifts to the poor is the same bag he was given by Sixtus. Or so it appears. According to the story, which takes place in the third century, the Emperor Valerian ordered all bishops, priests, and deacons to be put to death. St. Sixtus was killed then, and St. Lawrence was ordered to hand over all the riches of the Church to Emperor Valerian. Lawrence said he needed three days to collect the wealth. Then he went out and distributed the riches among the city's indigent, and when the time came to hand over the treasures of the Church, Lawrence handed over the disabled and the incapacitated and the poor, and said these are the real treasures of the Church.

In true Buddhist fashion, although he was a Catholic archdeacon, St. Lawrence did manage to give the treasures from faith, with a generous heart, at the right time, and without denigration.

Much later, in fact very much later in life, I began to think of a fourth merit as being necessary, and to add it to the three merits in the Pāli Canon. That merit is *loving-kindness*. I had often heard loving-kindness spoken of as some kind of quality of an arahant, or enlightened person. But it is more than that. Loving-kindness is a practice. It is not a feeling but a kind of training to see. And also a training to be.

In the Pāli Canon, the Buddha talks about loving-kindness as having three elements, what are called 'principles of cordiality.' There are bodily,

verbal, and mental acts of loving-kindness. In so many words, treat your own and others' physical beings with care. Speak kind words to others. Think kindly of others. Regardless of surface appearances of things or of what people say about things, maintain the principles of loving-kindness.

There were times during our final journey together when I was reminded of the importance of this simple principle. When you are vulnerable, when you are uncertain and alone, the kind acts, words, and thoughts of others are not only things that help see you through; these are things that help keep you alive.

He and I agreed on most of the Buddhist concepts and principles. We talked about them: when we took our long walks along Mercer Road or through the forest to the east, up the hill along a logging road that reached to a small lake deep in the mountainside. We sometimes saw a large buck with huge antlers racing down the road in front of us and into the woods.

We talked about these ideas and we realized we were in perfect accord. He had not found anyone in Norway who thought this way. But we found a meeting ground that was ours alone and that we thought most of the people in our family and most of our former friends might not understand.

It was how we lived. Simply, without drama or excess or extreme emotion. Just hard work and compassion, which is often translated into *love* – another much-used and much-misunderstood word.

The 'wisdom literature' of our time usually has a very clear message. That argument is that we are living out our conditioning rather than what we in our innermost selves think and believe. Our thoughts, words, and actions are in fact not our own. They have been put there by our conditioning, and we keep them all our lives. When we investigate

further, we may find this conditioning is all we are, and there is really 'nobody' there.

The 'wisdom' part of this is that we are able to transcend this conditioning. In fact, we need to work on doing that. To go beyond what we have learned to think and do, feel and believe, and reach an inner core where we act and think out of an authentic sensibility.

It sounds easy when you hear this, but it is not always acknowledged how hard that is to do. Because before you can shed your acquired self, you need to dispose of all the clutter that has accumulated in your mind, and even your body, over the years. It is not at all easy to 'declutter' the mind. Maybe it could be done one thought at a time. If you think a thought and then ask yourself: Where does this thought come from? To whom does it belong? My parents? My spouse? My workplace? Peers? Even social media? We sometimes do not say things so much as we parrot what we have already heard, because that we know is 'acceptable,' whereas if we said what was really in our minds, that might not be so.

He used to joke with me that he had 'parrot syndrome,' as he called it. He had an inner mimic, and he picked up what he heard like a parrot and then he repeated it many times in different situations. He was fully aware of how this worked and he made a joke of it. But underneath it all we recognized that everyone has 'parrot syndrome' to some extent. In fact, sometimes the mimic in us takes over.

So much of this 'wisdom literature' says it is important to control your mind and not let your mind, full as it is of extraneous thoughts, control you. That you need to control your emotions so they do not control you. The larger question is: Who is this self who needs to control the mind and emotions? Where is that self hiding?

In Buddhist circles, this is sometimes spoken of as the 'empty cup.' You pour tea into a cup, but then you keep pouring and the tea spills over. You still keep pouring and the tea starts flowing onto the table and the floor. All this tea is the material you have stuffed into your mind and there is always more and more of it. All the thoughts you have about so many things, more than you can manage.

That cup needs to be emptied. The space needs to be cleared.

✳

There are no human gods, no perfect people, no unassailable individuals. There are, however, great ideas and worthy ideals. There is a Way that leads to better harmony around you, and there are also erroneous ways that lead to discord. Also, perfection is unattainable; perfection is simply an ideal. When you fail, you pick up again and re-establish your goal and your methods. When you succeed, you examine your success for the inevitable failures lurking inside. Nothing goes right without something also going wrong. The main point is to keep trying. In fact, it is often noted among artists that failure is part of the job.

Those are things we talked about. We had already said so much about this and other matters that when it came to his final months, we did not have to say anything more.

PART TEN

The Buddha's words in the Pāli Canon have much to say about discord and conflict, and those words tend to echo the psychological findings of our own era. That is to say, the roots of 'evil' are said to be greed, hatred, and delusion. Greed is self-explanatory because it is about wanting more than you need and wanting what you should not have. Delusion is hard to fix because a deluded person will resist the disillusion that comes with getting a handle on reality.

But hatred is something else. According to the Buddha, the roots of hatred lie in envy and niggardliness. Niggardliness is a form of extreme stinginess. Envy and stinginess are tough emotions, and they get in the way of everything. It is advised that when people are talking about other people behind their backs, you need to withdraw from those conversations.

Between us there was no envy or niggardliness, neither between ourselves nor toward others. That was the clarity we lived in and for which I was grateful.

To talk of 'holding space' is to acknowledge that every person needs time to be alone, to be who they are in their own personal space. It is not necessarily space but can be simply time, to have time alone.

That personal requirement was always well understood by us. We kept our own activities and personal places even while we were together. He had his workshop where he designed and built projects, many of them large. I had my studio where I painted and explored uses of various materials. At the end of the day we reunited.

But during those months in Norway this mode of being together fell away. We were thrown together in a small apartment with a looming

cloud over us. Perhaps we both felt trapped. Nonetheless, he worked on his computer for long stretches, and I did not bother him.

I continued to paint. I picked up some inferior art supplies at Clas Ohlson on Bogstadveien – canvas and paint and brushes – and took them home. I put the canvas on the floor and moved paint around on it. We managed to be alone together, in silence, but knowing we were there. It was the best we could do, but we did not want to be apart either.

I was reminded of the advice given to painters I had heard from more than one teacher: do not let your ego get in the way of your work.

Paint in quiet. Paint in silence.

Gabor Maté, in his various dissertations on illness and the mind, especially in *The Myth of Normal*, assures us that negative thoughts, especially when they come from trauma experience, can make a person sick. In Buddhism, negative thoughts – like anger, rage, apprehension, anxiety, fear, envy, and so forth – take your freedom away. It is often heard that one should avoid anger and negativity for one's own health and freedom rather than for the act of being nice.

I was aware of all that, and yet feelings are hard to control. There were so many reasons to feel bad about things. The loss of life; the loss of our life together; the loss of companionship; loss in general. And if I felt trapped in a bitter circumstance, unable to move, he must have felt beyond trapped. And yet he seemed very resigned to his fate. That resignation too made me feel bad. I thought he should fight it more.

But I was not him. He had decided this was now happening and he was letting it happen. It was as if he had the intuition that everything was already decided long ago, maybe even before we were born.

The language we use for things matters. Our language frames our thinking. People who have a serious or chronic or even fatal illness are said to be 'doing battle.' Someone is 'fighting' cancer, say. Or is a 'cancer survivor.'

The person who is ill is engaged in a battle of life and death, people say, and the army of medical and surgical and pharmacological teams are lined up like troops for the attack.

In reality, the idea of a 'battle' or a 'fight' was never there for him. He did not see his condition as a battle. Perhaps everyone else wanted him to. People wanted him to be like Emperor Constantine facing the Battle of the Milvian Bridge. They wanted him to have a miraculous Vision and go into battle with all his troops and the symbol of *Chi Rho* to protect him and the words 'In this sign, you shall conquer' ringing through the flag-draped air with the city of Rome in the distance, just as in Raphael's fresco of the *Vision of Constantine*, the pyramidal tomb of Romulus in the background and the Castel Sant'Angelo under a leaden sky, and the emperor holding forth to his troops under the standard that would save him, the troops all leaning in, holding spears and shields, eager to hear his words.

But all that was an illusion. It was as if he knew it was never a real picture but instead only borrowed tropes and mannerisms. As if he knew something we did not – we in our zeal who were primed for action like supporting troops facing a new war. He did not say so outright, but it was as if he had become infinitely wise and knew we would not be able to understand how it is that your illness is also you. When you do not know who you are and you see your illness as an alien, you forgot that this is also who you are. You simply did not know yourself in full. You only knew the parts of yourself you wanted to know.

At the same time I knew I had to let that idea of doing battle go, and I also knew there was a way of being free inside this calamity. If I could concentrate. They call it 'inner agency.' There was also a host of good things to think about. At the time, however, chronicling the good things felt like a superhuman task, so easy to say in words, so hard to put into practice.

It is not easy to change our relationship to difficulty. When things are difficult we naturally respond negatively. But there are ways of

thinking about difficulty that create a space for compassion instead of negative feelings. That includes compassion for oneself. No one would benefit if I lost my cool or harboured negativity – least of all he whom I was trying to help, and also least of all myself.

I placed flowers that I picked up in Vinderen in vases all about the apartment. Garden tulips just opening, ruby red with lime-green leaves that folded on themselves. White baby's breath that had a pleasant, delicate scent of vanilla, clustered together in a bundle. And the hyacinths were lined up on the windowsill overlooking the street. I remember reading in a book on etiquette when I was a teenager that when you are facing poverty, that is exactly when you should bring out the fine china and the gourmet meal. Defy the odds with your positive spirit.

It was also interesting to me that stress itself produces stress. There is a 'stress of stress,' as they say. In Buddhism this is called the 'second arrow,' because you get hit by an arrow that makes you feel bad, but then you feel bad about feeling bad, and along comes a second arrow. There is a special karma connected to negativity. When a negative thought starts, it produces more negative thoughts. This is commonly known as a 'downward spiral.' That is not just a saying. It is very real.

It is also true that your body stores up traumatic experiences and keeps them. Long after the actual trauma is over, you may still be reacting as if it were still happening. I knew this, and I was trying to work out ways to release the pent-up emotions so I would not carry them out of there with me like heavy baggage, only to be dealt with later in an uncomfortable and possibly disastrous way. I could not know if my small efforts would succeed, but I could try to lessen the blow.

So I took walks in the winter snow. It was a mystery to me why the winter air in Norway is so delicious. I had experienced winter weather in the Canadian prairies, on the Pacific Coast, in Iceland, Denmark. Those winters were either dangerously icy, inundated with dampness and rain, fiercely windy and stormy, or just foggy. But in Norway, the winter air is

as if made for human beings to thrive. Unbelievably refreshing. For that reason, Norwegians go out walking, hiking, skiing all the time. I did too, whenever I got a chance. Just breathing out in the open air was delicious.

Those walks in the winter snow always transported me to another world. Another, better one.

There are so many kinds of snow. The sound of your footsteps on the white-covered ground is different depending on what kind of snow it is. Sometimes the snow is really ice crystals that hang suspended in the air when there is no wind and it is very cold. That kind of snow is called 'diamond dust.' You feel it as pins and needles on your skin.

There is also a kind of sleet that happens when ice grains thaw and freeze again. And hail, made of large stones of ice, all irregular. And what are called 'snow grains,' which happen when there is fog; they fall in little bursts. And 'snow pellets' that bounce like little balls when they hit surfaces.

Then there are just 'snowflakes,' ice crystals that attach to other ice crystals and make large flakes that float to the ground. Sometimes such snowflakes float feather-light on air currents and even fall upward instead of down. They float sideways and upward like the transfiguration, when the Christ figure simply ascended up into the air with its clouds, and his white fluffy robe and outstretched hands and arms were weightless.

It was a realization that occurred after I saw the painting *Transfiguration* by Raphael. Or rather Raffaello Sanzio da Urbino. An oil painting on panel created between 1517 and 1520 that became one of the iconic paintings of the world. The painting shows two realities: one low and dark and difficult, the other light and airy and easy.

Down below, a crowd of people are shuffling and stressing about how to cure an epileptic child, and they look like they are underground or in some cave. Above them, or above ground, the amazed apostles

Peter, James, and John are flat on the ground in fear, and on each side the floating figures of Moses and Elijah hover, and between them Christ is ascending ever higher.

Two realities.

The Korean painter Park Seo-Bo uses the colours of nature to let the painting absorb the stress of the viewer. He says we are all stressed and need art to heal us. His words were: 'Because of stress, people will get sick and earth will turn into a huge hospital.'

Park paints large canvases whereon he places a section of white paint and then scratches into it a series of vertical lines with pencil. This is very time-consuming and repetitive. He studied Buddhism and says such repetitive actions make for good meditation practice. It is similar to reciting 108 mantras in a row.

What is called the 'wisdom of trauma' is simply learning how to be friends with catastrophe. How to learn from it, let it expand your mind and make you a better human being. These experiences are there to teach. Calamity is another teacher.

I do not know if I can say I learned from our personal disaster. It is better to let go of even the idea that you can assess your own progress. If you keep judging yourself, the verdict will probably be too harsh. So I tried to stay away from self-incrimination. There was always the possibility that I could be doing better. That I had made a mistake.

I imagine this aspect of the caregiver's experience is sometimes glossed over: the fact that you are always inadequate to the task. You are supposed to look after someone who is ill, but you are not a medical expert, not a psychologist or a pharmacist or a theologian or a priest. You have no expertise. You fumble about with medications and strange meals your patient refuses to eat. You hover between being there and leaving him alone. You do what he asks of you until what he asks for is

detrimental. You put your own needs aside while you simultaneously try to answer them. You are in a position of no position.

From a Buddhist perspective, this is especially difficult. When we are advised to do the work but not to be attached to the result, it is almost impossible to follow. How could one not be attached to the result of another person's welfare? And underneath it all there is the magical possibility that you might be able to 'save' this person and make him well again – against all odds. We have this magical kernel to cling to as well. *What if?*

Folkloric remedies in our private medicine bundles: turmeric, shark cartilage. Spiritual remedies like mantra or prayer. What if something outside of the scientific, socially acceptable methods, what if something were to 'work'? Many believe so, and it is a way to keep hope alive. But the only magical thing we really have that will keep us going is human compassion.

To be in a position of no position has more to it than being stuck or trapped in the incomprehensible and the unforeseeable. I am reminded of an essay by Jacques Rancière titled 'The Machine and Its Shadow,' in *Aisthesis*. Rancière is talking about Charlie Chaplin, the 'little man' whose jacket is too tight, trousers too big, hat too small, shoes too large, and who moves the way people who work with machines move. The character of Chaplin is a virtuoso goof, who 'fails every time he succeeds, and succeeds every time he fails.'

What is more, things that happen to him only happen the way events 'must fall upon me like a kind of avalanche but none of them must have a voluntary act on my part as a point of departure.'

He must be the cause of nothing. Things happen to him like an avalanche of snow that began somewhere in the high peaks and built momentum on its way downhill, until the whole edifice crashed onto the land below.

Sometimes I think that 'little man,' awkward and clumsy, confronted with events and incidents that appear out of the blue and seem to have

no logical origin, that little person is also part of ourselves. The part we try to keep hidden, but we know he's there. We know she's there.

Later on, after all was settled and this story was in the past, I was listening to a lecture by the American professor Donna Haraway. She talked about what she called the 'Chthulucene,' which would replace the much maligned 'Anthropocene.' Instead of the world being dominated by humans, we could view the world as being primarily tentacular. Tentacularity is about variety biology and interconnectivity. We are always in a relationship with all other modes of being, both to earth and to kin.

This is a way to say that 'we are not alone.' She asks us to engage in 'rich thinking' because we need 'a higher variety mind for a higher variety of problems.' Our aim is not to find solutions, but rather to find relationships.

I had often thought about the poverty of our language. So silence seemed a better option. But I agreed with her conclusion to stay with the trouble. We are living and dying in a damaged world, but don't try to escape it. Stay with it. *Stay with the trouble.*

Then there is that famous quote by the Austrian philosopher Ludwig Wittgenstein, which never stops seeming relevant: 'Of that which we cannot speak, one must remain silent.'

PART ELEVEN

On one of our outings in Oslo, he took me to see the great fortress known as Akershus Festning. I do not know how you can be in Oslo without investigating the fortress that has fended off armies and attacks since the thirteenth century: from Sweden, Denmark, and dissident Norwegians themselves. The fortress is inscribed deeply into the history of the city, as well as the country. From it, you can see the waters of the ocean, and if they parted like the Red Sea, you could watch as calmly as Moses while the entire Egyptian army succumbed to the waves, horses splashing their legs in panic, warriors in their armour and headgear thrown into the waters with mouths open, long spears and red flags criss-crossing out of the waves like a barren forest in tumult.

Now it looks like a peaceful castle made opaque and thick by time. But the black doors and heavy stone hold up some dark moments in history. We wandered through the rooms and I learned there are still state dinners held there and that the prime minister still has an office in the palace. There are large, impressive medieval tapestries on the wall in the great hall – I admired them so much I took pictures of them and studied what they tell later. Tapestries contain so much information about life and society, work and class divisions, conflicts and play, that you cannot simply look at them briefly. They are like wordless manuscripts.

But as we went downstairs, the imposing air vanished and something else took over: the dankness of underground stone. We were suddenly in the sarcophagi of King Haakon VII, whose name was used for the street we lived on, and the famous Queen Maud, and King Olav V and Crown Princess Märtha. I was weighted down by the feeling of being in a tomb. But it got worse when we entered what is called 'the slavery,' which was the prison where prisoners were holed up in small stone rooms and rented out for labour in the city. I understood there had been executions at the fortress as well.

In the end we went into the Akershus Castle church. The seats were scrawny and uncomfortable and the place was quite simple. But we had seen a notice of an afternoon organ concert in the church, so we went and sat down to listen. But the organ was behind us so we had our backs to the musician, who played Bach so strangely he might as well have been making it up on the spot. We concluded the organist was quite drunk; we looked at each other and tried to suppress laughter. We were also the only people in the audience. But it gave me time to process what I had seen and felt. Somehow this was, after all, the centre of the city.

When we came out, a gigantic cruise ship was leaving the harbour. The passengers, who hailed from who knows where, were lined up along the railing facing the fortress. We stood on the hill outside the gate and watched them. Then they all began to wave goodbye at us; one after another they raised their arms and swung them from side to side. We waved back. As if we were seeing off our weekend guests in front of the gate to our house.

For some ironic reason, when death is near, everything comes alive. Even inanimate things come alive. The entire universe becomes symbolic and emits signals of great import. The stars and the moon do, the trees and flowers, the trains and cars and boats in the water. The furniture inside, sofas and chairs, coffee tables, dining tables, door handles and windowpanes. They are all suddenly imbued with life and intent.

It is well-known in sociology and anthropology that 'things' supposedly made of dead material have, in spite of their impenetrability, a social life like the rest of us. It matters to us where an object has been before we had it, and where it will be later. It is as if we sense there is a karma that follows things. If your grandmother owned this piece of silver, it is imbued with her spirit long after she is gone. So you keep it.

When we were going through those final months, I became more sensitive to the way objects around me began to send signals. Some things I dared not touch. Other objects I held dear. The chair he sat on when he was at home became a chair I could not touch or use when he

was gone to the hospital and I was there alone. It was *his* chair and had him in it still. The same went for the bed he slept in. The glass he drank from. Those objects were possessive and jealous and did not want to be touched.

At heart I began to believe that when irony falls into your life, it is not an exception. Irony is at the centre of the universe. That had to be my conclusion, because everything seemed so ironic. An irony like: just when you finish building your house and you sit down to tea, there is a flood and it is all washed away.

It seems natural to think there is another realm somewhere around us, where spirits live and move with their own agency. A world that is invisible to us. All cultures seem to have versions of a 'spirit world' that is alive. My own culture in Iceland has well-known beliefs in spirits of mountains and valleys and boulders and lava fields. These are spirits that have to be appeased and should not be disturbed. This idea has been eliminated in modern, 'rationalist' times, so we seldom admit to thinking about such matters. We have psychological and emotional, even neurological, explanations for what we are sensing that seems strange or uncanny.

I recall reading in the book *Roaming Free Like a Deer* by Daniel Capper that in Thailand there are thought to be spirits of almost everything: Spirits of places and natural landmarks. Spirits of mountains, of rivers, of swamps and hills, of rice fields and trees. So various rituals have been developed to appease the spirits who might otherwise cause distress.

That is why there are so-called 'spirit houses' outside homes and also outside temples and monasteries. The spirit houses are small, elaborately constructed traditional houses. This is so the spirit of the house can have its own place to live and be content there, so it will not cause any trouble, and life will go smoothly.

The first time I saw a Thai spirit house I was struck by its beauty. It seemed like a good tradition, regardless of whatever one might believe

in. After all, even for a rationalist, why not? Why would it not be good to have a spirit house that will help protect the house you live in?

The French philosopher and theorist Jacques Derrida mentioned, in a book-length essay on the writings and drawings of blind people titled *Memoirs of the Blind: The Self-Portrait and Other Ruins*, that there are four levels of invisibility.

First, there is the level of hypothetical potentiality. That is, something is not visible, but it could be and you know it. Second, there is the concept of invisibility, where you are thinking about an invisible object or being that you cannot see, but you know of it conceptually. Third, there is a level of kinetic invisibility. That is, you cannot see something, but you can feel it. You sense it is there. And fourth, there is a sayable level. You cannot see something, but you can talk about it. So the invisible exists in language.

There must be more levels, I sometimes think. Maybe an imaginary level, where you imagine something although you cannot see it. And a hidden invisibility, where what you cannot see really is there but it is hidden from view. Maybe the invisible world is actually invisible on all levels at once, there to all our senses except vision.

I wonder if we have privileged vision as the most important sense. Ironically, in that case, if we rely only on our vision to confirm what is really there, then we are blind.

The book *Memoirs of the Blind* is an in-depth exposition of the problem of seeing versus believing; the problem of the eye; of light and darkness. What we see and what we do not see. What we think we see.

Jacques Derrida was commissioned in 1990 to write this book-length essay on drawings, some self-portraits, held in the Louvre, that depict blind people. He was trepidatious, nervous, about the writing because he knew it was such a complex subject. He opens the essay with the

assertion that his subject matter is 'the difference between believing and seeing.'

What we see is in competition with what we want to see or want to have seen. The will to believe is sometimes stronger than the confirmation of seeing what is before our eyes.

In an astounding analogy, Derrida in the same book likens the act of drawing – placing pencil on paper – to surgery.

Then in reference to the biblical story of Tobias curing his father Tobit's blindness by massaging fish gall onto his eyes, Derrida talks about drawing, writing, healing the sick: they all involve the 'laying on of hands.'

Symbolically for the *Book of Tobit*, the blindness is spiritual darkness; the fish is a symbol of Christ; the eyes are the instrument of our awakened seeing; the act of massaging the father's eyes is a form of blessing. Tobit sees again; he has been enlightened.

In the story of Tobias and the angel, which is so central to his whole thesis, Derrida suggests that, in fact, 'The Gospels can be read as an *anamnesis* of blindness' because 'the good news, always *happens* or *comes to blindness*.'

Then he quotes the Gospel of John where Jesus says: 'I came into this world for judgment so that those who do not see may see, and those who do see may become blind.' So, ironically, you are blind if you are not awakened to the consciousness of Christ in this analogy, but when you gain your 'sight' you then become blind in another way.

There is an inner light and an outer light, and they seem to cancel each other out. When one is on, the other is off.

Rather memorably, though, when Tobit the father opens his eyes and sees his son, who has healed his blindness, the angel Raphael stands next to him, but the angel claims he is only a vision and is not really

there. However, he tells the two of them to stand up and give thanks for what has happened. They need to express gratitude by inscribing the event on parchment.

The angel Raphael tells them: *Write down all these things that have happened to you.*

The written story gives thanks. Writing is a form of giving thanks – *for all the things that have happened to you.*

It is said that when the Buddha died, all manner of ironic events took place. The wind started to blow and suddenly there was thunder and lightning. A fire spontaneously broke out nearby and the moon went behind a cloud. At the same time there was a fierce earthquake and the sāl trees the Buddha rested under, lying on his right side – like a lion, they say – began to rain blossoms entirely out of season.

It seems natural to think, when someone important to you dies, that the earth and all its creatures, minerals and waters and plants and trees, are going to feel the effect. It is another way of saying we think nature is an extension of our own minds and feelings. It is not, but this is how we feel about things: nature is a mirror.

We were driving through the countryside in Sweden one time on a weekend outing. It was late fall, the November light was dim, and the cloudy cover made everything look grey. We were driving through a large forest of spruce trees.

But then, as if in a sudden and miraculous change of scene, all the trees of the forest were lying on the ground, broken, uprooted, and barren. The amazing thing was they were all lying facing the same direction. Every single tree was down, as far as the eye could see in all directions.

I was shocked and asked him what happened here. He said it was a windthrow. There are storms that come through and fell all the trees. This has been happening more frequently in the last several decades,

and spruce trees are especially vulnerable to being felled by wind. The root systems are not strong or large enough and the trunks are fragile. It is happening more, he told me, because of a reliance on monoculture in forestry practices. Forests need variety.

I could not get the vision out of my mind for many years. It looked so devastating. So destructive. And even though the air was still when we came through, and it seemed as if time stood still too, the vision of a whole forest lying on the ground, all facing one way, seemed so sudden. That was what I felt: a sense of suddenness.

If you go by the teachings of the Japanese Shingon Buddhist Kūkai, there is nothing that is not sentient. Everything springs from Dainichi and everything expresses the Dharma. Which is to say, whatever is there in physical form and also not in physical form is alive because it is there.

Kūkai taught that nature itself is a scripture. We can read nature the way we read holy scripture and we can appreciate the fact that scriptures are not relegated to books in libraries and temples and churches, and not always written in human language. Read the mountains; read the forests; read the sea.

He said we might meditate by the moon. When we see the moon we see our own mind. There is also something he called the 'Morning Star Meditation,' dedicated to the planet Venus.

Some years after our last experiences in Oslo, I returned to our home in Canada. It was my habit to engage in such a meditation practice, somewhat like Kūkai's notion of being attentive to nature. Not for any intentional reason, but rather because it happened naturally. At three or four in the morning the moon travelled across the panorama of my screen-door window and I could follow its arc slowly, sliding through the night sky and then behind the tall fir and cedar trees. For a while it would show itself between the large, swaying branches in the early breeze and then it would say goodbye behind the hills.

For some time I collected rosaries and mala beads. The praying or meditating person holds these beads among their fingers and counts the number of mantras as they recite them. A mala has 108 beads and a cornerstone bead. A Catholic rosary has a crucifix at the end. I never used these but sometimes I wound a mala around my wrist and wore it as a bracelet. I probably felt that all those mantras and prayers imbued the beads with a good spirit.

As for the Morning Star Meditation in Shingon Buddhism, it is my understanding that a rosary made of oak wood is to be used to recite a mantra one million times. Once this is begun it must not be stopped until it is over. Like everything else. What has begun needs to run its course.

✳

It had been a practice of mine to find unusual stones and pendants and beads and then eventually form them into an interesting necklace or bracelet or even a wind chime if they were pieces of raw wood or shells. But while we were in Oslo, I confined myself to the bead shop I had discovered with the wide-travelling proprietor. I enjoyed going in there and taking in the baskets of many-coloured glass beads, some distressed glass, which I always enjoyed seeing in their opaqueness. The owner and I eventually became acquainted and, as I browsed, she told me stories of the places she had been.

One of her most visited places was Mongolia. She had her Tibetan thangkas and singing bowls around the shop, and some multicoloured jackets for decoration. She assured me that Mongolia was a Buddhist country with a long Buddhist past going back to the fourth century. They adhered to Tibetan Buddhism, she told me. Many of their temple rites were read and spoken in Tibetan instead of Mongolian.

In the old days, before the Soviet takeover of Mongolia, which destroyed much of the Buddhist art and architecture and customs, there were Buddhist temples and monasteries, strategically placed on old trading routes and at Shamanic sacred sites. This was so the nomadic

families could visit them when moving across the terrain and have social gatherings there. In those days, she said wistfully, gazing out the window of her shop at the flying snow, the great lamas resided in these monasteries which were lit by hundreds of butter lamps that shone in the Mongolian darkness.

The temples and monasteries were places of learning and art and light and enlightenment. They practiced traditional medicine and performed rituals and gave advice there, and they also educated the people and offered meeting points for the nobles. The lit-up temples were reliable stations of contact in a transient landscape. Then she looked at me and breathed as if she were smoking a cigarette, inhaling deeply. She had the ability to gaze into your eyes when she spoke. Direct eye contact, something she must have learned on her travels.

'So much of this old magic has been desacralized,' she said. 'Everything became very secular during Soviet times, and after independence it was hard to regain something like that when modern times competed, with industry and computerization. It is like a dream. A lost dream,' she said, and smiled rather sadly.

Losing a dream is at the heart of our experience of loss, I soon discovered. When we lose a person in our lives, it is not only the person who goes. It is also every dream and longing and desire we had attached to that person, the part of ourselves that is composed of this person, that disappears. We lose part of ourselves when we lose a dream. It is something we all know about and it is why we are afraid of such loss.

When I think of the climate catastrophe we are all facing, I think of that kind of loss. When the earth's regions – glaciers, grasslands, forests – when they die because of climate change and its disasters, we ourselves die. Our spirit: our dreams and longings. Not only our physical selves, which is what all the fuss is about.

I later read a book by Saskia Abrahms-Kavunenko titled *Enlightenment and the Gasping City: Mongolian Buddhism at a Time of Environmental Disarray*. In this book the author delineates the conundrum Buddhists

there face with contemporary pollution. Air pollution can be so thick you cannot see across the street, which comes from burning coal in the cold winters. The idea of cleanliness and purity is so strong in Buddhism that when the air itself is unclean, the whole edifice of your spirituality is at risk.

PART TWELVE

I sometimes think of the story of going to the centre of things I once read in the discourses of the Buddha. Gautama said that many people take only a part of something and mistake it for the whole of it. For example, they take part of a spiritual path and think it is the whole Path.

Taking a part for the whole is like a person who needs heartwood, the inner core for work. This person comes to a tree that has heartwood in it, takes some branches, and thinks he has what he needs. But he does not.

Another comes and takes the outer bark and thinks the same. Another comes and takes the inner bark and also thinks he has it. Yet another takes the sap of the tree and thinks this is it. But it is not.

The one who then comes and takes the heartwood that is inside the whole tree has the right material. To get the right substance, there needs to be perseverance, concentration, and hard work. But when you have the real heartwood, you have what you need. Then you have a better understanding.

There is a famous story in the New Testament about a fishing expedition that I sometimes thought about when things were looking so bleak and there was no way out. There are always questions around treatment for someone who is terminally ill.

In this story, Christ and some of his apostles are out on their shallow boats intending to catch fish with nets. They throw out their nets but when they draw them in again, they have no fish. They throw the nets out again, and again they catch nothing. They do this all night long, with no result. The dawn creeps in pale white, the black birds begin to fly overhead, the cranes begin to watch in anticipation because the boats are not far from shore. The village on land begins to wake up and clouds are forming.

In the end Peter says they need to give up and go back to shore. The effort is useless. But Christ says that before they do, they should try just one more time. So they throw out the nets again, reluctantly because they are tired and their clothes are wet and they are weary. When they pull the nets in again they have caught so many fish that the boats fill up and the load is now heavy and plentiful.

Peter immediately attributes this stroke of luck to a miracle occasioned by Christ. He declares out loud he will be a believer and follower from then on. This story is sometimes taken to be a lesson in faith. That you have to believe. But it could also be a lesson in perseverance. That you should not give up, you should hold on to that one thread of hope in the net of disappointments and failures you are bound to experience.

So I didn't. I didn't give up.

Sometimes that is how it is: there is no willpower, no desire, no resolution or vow or intent that will determine the outcome of things. What happens is just what happens, regardless of you and your wants.

Many years later, when I set out to learn Chinese brush painting, I encountered something similar in a strange way. I had been putting paint on surfaces with brushes for many years, but suddenly here I knew nothing. It was as if I had never handled a brush or seen paper before.

Everything was new to me. The flimsy rice paper. The gradated ink in the ink stone. The long-handled brushes with pointed tips. My instructor Toshiko tried to show me how to hold the brush, straight up, but I was clumsy and incompetent. For half an hour I tried to paint one line. Line after line, they all turned out wrong.

Strangely, now, I could not even paint a line. I was in a world of unfamiliarity. The room we were in with the wide tables and painterly equipment – easels and brushes and paint everywhere in our community studio – this was by now familiar enough, but suddenly that too seemed new and unknown. I sat in my chair and suddenly felt like Raphael's Pope Leo, who should be in charge of what he knows but is now unexpectedly lost, hands laid idle on the table, the paper open in front of

him with writing on it that has turned illegible. And a bell laid down in silence on the table next to him, a hand bell that would not ring.

It can happen so suddenly that a world shifts on you and you seem to have entered a parallel reality without knowing it. A reality so ancient you cannot see the end of it, only the winding road up a mountain that disappears in the mist. You realize you have everything to learn. You know nothing.

What I had yet to learn I later started to pick up, bit by bit. Sometimes a learning curve is very long. Chinese brush painting is not only about the ink and the ink stone and the brush and the paper. Taking its cues from Daoism, this kind of painting is really about the space that is empty on the paper. Empty space: the 'nothing' where you do not paint anything. In the process, emptiness itself becomes a substance.

Painting is meditation in this world. Since Chinese painting takes its inspiration from nature, everything in nature serves as a guide. There is simplicity, spontaneity, and asymmetry. Nature does not supply symmetry everywhere; nature does not proceed according to any plan; things grow spontaneously wherever they can grow.

But painting is not nature. The painter takes away all unnecessary detail and leaves only a suggestion of the bamboo or the chrysanthemum or plum blossom. This is not representational painting: the artist looks for the essence of an object like an orchid rather than a picture of an orchid in its details. Painting what the mind knows rather than what the eye sees.

I thought it would be just as feasible to do this with writing: to write asymmetrically and spontaneously; to leave things undecorated. A text that occurs sometimes in thick clusters, sometimes in thin lines. Always turning in an unexpected direction.

There are not only four directions and there are not only four seasons. There are hundreds, thousands, of directions. For the long-distance traveller, mistaking a direction by even a fraction of an inch will eventually get you lost. And every new day is a discovery of the start of a new season.

Nonetheless, this does not tell the whole story of Chinese painting. There are, I learned, two major 'styles' of Chinese painting. One is *Gongbi*, called 'laboured brush.' The other is *Xieyi*, or 'idea writing.' Laboured brush is meticulous and careful; idea writing is unrestrained, free and quick and bold. The former is an academic discipline of slow and fine-tuned brushwork. The latter is lyrical freehand.

The freehand painting is associated with a style in cursive calligraphy called 'grass writing.' Grass writing refers to the way tall and slender grass sways in the wind. To be bold and courageous in drawing a line and at the same time be as fragile and sensitive to the forces of nature as a blade of grass in the breeze. These seemingly opposing qualities are not only to be found in the writing, they also need to be present in the writer and the painter.

✳

In the still hours of the night, when I put all the glass beads on the dining room table and arranged them for a necklace or a bracelet, I sometimes thought about the bead seller's stories. She remarked that in Tibet and Nepal and Mongolia there was so much emphasis on purity. 'First the Soviets and the Chinese had to rid their colonized regions of Buddhism, which was an impure element in their view. Then Buddhism had to rid society of the impurities of modernity and pollution. Then modern Mongolian society looks on Chinese food as poisoned with evil intent.' She chuckled a little.

I have been reminded many times of the dangers of striving for the pure. I love the newly fallen white snow, which looks so pure and fresh as it settles on the ground and on the trees and bushes and the parked cars along the street, the colour so pristine white. But the idea of purity is a false idea. Nothing is truly pure, and in Buddhism it is a trap of samsāra to be striving for it.

When someone is sick, such as he was, suddenly the pure body is 'contaminated' by an illness. But it is an illness we carry with us all

our lives. This sickness that now assails you is something you had even when you were born, but now it has matured. When I thought about it, everyone is to some degree ill, and the idea of pure health is also an illusion.

Unknowing is now a subject in anthropology, sociology, cultural studies, and theology. Ignorance is filled with the attempts of others to prey on it. That is why dictators and strongmen wish to keep their people ignorant, to remove education and possibilities of enlightenment. That is a form of control. Women have traditionally been controlled this way, and followers of various cults as well.

But unknowing is not the same as ignorance. Knowing that you do not know things with certitude is rather a form of wisdom, according to Buddhist thought. Ignorance is a deliberate refusal to know. Even to know that you do not know.

I thought of those things often during my walks in the Oslo winter air. Everything is in the future, and the future is unknown.

In our situation during those months in Oslo, there were some things we knew although they were not certain. We knew death would come. We knew it was going to be uncomfortable. But we did not know when this would happen or how it would be. When we looked at each other we had the same silent question about this big gap facing us: How would we go through it?

What I was reading was that ignorance turns out to be an important part of social and political oppression. When a phenomenon is feared enough, there is an attempt to ban it or destroy it or prevent it.

In the meantime, the space of ignorance is filled up with misconceptions put there by those who wish to influence people. It seemed to me we were all living in that space of being either wrongfully misunderstood or detrimentally oppressed.

People fear illness for the same reason. When you do not understand something that happens to you out of the blue, it feels like an 'evil spirit' or, worse yet, like something you yourself did 'wrong' or somehow it is the 'payback' of fate in a world of karmic repercussions.

We cannot be comfortable, it seems, with what we do not know. Instead we fill our discomfort with explanations. The opposite of this approach is non-knowing: to accept the fact that there are things you do not know and cannot control. The world is not there for you to dictate its terms. The world was not created just for you.

The Japanese artist Makoto Azuma creates flower arrangements for a living. He buys thousands of flowers, then cuts, trims, and arranges them in dark green styrofoam placed in shallow pans of water. His partner in art, a photographer, then takes photographs with different backgrounds. The result is large, astounding photographs of flowers you never see like that in real life.

Azuma sent his flower bouquets into space. He and his team attached a bouquet of flowers to a space balloon with cameras and sent it up to see if the flowers could withstand the pressures of space travel. They got photos of a bouquet of flowers with the earth in the background. It was astounding. The flowers did not change or droop or wither or tear. They just smiled their flower smiles with the marble planet behind them, floating in space.

He did the same thing with the ocean. They sent a bouquet of flowers down to the bottom of the ocean depths along with a camera. To their amazement, the flowers were not crushed or twisted by the pressure of the ocean water. The flowers continued to bloom and remained in their bouquet arrangement unscathed. Makoto Azuma said he did not know flowers were so resilient. Much stronger than human beings.

Perhaps it is their fragility that allows them to remain strong. That was my thought. Perhaps fragility is a kind of strength.

In earlier years we lived in a small hamlet southeast of Oslo in the municipality of Enebakk. We bought a wooden house overlooking the lake Øyeren, which gave us a view of water and rolling hills. This was not very far from the Swedish border; the nearest towns were Lillestrøm to the north and Ski to the southwest. The municipality used to be a parish around a medieval stone church, dating back to the eleventh or twelfth century.

We often visited this old church. It lay beautifully white in the green landscape, surrounded by a small churchyard. The building was made of quarried sandstone and macadam, but the tower was made of wood. It had been restored several times in its history, but the restorations did not ruin the original character. The silent white building, where it stood in the hills, exuded a kind of timeless peace. It was a palpable peace; on a sunny day you could almost touch the stillness.

Many believe it does not matter what religion you belong to because it all amounts to the same thing. I think the differences between religions are palpable and real, but I have never had a sense of not belonging when I visited a religion. There is something familiar in all of them. What would it take to be a 'real' Christian or a 'real' Buddhist? Not much, in all likelihood. A certain disposition. A certain desire and willingness to let it all go.

I have sometimes thought that the answer to all Zen koans is 'never mind.'

The landscape in Enebakk was memorably beautiful. It was an area of thick woods, rolling hills, pastures, and a number of lakes and rivers running through the whole region. The lake we looked at daily was a nature reserve and so it was protected. We watched the sunrise on the water in the morning, sometimes glowing pink along the horizon. We wandered in the woods behind the house, along small trails that pierced through the thicket until you got to the inevitable waffle kiosk.

Sometimes when he was at work and I was alone at home, I drove the distance from Enebakk to the town of Ski. It was a twenty-four-

kilometre drive through the pasturelands that I could never tire of. First you went down along the whole of Lake Øyeren, along Tomterveien and the small lake of Mjær, where I stopped to look at the water. The grass undulated lime green and the soft hue of tulip leaves, with bushy woods covering parts of it. The water was steely blue with a tinge of pink.

When it was still, there were swans floating in pairs. They would glide along soundlessly, white with orange-and-black beaks, looking right and left and down into the water. I enjoyed seeing them: we always enjoy seeing swans. They are quiet and graceful and they are never in a rush. I took the time on my way to the village to sit quietly on the banks of the lake and watch the swans glide forward.

I was reminded how it is said that at one time Gautama Buddha himself waited in longing for a lost friend who was a swan.

I was also reminded of Thoreau, in his book *Walden*, saying a lake is 'the earth's eye.'

He also called the lake 'sky water.' *Sky water.*

When we bought the house in Enebakk it involved a series of coincidences that I have come to consider meaningful synchronicities. When events and accidents line up in your favour, it feels like there is a guide somewhere. An invisible guide, hiding in the forest. I noticed an advert for an open house in the hamlet of Enebakk, and we went there on one of our Saturday outings. When we arrived, there was no open house after all. You had to be swift in these parts to secure a house because they sold so quickly. But by chance we ran into the realtor in the street and he said there was another house further up the hill. He took us there. The elevation was higher, and the main room had a big window with a better view of lake Øyeren.

We thought it over that night and next day went back to secure the purchase, which happened much more quickly than such transactions

in North America. The ritual consisted of a meeting in the real estate offices, where the sellers and the buyers and the realtor sat at a boardroom table. Papers were signed, everyone shook hands, and the keys were handed over.

It was a plain old wooden Norwegian house, painted yellow with terracotta tiles on the roof and a big pinewood deck wrapped around it, sitting on a forested hillside overlooking the water. It was nothing fancy. The floors were all hardwood, the ceiling was panelled in raw fir, and there was a wooden spiral staircase going from one floor to the other. The house had a distinct smell of wood. We each had an office and there were plenty of shelves for all our books. Soon we planted a very large pinewood desk in the middle of the main room. Eventually I got hold of an Indonesian wooden dragon, which we suspended from the ceiling above the stairway, so it hovered with spread wings whenever we wound our way up the spiral stairs. And on the wall we put an oil painting of a Tuscan landscape, a painting we brought back from Italy.

It was just a humble wooden house in southern Norway, but it might as well have been the Vatican palace. When the keys were handed over on that hasty day, for me it felt as important as the consignment of the Vatican keys to St. Peter himself. We entered that very plain office like supplicants, wrapped in our overcoats and kneeling at the table, and we came out again somehow fully ordained.

It happened, as I have heard it retold in a book by Daniel Capper, *Roaming Free Like a Deer: Buddhism and the Natural World*, one morning when the Buddha was a young man sitting in the courtyard of the royal palace. Suddenly a swan fell from the sky. He picked up the swan and traced his hand lightly over its feathers and spoke to it softly. The swan had been shot in the wing while flying, and the Buddha removed the arrow. While the Buddha was speaking softly to the swan, his cousin Devadatta came running up and cried this was his swan because he shot it to kill, so it belonged to him. The Buddha said the swan belonged to him since he had healed it.

The issue of whose swan this was came before the council of elders. The elders said that life had more value than death, so the swan was Gautama's. The prince continued to heal the swan until it was ready to fly away on its own, and he let the swan go. But when the swan left, Gautama Buddha remained sad and dejected because he had lost his beloved friend.

PART THIRTEEN

It seems natural for people to feel the specialness of birds. Birds are said to be angels or messengers or somehow mystically connected to an invisible world.

During our years together on the West Coast of Canada, we sometimes took the ferry and drove into town to stock up on supplies for our country home. It would happen almost every time we crossed the Port Mann Bridge: we would see crows flying overhead to their roost in the mountains north of Vancouver. The numbers seemed to be in the thousands; they darkened the sky and they kept coming, more and more of them.

Many years later, I happened to be driving on Highway 17 toward the town of Tsawwassen when a murmuration of starlings appeared within sight. They wove and twisted in the sky by the thousands like a magical vision. I learned they do this instinctively, either to keep warm or to fend off their enemies by staying in groups.

Another time I stopped in a parking lot, and as I stepped out of the car, a single raven came swooping down and attacked my head. Its feet clutched my hair and then it flew off and stood on the roof of the building in front of me, making sounds. I did not know why the raven did that. It was October and not mating or nesting season, so there was no nest nearby. I was wearing a shiny black raincoat and I suddenly thought the raven mistook me for one of its own. I stopped and looked at it for a while up there as it stood in profile on the roof, casting its eye on me from the side of its head.

Yet another time I was again walking across a parking lot and a colony of seagulls began to fly in helix formation over my head. They flew across from me, then turned around and flew over me again, and yet again for the third time. This time I was wearing a fluffy white jacket. I thought perhaps they mistook me for a big version of a white seagull. But I stopped what I was doing and stood watching them.

I do not know why these birds were making themselves conspicuous. But on vulnerable days it was easy to attach significance to such encounters.

I was reminded of the writings of ecologists and environmentalists, people who are trying to change the way we see nature because nature itself is in distress.

They write that nature is not mute, but human language cannot help us understand what nature is saying. *We need to learn the language of the birds.*

In 'The Historical Roots of Our Ecologic Crisis,' Lynn White Jr. asserts that St. Francis of Assisi is the 'greatest radical in Christian history.' Because he was humble.

It is said St. Francis preached to the birds around him, and 'he urged the little birds to praise God, and in spiritual ecstasy they flapped their wings and chirped rejoicing.'

There is also a story of how St. Francis talked to an angry wolf that was ravaging the territory of Gubbio in the Apennines. St. Francis persuaded the wolf that it was wrong to be so fierce and violent, and the wolf listened, was sorry, and repented.

After our story was over and I had returned to our home in Canada, I ended up in a house on a mountainside. Behind me was the mountain, and before me was a view of fjord and mountain and ocean. It was a house that needed repair and I worked hard every day, all day, putting

this house together where it was falling apart. I replaced floors; painted walls and filled in cracks; removed clumsy built-ins; converted a frightening storage room filled with shelving and darkness and dirt into a new cold room with new floor, painted walls, and a chandelier, which, with wine racks I painstakingly built on the floor of the hallway, became a wine cellar. I restored a shattered and dirty workshop room into a cool, elegant, light-filled front office. It was work I threw myself into just to be doing it and to see satisfying results afterwards.

But every day at five in the evening I stopped work, showered and changed, and sat down in the sitting room by the front windows to watch the crows fly home. They came out of the southeast, flying into the northwest, where sea and mountains intersected. They flew overhead by the thousands and kept coming for at least an hour, darkening the sky with their numbers. They were going home for the night. It felt like we were having a rendezvous every time, where I could greet them from afar and say good night.

Of the many things he built while we lived in the Pacific Coast wilderness was a large deck over the rocky boulders under the great cedar trees. He placed the planks of wood on a pedestal he had made around the boulders, and then treated the planks with oils and weather-resistant stain. It was a beautiful deck and on it we pitched a big tent with mosquito netting along the sides. We had a table and chairs in the tent and we enjoyed dinners there in the evening as the light waned and birds flew home to their roosts and the world went quiet.

One day I decided to string up a row of prayer flags along the tent. I did not have any specific reason for doing so, just a kind of fun. But eventually we got used to seeing those flags wave about in the breeze, blowing the prayers inscribed on them all over the valley below and on down to the sea. We could see them while we were in the tent as well, and I hardly remember a single moment there when we were not smiling with the pleasure of the lowering sun and the gentle evening breeze.

I imagined I could see the wind horse soaring across the sky, just

like the wind horse in Mongolia, over the rocky hills and pine and fir and cedar forests down to the sea and across the ocean and over all the Gulf Islands in the Pacific.

One evening, however, we happened to look out the side of the tent facing the trees. There, half submerged in the dark shadow, stood a red-furred fox. It was staring at us and it was scowling, teeth showing.

There was another time when we had taken our daily walk, through the woods and along the beach. We walked for a couple of hours, by the marina where boats were lingering and the sun shone on the tiny wavelets in the water. We stopped and looked at a myriad of tiny fish swimming in groups just below the surface of the water.

When we got back to the house, as we rounded the corner, we saw a fox standing at the edge of the driveway. The fox stood very still and stared at us as if it knew us from before. We stopped and stared back. We all waited.

In folklore, a fox is not always a fox; it can also be a person under a bad spell. There is a story told among the fairy tales collected by the Brothers Grimm called 'The Golden Bird.' That tale is supposedly about a golden bird, a tree of golden apples, a golden horse, a princess, and on the other side a king with three sons. But the story is really about a fox.

A king has a tree that bears golden apples. But a bird is stealing the apples, and the king sends his three sons, one after the other, to retrieve the bird and the apples. They discover the bird is a golden bird and so the king wants the bird instead. The two older sons fail in their attempts to find the bird because they do not listen to the advice of a fox that comes out of the forest to talk to them. Only the youngest son listens to the fox and takes its advice, and the fox helps him not only to find the golden bird, but also a golden horse, which he rides through the air to a castle where the princess is held.

The youngest son also makes a crucial mistake each time, but the fox gives him another chance because of his kindness. In the end the youngest son returns to the king with not only the golden bird, but also the golden horse, the golden apples, and the princess whom he weds. The two older brothers come to a bad end.

The fox instantly turns into a prince as soon as the king's youngest son has done what the fox asked him to do. The prince is the brother of the princess who was rescued. But the real reason for being released from a bad spell turns out to be simple kindness.

This story is one of the many folk tales that have come to be known as the 'grateful dead' stories. They exist all over the world and throughout time. These stories are always about a dead person who needs a last deed done before they can rest. If you do what someone, disguised as a person or an animal for example, asks you to do, that person will be grateful.

It seems people all over the world and at all times have thought it was important to follow the wishes of the dead and dying. To the letter.

In our time in Oslo, there were occasions when I took my walk among the city streets late in the afternoon. The sky was light charcoal in colour and the street lights were on. A moon glowed icy above the distant roofs of white and yellow concrete buildings. The architecture in many parts of the older town was neo-imperialist in style, no doubt meant to enhance the sense of national strength and importance. The sidewalks would be cleared of snow enough to walk on, but the heaps of snow that lined the street would remain. Sometimes they did not clear the sidewalks or streets because the feeling seemed to be that people should be able to ski to work.

By that time of day, the snow on the ground had acquired its personality and character, after many had walked and driven on it, even skied on it along the sidewalks. I could see the 'corn snow' that had frozen, thawed from human heat, and frozen again. Along the edges of the sidewalk there was what is called 'crud snow', made of snow powder the

wind had blown into little ridges. The patches and blocks created by the mixture of this with water, maybe by a light rain, I knew was the bane of skiers. Sometimes there was packing snow, which children in playgrounds liked to make snowballs out of and throw at each other.

In the late afternoon sometimes the snow turned up just 'snirt snow,' the white powder and white ice crystals mixed with the dirt of gardens and fields and car exhaust. Ugly snow. Sometimes my mind reached back into the years I had spent in my own homeland, Iceland, where snow events came in so many variations. The most prominent variety in my memory is still just plain slush. When it is snowing snowflakes and it is not cold enough so the snow melts in patches on the ground and creates watery slush that sounds sloppy when you step into it. Sometimes when the snow falls onto the ground, the ground is warm, and snow melts on contact. The ground can be so warm in places that steam rises from the dirt and rocks.

Late afternoon in the side streets of Oslo was a lonely kind of time, if time can be said to be lonely. The sunshine that made the fresh snow glisten like diamonds would be gone and now the snow cover seemed like a pure white shroud. All the parked cars that lined the street were covered over in white, as if ready to be taken to the place where dead things go. Most of the windows were dark already because people had gone home for the evening from these offices. A certain emotional chill sometimes overtook me as well. It was so much like an end of the line, but I did not know what the line was.

At night I corresponded with my friends all around the world. Most of my friends were in other time zones anyway, so when we wrote at night it was day for them. Sometimes we also talked on FaceTime and it was good to see their faces and hear them speak. This technology was never available before and we did not miss it, but having it now seemed like something I would be unable to do without.

One of my correspondents came into my mailbox quite incidentally. He was a former friend from high school in Oregon. He said he had

spent some time looking for me and finally found an address to write to. He was himself in the last stages of cancer, and he was contacting former friends, probably to say goodbye. I told him what was going on with us and said our biggest problem at the time was that my husband was not able to eat anything.

He told me he had the same problem until the nurse got the bright idea of making him a milkshake. A milkshake will work, he said. I took his advice and made milkshakes, which turned out to be the only food he would take. When I told my correspondent this, he said, 'Maybe the reason I got in touch with you was really to help you out when you needed it.'

I have since thought this might be true. Help comes from unexpected places when you need it. There is no knowing.

On the importance of milk, the cow is revered in Sri Lanka and in India because of its pacifism. The cow emanates peacefulness, and it bears with it the gifts of the mother.

In Mongolia, dairy products are sacred. Milk and milk products are symbolic of purity: pastoralism and maternalism and goodness.

There is also a sacred cow in Norse mythology as is known from the *Prose Edda*. The primordial cow is known as Auðhumla, a hornless cow with udders that provide nurturing milky rivers. Icelandic environmental writer Andri Snær Magnason, in his book *On Time and Water*, makes a case for the relationship between Auðhumla and the glaciers and snows of the Himalayas, from where the four sacred rivers emanate: the Indus, the Sutlej, the Brahmaputra, and the Karnali. Glacial rivers are milky white, rich with nutrients for the lower lands and the sea.

When I thought of that, and I realized he could drink the cold milk and get nourishment from the liquid and the sugars in it, I thought of his own mother. When she passed, she gave me one gift. That gift was a diamond.

I have read that there are ten 'black actions' in Buddhism. Three of those actions are of the body, four are of the words you speak and speech, and three are of the mind.

Black actions are about taking life, taking what is not given, and engaging in uncompassionate sexual encounters. Then they are about speaking untruths, gossiping about others, speaking harsh words, and engaging in meaningless chatter. Finally they are about coveting things with greed, allowing yourself to have toxic thoughts, and holding false beliefs.

Black actions are not 'sins' the way Christians see sin. They are simply things that will obscure the clarity of your Path. They are obstacles and they produce more suffering and unhappiness.

In many ways the negative effects of stealing and lying and arguing are just common sense. Nothing good will come of these actions. As Buddhists say in their own language, these bring bad karma.

However, apparently the Buddha said that karma is all just intention. What you intend to do, your aspirations, are just as effective in producing karma as your actions are.

When I read the Pāli Canon I was struck by the many times Gautama Buddha enjoined his listeners to refrain from 'taking what is not given.' It is similar to the act of 'stealing' but is a bit broader. Taking what is not yours to take is usually thought of as being about property. That is because we live in a property-oriented economic system. Everything in our modern times is about property.

But taking what is not given can refer to pretty much everything. You can take someone's reputation, someone's equanimity, someone's affection even. If you take them when they are not offered to you, it could be seen as stealing. You can take someone's sanity, which is what gaslighting is about. You can take someone's health, well-being, time, energy. You can take another person's self-respect, or agency, or liberty. You can take another's happiness. You can steal them all and the other person will be depleted.

I thought of the fresco depicting *The Expulsion of Heliodorus from the Temple* by Raphael in the Stanza di Eliodoro in Rome. Heliodorus was found to be stealing treasures from the Temple of Jerusalem. In response, he is pursued by avenging angels, one of whom is on horseback. Heliodorus, still wearing his official armoured garb, is on the ground being trampled by a white horse. A clay vessel is lying on the ground beside him, broken and spilling out the golden coins he had taken.

There are also ways to remove the bad karma and even to prevent it from being there in the first place. That is what Buddhist rituals are all about, because it is hard to be a human being and not fall short somewhere in the world of black actions. Sometimes we take a wrong step.

There is meditation. The reading of mantras. The saying of prayers. Chanting and bowing. Acknowledging the wrong you did. Attending rituals. Making offerings.

Many of these actions are things people do automatically, everywhere in the world. It is common for people to stop and think; to repeat to themselves what seems important; to pray, even if there is no God; to admit being wrong; to go to church service or other services; to put things out that seem helpful: a shelf of photographs, a bowl of seashells, a set of stones on the sill, driftwood hanging from a string. Repeating part of a song and joining parades.

It is not necessary to make yourself 'foreign' in order to observe Buddhist wisdom. It can all be done at home in your own environment with your own people and ways. In your own language. There is nothing 'other' about this; it is just a disposition. A desire to do better. To be better.

If you find you have taken something from another when it was not given, what should you do? I think the answer would be that you need to give it back, the thing you have taken. You need to make amends and apologize. You need to accept that you have taken another's happiness, another's self-respect, another's chance at real life.

You need to live with the distress and stop defending yourself.

A flame will help take away the distress. That idea seems to be universal. It is why they light candles in church. And why there are small tea flames on Buddhist altars and incense.

Unaccountably, I have also heard it suggested by British artist and architecture professor Keith Critchlow, when talking about why people smoke, that it is not the act of smoking the cigarette that is the important thing. The important thing is striking the flame that will light the cigarette. It is the flame we are after: we need to see a flame much more often than we do.

I lit a candle at night during those months in Oslo, when all was quiet. To take away the growing despair and the unhappiness I knew was lurking in the background. The grief I had come to feel had multiplied into many griefs and they were interfering with each other. Then the small flame became a source of comfort and calm.

When you are waiting for something, usually it is a waiting for what you want to happen. So you wait in anticipation or even impatience. But here I was waiting for something I did not want to happen. That kind of waiting is a form of dread. Anxiety and even fear come in. Emotions you do not want to have. What are called 'black thoughts.'

Sometimes this is also called a vigil. But it did not feel much like a vigil. Whatever it felt like, I was hoping the little flame would help dispel it.

It occurred to me that I had an opportunity to think about happiness during this unhappy form of vigil. What do we think happiness actually is?

I remember a story from the Pāli Canon where Gautama is talking about happiness. He said he was sitting in the cool shade of a rose-apple tree after fasting and secluding himself from life's pleasures.

But he began to wonder, 'Why am I afraid of the happiness that has nothing to do with sensual pleasures and unwholesome states?' And he answered himself that he was not afraid of the kind of happiness that comes from seclusion and fasting.

There is a happiness that comes from living in a way that is outside of the normal daily life of coming and going, working and resting, eating and sleeping and socializing. But it is a different happiness.

What the Buddha was also referring to was the question: 'Why am I afraid of doing nothing?' We feel we always have to be industrious, and that is a virtue in Buddhism as well. Being at rest or at leisure is, for some reason, not for us.

Jacques Rancière mentions this in his book *Aisthesis*; he says doing nothing can be a subversive act. Taking leisure is 'the enjoyment of *otium*.' *Otium*, he writes, is 'precisely the time when one is expecting nothing' and, furthermore, it is 'specifically the kind of time that is forbidden to the plebeian.' Only the 'leisure class' is permitted leisure. The 'working class' needs to work.

It also seems true that in a working world, it is easy to forget how to be at rest. How to be in what Jean-Jacques Rousseau called a state of 'reverie.' There is a kind of happiness that consists of 'expecting nothing from the future.' It is a deep and strange happiness, when there is only the moment we are in. There is no past and no future. Only *now*.

PART FOURTEEN

One time a doe and her fawn wandered into my yard in the Canadian rainforest. To keep the jungle at bay, we had a grass plane that was bounded by thick bush. The deer came onto the grass and, soon after, the fawn lay down, shook violently, and died.

The mother deer sat down beside it and waited. Eventually I called the conservation officer because there would be predators if we left the dead fawn on the lawn. The officers came and took away the small dead animal, but the mother deer stayed where she was.

She remained in the same spot for several days. She did not move, look around, or exhibit any form of anxiousness. She just lay on the grass looking at the spot where her fawn had died. Every morning we looked out and saw her there still.

During these winter months in Oslo, we did not discuss the oncoming catastrophe, as I thought of it, so I did not know how he saw it. We simply went through the days and nights as best we could.

But one day I broke the film that was hardening around us. The film of silence about this. It was during one of the grey-skyed afternoons when we were reading and dealing with the small matters of daily life like rinsing dishes and folding laundry. He was in his favourite easy chair by the window, examining the news.

'You know Siddhartha Gautama had already lived 547 times before he became the Buddha,' I said. He looked up and after a brief silence he began to laugh. It was that light laugh, almost a chuckle, accompanied by a wide smile, which I had come to know.

I remembered how the British poet William Blake indicated on many levels that silence is a sign of love.

Where I live now there is a large Chinese Buddhist temple nearby, the International Buddhist Temple. It is a traditional building in Chinese imperial style, decoratively carved pillars and heads of Nagas facing the crisp Pacific air, all painted oxblood red with tiled roofing that curls up at the corners. An elegant design that is always good to look at. Inside the big hall is a giant gold Buddha, sitting calmly and flanked by four other deities.

There is a classical Chinese garden around the temple, with bonsai trees and fountains and ponds, gazebos with benches where you can stop and reflect, and rock gardens and lotus ponds where you can contemplate. There are cherry blossoms and lotus flowers and pine trees set out deliberately to look like a scholar's courtyard. The garden is designed after the Deer Park where the Buddha taught his first five disciples.

When you arrive, two lions in stone greet you at the gate, and before you enter the temple grounds a nun dispenses incense. There is an open flame where you can light your incense stick and you can walk in holding the tiny spark and the scented stream it produces onto the grounds.

You can wave the flame in front of the image of Avalokiteśvara, the deity of compassion. You can place it in a large box of sand in remembrance of those who have passed. Just like the votives in a Catholic Church.

I sometimes go to that temple. It is good to get away from the everyday and be in a sacred space. There thoughts can roam free, free as the deer.

When I look at that box of sand in the middle of the courtyard of the Buddhist Temple in the city of Richmond, with all the incense sticks standing up and emitting tiny rivulets of smoke into the air, I think of the sands of separation. If the Egyptian writer Edmond Jabès can write a 'book of sand,' perhaps I can think of a 'book of snow.'

All the different trees in the temple gardens are there to remind people that the Buddha lived his whole life with a special connection to trees. He was born under a tree, became enlightened under a tree, gave his first teaching under a tree, and died under a tree. Daniel Capper retells the story that when Gautama was being born, a sāl tree lowered one of its branches so his mother could hold it without falling. When he was a youth, he found solitude under a jambū, rose-apple tree, where the shade lasted all day.

The trees taught him there were four states of mind we could follow: 'divine abodes' as they are now called. They are loving-kindness, compassion, appreciative joy, and equanimity. Since these states of mind are limitless, they are called 'the Four Immeasurables.' They are as limitless as the clear blue sky.

A friend once reminded me that when the world begins to feel hostile and harshness is all around, remember the immeasurable of loving-kindness. Think of where you may find it, where you left it abandoned like an old farm implement outside the barn. Go where the loving-kindness is and be there.

The Buddha himself said he had only a few simple things to teach. Nothing here is complicated. The number of things he had to teach, he said, are as few as a handful of leaves in the forest.

Where I live now there are dogwood trees in a long line down along the edge of the urban forest. At their feet are chaotic oceans of blackberry bushes, leaves bursting in all directions. Every year in May the dogwood trees explode into bloom, with large white flowers filling every branch. When you look down the line of dogwoods, you see a bath of snow white. It is their wedding season: they dress themselves in white and spend two weeks feasting with bees and hummingbirds all over the leaves and flowers, and squirrels running up and down the trunks like little waiters.

The sea of trees in my visual landscape reminds me of a comment Thoreau makes in *Walden*. He heated his cottage with the firewood he chopped down but regretted the loss of the trees in the process. So he thought of the smoke from his fireplace chimney when he burned the logs as his incense to the heavens and he prayed for the gods to forgive the taking of the trees.

We lived in the forest in the Canadian Pacific, but the village was not too far away. Besides the house in the woods, I had a studio in a separate building. There I could paint large canvases and create big fibre works without having to think about being tidy. I enjoyed the days spent in the studio while he was working in the garden or in the workshop he had at the end of the driveway.

He built a deck around the studio where we could work outside, and I hung a bird feeder from the eaves on the corner so we could see the songbirds flying about.

One time I decided to take a break from painting and go outside to sit in the sun for a while. There were certain times of the day when the only place not shielded from the sun by the tall trees was the studio, so I had an old wire chair outside on the gravel where I could enjoy the warmth of the sun.

I sat in the chair and felt the sunshine being absorbed by my body. I closed my eyes to feel it even better and to smell the scent of the cedar trees all around me that had grown high into the sky. After a while I realized there was a continuous high-pitched call coming from one of the treetops. The call kept on coming and it sounded anxious and alarmed in tone.

I opened my eyes and looked up. There I saw a large bald eagle sitting at the very top of the cedar tree high above me. The eagle was looking down at me and calling out in apparent alarm. I did not understand what that was about. I watched it for a while and then stood up to go back inside. As I stood up and made a sound with the chair on the

gravel, I heard a panicky rustling right beside me. Then I noticed a black bear quite near my chair. The bear was lying on the ground. It was asleep and when I stood up it woke up and jumped to its feet in alarm.

I saw what had happened. The bird feeder hung crooked and the ground was full of birdseeds. The bear had knocked down the bird feeder, spilled out all the seeds, and gorged itself on them. When it was full, it decided to take a nap in the sun. It seemed we had both been sunbathing next to each other in quiet until one of us moved. And the eagle above us was very concerned.

It is said that the forest-dwelling monks in Sri Lanka have certain practices to avoid negative encounters with bears. They say we should be kind to bears because they suffer more than we do. They are hungry all the time and thirsty, and they roam the forest all day looking for food and water.

According to Daniel Capper, those forest dwellers, the forest monks, have a prayer to help them show kindness to beings, as they word it, 'beings with two feet, and also beings with no feet, with four feet, and with many feet.'

The proprietor of the bead boutique in Oslo told me about the wind. In Mongolia, she related, the wind is a spirit. 'The wind can carry the prayers written on those little flags and distribute them all over the countryside,' she said. 'That idea has caught on,' I mentioned. 'People have prayer flags in all sorts of places now.'

'But it can also carry what is written in books,' she said, with her pointed, knowing smile. 'If you hold a book in your hand and wave your other hand over it as if you were turning the pages, what is written in the scripture will waft off the pages and fly over the city and all its streets.'

'I suppose you could do that with the Bible as well,' I ventured. 'You could waft the words off the Bible and spread them over the countryside

that way, to the benefit of everyone.' It was a nice idea: an alternative way of reading.

'Well, everyone has their own wind horse, you know,' she added.

The horse has been an important animal in Buddhist thought, I knew that to be so. I thought of the Thai forest monk Achan Man, who was of my grandparents' generation. He had a dream wherein he rode a white horse to a case holding the Pāli scriptures. Daniel Capper tells this story and explains that Achan Man thought of this as riding the white horse of meditation to enlightenment.

I have since learned there are Buddhist practitioners in the Thai forest tradition in Norway. It is a small group of Norwegian monks who live in a hut in the forest. They go through their daily rituals the way it is done in the forest tradition. They wear robes and sandals, except in winter, when they wear parkas and boots as they make their way along the Path on their daily treks.

But there was something more interesting about Achan Man than his dream. He was known to meditate in dangerous places because he said you need to overcome your fears. There is a quote that circulates from him: 'Let what you are afraid of be your teacher.' Then, when he was confronted with a mortal danger in the form of an angry tiger, he decided to stop being fearful and take a more philosophical approach. He asked, if the tiger kills him, who is the one who dies? When you die, who actually dies?

Tigers are archetypes of a kind. An archetype is an image or a motif that can be found everywhere in the world, regardless of landscape or culture. A tiger is an archetype and it even appears in Oslo, which at first surprised me.

Some days when we were living in the township of Enebakk, outside the city, I took the train downtown and we met at Oslo's Central Station.

He took the car most days, and I used trains and buses if I wanted to go somewhere. We would meet up in the large square outside the station and then go visit a bookstore or a gallery and a café somewhere, before driving home.

I often ended up waiting for him in that square at Central Station. Many people traversed this square because all the trains from all directions ended up in the Sentralstasjon. The snow in winter would be almost green with all the trampled footsteps and the concrete under it. There are long, wide concrete stairs from the square to the station doors, with scattered railings in the middle. Behind the steps are the inevitable walls of glass and concrete.

In the middle of the square is a statue of a tiger. It is trampling fearfully across the snow, but it never gets anywhere. Its face is stiffened in a tired frown and it looks exhausted. It is four and a half metres in length and made of bronze by the artist Elena Engelsen. The statue was a gift in the year 2000 to Oslo for its thousandth anniversary as a city.

According to the tourist brochures that lie abundantly about the place, the tiger statue is an acknowledgement of a poem by Bjørnstjerne Bjørnson titled 'Sidste Sang,' or 'Last Song,' written in 1870. The poem is about a battle between a horse and tiger. The horse is the countryside. The tiger is the city. Since this was the city, the statue had to be a tiger and the nickname for Oslo became Tiger City. Perhaps Bjørnson meant the tiger to be a negative symbol of urbanity opposed to rural life, but it is not. The tiger is a symbol of the world we live in, in all its aspects. There is beauty and there is terror.

In the Palazzo dei Conservatori on the Campidoglio in Rome there is the original Capitoline Wolf statue, showing the she-wolf who rescued Romulus and Remus from the Tiber River suckling the twins. The statue dates back to the eleventh century and is thirty inches high and forty-five inches long. Everyone recognizes the statue and what it stands for: the wolf is the iconic animal for the city of Rome and its founders are in her protection.

Perhaps the Oslo tiger was meant to be an answer to the Rome wolf. It was a thought I sometimes had when confronting the statue, alone

and somehow deprived in the middle of the square. The longing to be Rome seemed to be written all over Oslo: in the architecture, the boulevards, the large, paved squares that wanted to be piazzas.

This bronze tiger in the square of the Central Station in Oslo and I became 'friends,' as I associated it with the waiting I did when expecting him to come down those Romanesque steps in front of the cathedral-shaped windows on the wall of the station building with its cold white attempts at imperial Roman grandeur.

PART FIFTEEN

Because we had a long-distance relationship for some time, waiting is something I was perfecting over the years. Waiting for him to show up or for me to arrive. Many times when I was in our home in Canada, I waited at the airport for his flight to come in from Amsterdam or London. I got to know the international arrivals area of the Vancouver airport very well, and I had a routine for how to wait in it. Sometimes flights would be delayed and waiting time would stretch into something long. Or else customs would take longer than expected if the flights were very full.

At the back of the terminal was an open-area café. I often ended up at a counter there with a coffee, and from that vantage point I could see when flights came in and the passengers entered through the automatic glass doors. I watched the people waiting, some anxious, some worried, some looking like they were anticipating the arrival of the pope himself.

I watched for him from the counter in the back. There were no windows and the area felt claustrophobic. But outside there were hills, mountains, forests, castles in the sky; there was the open sea and the harbour and all the ships stalled in the channel waiting for their turn to come into port. At least knowing they were there helped alleviate the sense of oppression. Everyone associated with flying undergoes this pressurized feeling, just like it is inside the airplane itself with its controlled air pressure and stale atmosphere. It was always a big relief when he appeared with a new group, walking down the ribboned-off lane, smiling ear to ear as usual.

I told the proprietor of the bead shop in Oslo that I had an idea for a project. 'I make necklaces and bracelets for fun,' I told her, 'because it helps me think calmly about things when I do. But what I'd like to do is put together a ritual bag.' She clasped her hands together as if she had discovered something delightful in front of her. 'What should I put in it?' I asked.

'Well, you know,' she immediately answered, 'Buddhism developed in the rice-growing parts of the world, so there is always some coloured rice in there.' I nodded, but somehow that did not seem appropriate for this place. 'You can put in dark grain instead,' she advised. 'And medicinal things. Herbs for example. But you must put in nine precious jewels,' she said.

'Where will I find all those precious jewels?' I asked. I imagined such things would cost too much.

'You must find them,' she said. Find them. I understood I needed to wander out. I needed to try to keep the magic of the world from slipping away.

Then she added, with a smile that looked rather sly to me, 'I know some textile artists, you know. One good friend of mine wraps up sticks and twigs she finds in the forest, she wraps them with old thread and strips of material and beads and she calls them "when life gets tough, stick with it" and you know, she has little pouches or bags she puts them into and has one with her all the time, she calls them "purse pals,"' at which she herself laughed very lightly.

I had a project, or so I said. My project was to take care of him as he slowly lost the ability to take care of himself. It is common knowledge that caregivers also need to take care of themselves. That was also a kind of project. My walks and visits to places, painting and jewellery making, were ways of staying grounded at the time.

I knew you can have a project that is clear and obvious, but then there is a deeper project inside it. The deeper project was not so obvious, even to me. I knew that projects happen on more than one level, but I was not even sure what the other levels were about.

Perhaps, I thought, I would simply find out in time. There was some meaning in all this beyond the meaning that was prescribed for the situation. Some other meaning. Perhaps the meaning of it all would only reveal itself in time, slowly, even unexpectedly. Or it would be a surprise when I discovered it.

In Buddhist thought, the central ideals are the 'Three Jewels.' There is a yellow jewel, which is the Buddha; a blue jewel, which is the Dharma; and a red jewel, which is the Sangha.

They mean the Path, the teaching, and the spiritual community. The red jewel is the jewel of things to come. The jewel of a world awake.

There are also 'Three Baskets,' the three compilations in Buddhist thought. These three baskets contain Discipline, the Discourses, and Philosophy.

Discipline is about the rules to be followed by monks and nuns in their daily practice. The Discourses are the teachings of the Buddha and other inspirational works. The Philosophy is a collection of seven treatises that examine those discourses against the discipline of philosophical investigation.

This is what is known as the *Tripitaka*.

In northeast Thailand, it is a Buddhist folk belief that a person has more than one soul. Buddhism in actuality does not hold to a personal soul, but here, as in so many other places, Buddhism is infused with other belief systems, either from before or running alongside. Maybe in this folk belief, a person can have two souls, or some say thirty-two or thirty-seven souls. Sometimes one of these souls wanders off and is lost. If you lose a soul, you become ill or even die. So there has to be a ceremony to call the soul back. The soul-calling ritual is called *su kwan*.

To get the soul back, a tablecloth or floorcloth is set with offerings to lure the soul. There are cones of banana leaves and white strings. There

are enticing foods on the tray: rice grains, sweets, boiled eggs, flowers, incense, whisky, candles. There are personal items belonging to the one who has lost the soul: jewellery or perfume or a comb or even money.

Those present have to sit facing the right direction for the day. An elder is there to light the incense and candles, and a mantra is said. The soul is invited to return to the body it has left, which is surrounded by people who love him or her. The elder says, 'Come, spirit, please come home.' Everyone touches a string attached to an offering, and in the end the white string is tied around the wrist of the one whose soul has been lost and the flowers and branches are dipped in the whisky. The string is worn for the next three days to keep the soul at home.

There were times in our small apartment in Oslo when I wished I could engage in a ritual like that. I had begun to think that he had lost a wandering soul himself, even though the thought was more symbolic than real. I had this idea because of how he did not fight his illness but simply accepted it passively. It was as if he had told himself, 'All right, I am having my final weeks, so that is what I have.' It was disheartening to see how he just let it happen. I could not change his attitude or his disposition. It just was. His soul had wandered away: it seemed so clear to me.

But we have no special ways of keeping hope alive in this part of the world. When the physician, flanked by elaborate machinery, sits with you in what looks like a science laboratory and tells you this is it for you, then there is nothing to do but agree. I felt as though not only souls, but flocks of birds of all kinds, were flying off into the northwest. Everything that could fly away did.

Like the forest monks of Sri Lanka, followers of Buddhaghosa, he became a great renouncer. He became a food-renouncer: after a lifetime of cooking, hours spent in the kitchen making elaborate meals, he now ate only what he was given. He was now a sleep-renouncer: after a lifetime of sleeping

well, he now stayed awake much of the night. Then he became a clothing-renouncer: after a lifetime of buying shirts and socks and slacks and jackets, he now wore only the white robes given him to wear at the hospital.

The fact that he would not eat was a dramatic change. He was always the one who wanted to cook meals, and over time he became the head cook in our home. He would start preparing for the dinner meal early; already by five in the afternoon he was in the kitchen putting out the ingredients. In the afternoons he shopped in the markets: fresh fruit and vegetables at the farmers' market in the town centre, fresh fish at the local fish shop where the catch from the fishing boats came in every day.

He created entire feasts on a daily basis. Lima beans in yogurt sauce with lemon and fresh mint leaves. Cucumber, chili peppers, Chinese cabbage in a broth of coriander, ginger, and garlic. Something he called 'sea flowers' made of fillets of halibut with carrots, celery, onions, zucchini in a butter-wine sauce with coriander and orange juice. He made his own bouquet garni with bay leaves, thyme sprigs, and parsley stalks wrapped in cheesecloth and bathed in the cooking broth.

These meals were planned with great care. He wrote down his plans and how he would organize the preparations. He could have been planning the construction of St. Peter's Basilica, seeing how seriously he took his task. He was in his own small way Pope Paul III directing a great operation, the meal plan before him in a large white scroll held up by imaginary allegorical figures in pink and white, and behind him an imaginary crowd of meal-planning architects pointing to parts of his scroll in agitation and enthusiasm, their faces intense and showing surprise. All the while he himself was smiling and singing.

He created beautiful table settings, just for the two of us, with flowers from the market and candles every time. When we had dinner guests, he multiplied what he was already doing and created memorable banquets, sometimes for four, six, or even twelve. I never saw him in the kitchen without a smile on his face. He had a love of life that was completely infectious.

And now in these last months that zest for life seemed to have vanished into thin air. There was hardly even a trail of smoke left behind.

In every direction I went, I went in vain.

That is a line from the poetry of the nineteenth-century Chinese monk and Chan master Xuyun. Everyone knows how St. Francis of Assisi preached the Word of God to the birds. But Xuyun taught the five precepts to a tiger that wandered into the temple. The tiger listened patiently, and when the monk was done the tiger left in silence.

Xuyun also taught the precepts to a raven, a duck, and a rooster.

The sound artist Lawrence Abu Hamdan once said, 'I am not really an artist.' His works are about hearing the sounds of doors, windows, buildings, cars, airplanes, fighter planes. He said, 'I call myself a private ear.'

I thought you could also be a 'private eye,' wherein your work is about seeing the sights that pass by so swiftly you hardly know they are there. A kind of super-detective of flashing sights. Just as one afternoon when I looked out into the woodland I saw for a split second the sharp blue wings of a bird diving into the foliage. The blue bird came by only once and then was gone forever, it seemed.

I guessed it was a Western Bluebird, diving for insects. They can be found in California and parts of Washington, but I had not seen one in British Columbia before. The brightness of the blue colour and the lightning-quick vanishing stayed with me: a small, very small, split second of visual mercy.

Very few days in Oslo that winter were sunny and bright, and the snow was not always milky white and freshly fallen. Especially in the centre of town where there was traffic, both cars and pedestrians, the snow

became dirty and brown along the edges of sidewalks and buildings.

There were many bureaucratic things to attend to in different offices, and I eventually had to go alone and try to navigate a system I was not entirely familiar with. But he had good friends who helped out.

I went to meet one of his friends in the great piazza downtown at Karl Johans gate, which was really a square in the inner city. I came out of the tram station and walked through the crowd. The square was wide and the snow on it trampled down. In the middle stood a statue of a great man on a horse, huge in size. Some of the buildings around had columns in front; some had long steps leading to the front doors.

A man was running across the square. Two people were walking their dogs. Another person was running toward them. The comings and goings seemed meaningless to me. The buildings were unnecessarily grandiose. The air was almost yellow in its late-afternoon guise because the sun was low in the sky and the shadows were elongated.

I saw our friend walking toward me. I felt a great sense of relief.

During our time in Italy, he was out in the mornings with his camera, but he was not the only one taking photographs. I had my camera with me wherever we went, and sometimes I stopped to take a snapshot. For some reason I did not quite understand, I was taking pictures of doors and windows. Doors made of rich, dark wood, carved intricately in squares with decorations around them. Carvings of saints, horses, crowds, popes in their palanquins entering the city. Warriors rushing off with headgear and horses in flight, and St. Peter, crucified upside down.

The windows were mysterious and dark, set in sequence on every building like eyes on a face. Eventually, one of those photographs ended up on a book cover. The book was something I edited, essays about expats in France. For some reason there was a strange synchronicity about certain academic projects I undertook. Projects that took a long time because for one reason or another snags and hitches came up, delays occurred. But every one of those projects, from the first word on a page to the final published book in my hands, each project took exactly eleven years.

It did not escape me that circumstances can themselves take over your life and force you to remember some life precept or other that you forgot in your zeal. It is like a hand that comes out of nowhere and rearranges things. You did not intend to take this turn, but somehow the turn took you.

In *Walden*, Thoreau talks about such a situation, except for him it was all done on purpose. The whole idea of removing everything except the essentials from your life is almost impossible to accomplish on your own, so fate has to intervene if it is necessary that you learn something. It is a famous quote, often repeated, when he says: he went to live alone by a pond in the woods 'because I wished to live deliberately, to learn what it had to teach, and not, when I came to die, discover that I had not lived.'

*

Something I never told him, and never told anyone, might have explained my calmness during this ordeal of his – facing a death he knew nothing about. I think I did know something about it, though.

It happened when I was eleven years old. I came down with a serious illness, so serious I was in bed, in and out of consciousness, for several months. Somewhere in that time I think I may have passed away, or very nearly did, but it was only for a few minutes, maybe a few seconds, before I was back.

The doctor was in the room with my mother. I realized the doctor had his face unusually close, and I later figured out he was seeing if I was breathing. I saw him and my mother in the corner, talking very seriously, in a mournful way, my mother suppressing something massive. The room also seemed quite dark, and the two of them seemed very far away. Too far for the size of the room.

I understood they were going through a terrible experience, agonizing. I also remember thinking: Why are they so worked up? I'm perfectly fine. It seemed I was not in my place in the bed, but I do not know where I was.

I do know I was absolutely aware and very intelligent at that moment. Not at all out of it like I was supposed to be, lying unconscious in the bed.

It is on that account, and probably on that account alone, that I have always seemed far away from everything since. Perfectly calm and quite unable to orient myself when people forcibly interfere with my solitude.

But I was not the only person in the world to feel far away from everything. Thoreau, who retreated to a pond to live for two years, was actually close to town and friends and family. Yet, he said, he was 'as far off as many a region viewed nightly by astronomers.'

Where the mind is and where the body is: those two do not necessarily coincide.

PART SIXTEEN

One of our weekend outings into town ended up in Ekely. We had not intended to go there but were in the vicinity and decided to head down Jarlsborgveien to Edvard Munch's winter studio at Ekely. At the time the entrance to the tall, square building was nondescript. There were no guards or functionaries or greeters. We parked the car and walked in through the property and opened the green door ourselves. And entered.

It was a painting studio unlike anything I had seen. Supposedly built in the 1920s in Art Deco style, it was just one big room that seemed three storeys high with windows at the top for natural light, which kept the walls free for canvases. There was a ghostly aspect to the place: the ghostliness of emptiness. This is where Munch painted in the winter when it was too cold to paint in the outdoor arbour.

Because he did paint outdoors. He also painted the outdoors as subject. He painted his most familiar surroundings but he made them unfamiliar. And when his paintings were done, he left them outside for the weather to finish them. Nature would make its mark on his work. Many of his paintings were of the arbour and gardens around the studio, and that is where he had visitors come by. He was not necessarily the hermit he is often thought to have been. Instead, he felt isolated in some deep way, which is not the same thing.

We wandered around the studio, all alone in the big building. I had a case of studio envy. What would one not be able to create in a space like this? The sky was, literally, the limit. We also wandered downstairs, which felt a bit like going down into the dungeon of some medieval castle. But there was a small printing press, an old, hand-cranked thing, gathering dust on a windowsill in the basement.

I looked at him in surprise. I had read that Munch never sold his originals, but only the prints he made. Why would this printer be here, left out in the open for anyone to fiddle with? Later I learned the printing

studio in the basement was created more recently, in the 1960s, by other artists. Nonetheless, there was something about that excursion that left an imprint on me.

The artist's studio, I began to understand over the years, is not just a workshop where art is made and created. A studio is also a generative place: a meditation room, a thinking place, a study, a place of rest and a place of work, even a warehouse and a showroom. A studio is also a chapel, as Mark Rothko might say.

I sometimes thought of a comment made by Jacques Rancière, in *Aisthesis*, that in order to really know how art works in the world, the artist must leave the studio.

Art is a world to itself, but as a world, anything can be in it. So art itself is also something that is not art. Art can exclude and it can gather at the same time. Rancière also says we are now looking at 'the union of art with non-art.'

The power inherent in art, he says, is 'the power, which remains obscure to the artist, of doing something other than what he does, of producing something other than what he wants to produce … '

The artist will not know what art will make. She will begin the creating, but art will make itself and it will not be what the artist intended. She will not know, exactly, how this came about.

What is remarkable about the most notable painters of our time, and in spite of the essential *indifference* art has toward the 'studio,' what is noticeable is the sheer size of their studios. Many of the studios I see now dwarf the one in Ekely for size and scale. This is because paintings have become large – so large that assistants, maybe a whole army of people, are required to create them. Making a painting seems to be a factory production: I think of Anselm Kiefer's outfit in Barjac, where he set up his studio, which is more like a laboratory, in 1992. It is a huge acreage

where he created roads, built buildings and greenhouses, planted trees and other vegetation and even dug tunnels.

Kiefer's work is also amazingly big: his paintings are composites of all manner of materials, mediums, and debris; they are sculptures. In Barjac he lives out his inner life on the canvas of the land itself; inside and outside begin to merge. This is what I think of as 'beyond painting' even though painting is still there. The 'death of painting' has been pronounced so many times, but it never dies. It just becomes different.

In our small apartment in Oslo in those days I no longer had my own studio, but painting did not stop. I had no resources, no place to take what I did, and there seemed to be no purpose. But I learned almost by accident that painting is not really a business or an experiment or a factory laboratory involving many people. Painting, and art-making, is a practice. Those who are painters must paint. Their work is their life practice. No matter what the circumstances may be.

During those final weeks and months in Oslo, since he slept and rested much of the time and when he was awake he worked on his computer, I had ample opportunity to mull things over. I was thinking about something the German philosopher Theodor Adorno had said about art and society, which seemed relevant. This came up in an essay written by Hendrik Birus titled 'Adorno's "Negative Aesthetics."' Adorno said that art is the 'social protest against society,' and is always a 'negation of the marketplace.'

What is of course puzzling is the apparent dilemma artists then find themselves in. Among my artist friends it is a triumph and a sign of success if your work is sold. At the same time what you are doing is anti-market and anti-consumerist. The 'anti' nature of art is about negativity, which stands in opposition to what Adorno called 'vile affirmation.' Vile affirmation is basically the whole tradition of art, and is so overwhelming in terms of sheer plurality of works that it has become 'aggravating.'

Adorno, in his modernism, talked about the 'dissolution of the "idea of the well-rounded work."' A work of art is authentic in relation to its disorder, he said. The more finished, orderly, harmonious a work is, the less real it is. 'What is true is only what does not suit this world.'

Affirmative works of art, according to this theory, do nothing to further our understanding of who we are or where we are. There was a time in my career when such ideas were very alive to me, and they ran up against the opposition of the formalists in my field, who accused these ideas of being 'new' and simply an intellectual fashion. But that is of course not the case. Negative theology goes back a long way. A very long way. The core of the matter is embedded deep in our souls, whether we like it or not.

We know it is true that at the centre of things there is a black hole, a blind spot, a site of negativity that lives in the theology of the mystics and the poetry of inspired poets like the Persian thirteenth-century poet Rumi, or Jalāl al-Dīn Muhammad Rūmī, as he is known. There are things we do not understand and that we know we are unable to understand – an 'ununderstanding' we accept.

But this kind of thinking does not seem to be only about art. In those days in Oslo I felt I was looking at such a black hole in real life, not just as an idea. Almost for the first time in real life. A kind of inversion of everything. Nothing was as it should be. Everything was the opposite of itself.

Because of this dilemma, or the dilemma of needing to be in the social milieu while having to withdraw from it at the same time, nothing is 'convenient' in the art world. Especially not in a good art world. It has been pointed out to me many times in many ways that 'good' art is neither easy nor comfortable. Good art 'causes problems'; good art will not fit in your studio; good art is something you cannot afford; good art will not

fit in your car or even in your home; good art cannot be sent in the mail. Good art escapes all bounds and is too complex to be summarized.

They also say good art is mature.

The Danish jewellery artist Karl Monies, at his headquarters in Copenhagen named 'Monies,' creates extravagant necklaces, bracelets, rings, headpieces out of unrefined natural material. These pieces are so excessive they sometimes bear no resemblance to what people have been wearing over the ages. The necklaces explode on the body; the bracelets and rings become 3D sculptures that strike out from the arms and legs.

At the studio, they sometimes polish stones but try to stay as close to the natural shape and texture as possible. Karl Monies says it is nature that is the designer.

Monies once said that we think perfection is something pure, organized and smooth, well controlled and polished. But nature is not like that: there can be perfect chaos, perfect disorder, perfect complication too.

He has said that in art, you have to go 'too far.' Good art has to 'cross the line.'

In art you have to be lost, and somewhat outrageous.

We enjoyed the intellectual life together over the years. What kept us alert in the evenings, why we often stopped on our walks and sat down on a bench, why we were energized by meals together and travels, were our continuous discussions. We may have been in the same field, but we did not agree on some things. We debated formalism against post-structuralism, the value of certain texts, the importance of certain authors. Sometimes our disagreements turned into disputes. But in the end, we laughed it off.

At our wedding we had a 'pride' of intellectuals, poets, writers, scholars, musicians. It was a midday wedding, and after the actual ceremony, which was conducted by a marriage commissioner whose

name was Mr. WishLove, and we had our party of people engaging in all manner of discussions. Some were clustered in groups, some were holding forth, some were locked in conversation in a corner. Another was sitting on the steps leaning back, looking at the trees in the sun because it was a warm day in July. Musicians were clustered against the wall, playing and singing, one following a score.

Disputes and disagreements showed up as well as harmonious interactions. It was enough to give us material to talk about for months to come.

The collection of these people stayed with me. Not just because of the unusual occasion, but because people had such different views and they held them so strongly.

It was something I often thought of: what Gautama Buddha once said about people with strong views. Your view of things, your outlook, your standpoint, is what matters most. Your outlook will determine how things turn out. If things turn out badly, you need to reflect on your outlook.

The Buddha said it was like planting the seed of a bitter cucumber, when your views on things are the bitter cucumber. You plant the seed in good soil, fresh and nutritious, and you water it with clear spring water, and you let the sun shine on it. But no matter how good the soil you plant this seed in, or how well you take care of it, what you will get will still be a bitter cucumber.

There is something called Sun Yoga. It is not the same thing as sunshine yoga or the name of a yoga studio or some dreamy new age appellation. Sun Yoga is a traditional form of yoga in Mongolia. It is also called Sun Meditation.

To practice Sun Yoga, you need to sit in the open sun and let it shine on you. The sun will burn your skin first, which removes the negative

toxins from the surface. Then you have to stay longer and let the sun penetrate your whole body to remove negativity throughout.

You will feel pain.

In Japan, the Bodhisattva of meditation holds a sword. The sword is not for a fight with others. The sword is there to cut thoughts.

So many thoughts crowd in, vying for strange attention. The negative ones especially. They come as uninvited guests at all hours, day and night. They take up residence when you do not want them. They rummage in your closets and ransack your refrigerator and they drive your car without permission. Sometimes they pile up in corners and jump out to startle you.

They put sour air over everything. They bring with them dark clouds. They need to be wafted away, and when that does not work, they need to be chopped down.

In most countries in the West, like Norway, it is thought to be healthy and beneficial to talk about your distress. If your thoughts are distraught, you will find help by telling someone about it, someone you trust. Preferably someone you do not know. This is sometimes done in therapy.

But according to Sara E. Lewis, who wrote *Spacious Minds*, and who did a study of how Tibetan exiles deal with trauma, Tibetan Buddhists do not think talking about your pain is a good idea. If you dwell on your problems, they say, you simply dwell on them. They do not go away: instead they compound and get worse. The best way for them is to clear the mind, to expand your thoughts, and to try to reach that clear blue sky behind those clouds of emotions.

In Japanese Zen Buddhism, they say the more you talk, the more you waste your time.

In a Japanese Zen monastery, according to one monk in training, when they gathered in the dining hall for a meal, they chanted a Chinese sutra first. While they chanted, the cook kept time by beating a wooden spoon on a drum.

That monk in training was the writer Janwillem van de Wetering, who hailed from the Netherlands and went to Japan to live in a Buddhist monastery for a while in mid-century. He wrote a book about it, *The Empty Mirror: Experiences in a Japanese Zen Monastery.*

It is a charming little book I picked up in a bookstore in the 1990s. I thought I might use it as reading material for a class I was teaching at the University of Alberta in the writing of one's own experience. But there were no more copies to be had, so I left the book alone. I only read it many years later.

Sometimes books wait for the right time to be read. Books are like living beings: they have their own intentions.

The Sōtō school of Zen in Japan was, they say, founded by a thirteenth-century monk and poet named Dōgen Zenji. In fact he had several names: he was Dōgen Kigen, Eihei Dōgen, Kōso Jōyō Daishi, or Busshō Dantō Kokushi. He was born in 1200 and he died in 1253 of an illness.

First he was in the Tendai School in Kyoto. Then he went to China for four years and studied with his teacher Tiāntóng Rújìng, who was of the Cáodòng lineage of Chinese Chan.

When Dōgen returned to Japan he instituted a practice known as zazen, 'sitting meditation,' and this became the centrepiece of Japanese Zen practice. He founded a monastery in the mountains that is called Eihei-ji, and it is still the main temple of the Sōtō school. He wrote the monastic code Eihei Shingi, which is still in use.

It is said that Dōgen's mother, Ishi, died when the boy was seven years old. The boy asked his mother if she would go to Paradise when she died. His mother said: There is no Paradise to go to. 'I believe the only Paradise I will ever find in my life is here with you.'

Zazen, or sitting meditation, turns out to be both very simple and quite complex at the same time. Dōgen's instructions in the *Fukan zazengi* are simple: Do not eat or drink much. Go into a quiet room. Do not think about any of your affairs in life. Do not think about what is good or bad. Do not think about what you would like to accomplish. Do not think of anything.

Sit in a steady position, one hand folded over the other in your lap, thumbs touching. Stay in a state of repose and be alert to the present moment. Only the present moment.

Do not think of 'finding Buddha.' Buddha is within. Trying to 'find' Buddha is like 'being in the ocean and saying there is no water.'

It is not necessary to resort to incense, prayer, homage, penance, sutra reading, or other offerings and disciplines. There is no need for specific practices: just zazen. There is no need not to engage in various practices either.

Enlightenment is not something you *achieve*. You were born enlightened.

According to Dōgen, Buddha-nature is everywhere present; it is in the rocks and sand and water, in the trees and grass and soil. Buddha-nature is change itself; it is impermanence.

At the same time, none of this can be condensed into a few sentences.

Once a tiger was chasing a fox. In this story, told by the Korean Sŏn school master Daehaeng Kun Sunim, the fox retreated until it fell into a deep, dark hole, so deep it was unable to get out. At first the fox was frightened, but eventually it settled down into a deep, meditative state. In this meditation, the fox experienced Buddha-nature.

When the god Indra saw this accomplishment, he flew to earth and landed by the fox's hole. The god Indra bowed down before the dark hole that held the fox, but the fox called out, 'What good is your bowing?

Get me out of this hole!' Indra pulled the fox out and then offered it finely embroidered silk robes in honour of the fox's awakened state. But the fox said, 'What good are clothes to me?'

So the fox turned down praise and lavish gifts and wanted no reward or honours. All the fox wanted was to go back to the forest, and it turned and went into the woods and disappeared among the trees, leaving the god Indra with all the finery in his arms, alone by the chasm in the ground.

If the dark hole is the despair of knowing you will soon die, and you fall into it accidentally, and then you are offered all the fineries of the world, you realize there is nothing there for you anymore. No food or clothing or even people around you: nothing will matter anymore. You are going to go into the woods regardless. That is where you are going.

PART SEVENTEEN

Those weeks and months in Oslo seemed to me to be a soundless universe. I did not hear any sounds, day or night. Sometimes the screeching of the tram as it stopped by at Vinderen. The occasional car drove along Haakon den Godes Vei. But the sound of things, the usual noise of cities, was muffled by the many layers of snow. Instead of sounding, the flakes glistened like diamonds when the sun was out.

The snowflakes fell silently, coming from the white clouds and draping themselves on the sidewalks, streets, porches, and rooftops. I could hear the crunching sound of my snow boots as I made my way along the street. Sometimes on Sundays the bells on the nearby church would ring. They could be heard with their brassy tenor through the streets and alleys, dark and brooding. Otherwise I did not hear any sounds.

I ended up in a store one time called Miracle Shop, where the proprietor sold stones and bells and gypsy clothing, brass bowls and mandalas. I bought a singing bowl with a mallet there, just so I could make a sound at home. I put the brass bowl on a tripod when I got home and struck it so the reverberations continued for an extra minute, creating an eerie tone that is said to clear the air.

Every time I sat down for a spell, either just to rest or have a cup of coffee or even meditate, I first struck the singing bowl. It made me think of a story by van de Wetering I read about a Japanese businessman who left his job and joined a monastery. His new job in the monastery was to strike the gongs. Every day he sat in his 'fortress' of three gongs: a small gong, a medium-sized gong, and 'an enormous gleaming monster gong.' A monk outside struck a gong to begin, and the one inside the temple answered with a stroke of his gong, at which signal the monks' choir began to chant the first Sutra of Buddha, a vocal

droning interrupted at regular intervals by gongs and bells sounding their brass notes.

Perhaps it is true, what the American author Richard Powers says, that the greatest disaster for humankind has been that we began to take miracles for granted.

I was reminded of how at a commencement ceremony in Budapest, the Korean-German philosopher Byung-Chul Han quoted the German-American philosopher Hannah Arendt to the effect that the miracle in our life is having been born in the first place. The miracle of being born. On that score, he said, the words from Isaiah 9:6 are a beautiful expression of the one miracle we take for granted from the very start: *For unto us a child is born.*

Because that is the beginning of all things. A new way of thinking. A new way of living.

Later, much later, I was driving south on Highway 152 in the Lower Mainland of B.C. To my left was an open field punctuated with barren and dying trees that stood there like skeleton scarecrows with crooked branches stretching in entangled outreach from their twisted trunks. It was clear to me this land was going to be used for development, probably urban spread.

But then I noticed that high in one of those scraggly trees there was a gigantic eagles' nest. The construction was rough but solid, and it sat in the tree as if cemented there, a big bulge of twigs and branches and leaf debris sticking out high up where the view must have been expansive. It was a kind of miracle of construction in the midst of the deconstruction all around it, in the nearly destroyed landscape.

Then I remembered how I felt in those final months in Oslo. Even though we accepted the reality of things and we proceeded accordingly

– we did not question the process and we were ready for it – I still harboured a persistent idea that miracles might happen. I did not think there would or could be any kind of miracle and I did not hope for one, but somewhere deep inside I had the feeling there might still be one. A miracle, a kind of annunciation coming out of nowhere.

It was as if I lived in a secluded temple of my own making where visitors from the heavens just might arrive by the side door, slip in, and tell me something I needed to know because it would change everything. There would be a dark grey cloud overhead carrying a miraculous divinity standing in prayer, held up by a choreography of angels, and even the white sea and the black hills and scraggly winter trees would understand that something strange and unexpected was about to occur. I would never know what that would be. It would happen and I would not know it.

In the *Book of Tobit*, which is sometimes canonical, sometimes deutero-canonical, sometimes apocryphal, sometimes just a folk tale, depending on where you are coming from, there is a story of visitors from the heavens who do come in and change everything. The father Tobit is blind because a bird dropping fell onto his eyes while he slept. His wife Anna is suspected by Tobit of stealing, since he cannot see for himself. Their son Tobias is sent to fetch a debt owing to his father.

Tobias meets someone who wants to travel with him. They go together, and when they get to the river Tigris, the companion tells Tobias he should fish and use the burnt heart of the fish he catches to get rid of bad demons, and use the fish gall to cure blindness. They do fish, and later encounter Sara, who lives under a bad spell because all her suitors end up dying under mysterious circumstances. Tobias gets rid of the demon, marries Sara, brings her home to his father, Tobit, and cures his blindness with the fish gall.

What has captured the imagination of artists is not so much Tobias himself, or Tobit or Anna or Sara: it is the companion whom Tobias incidentally meets and who travels with him and provides the clue to all these cures. This person is not really a person at all, but an angel in

disguise. Not just any angel; this is the angel Raphael, sent to help Tobit and his family deal with their problems.

The consensus has been that sometimes a person is not a person at all, but is really an angel in disguise. You meet such a person and you do not know they are really an angel. You may know them for only a short time, or for a long time. But you are not aware of who they are. All you know is that something worked out and they were there.

In the Japanese zazen sitting meditation discipline, and also the Chinese Samādhi, which goes back to the tenth, or maybe even as far back as the second, century, the meditator sits and is aware only of what is immediately there, or of nothing at all. Meditators sit together, but first there is a bow to the cushion you sit on and then another bow to those who are meditating with you. During this practice it is forbidden to speak, so a bell is rung three times to announce the beginning, and once or twice to announce the end.

As for meditating monks, I have heard that in Thailand trees are symbolic monks. They stand singular, meditative, quiet, and slow, wafting only with the breeze and holding drops of rain carefully.

The four states of mind, or the Four Immeasurables, are also four kinds of meditation practice. The Pāli Canon describes those four ways of meditating. One is to meditate on *loving-kindness*, wherein you hope that all living beings find happiness. A second is to meditate on *compassion*, wherein you feel empathy with all those who suffer. A third is to meditate on *altruistic joy*, where you feel happiness for the success and good fortune of others. A fourth is to meditate on *equanimity*, where you train your mind to maintain a balanced reaction to all of life's joys and sorrows.

But the meditation on kindness is not just words. It was the English poet and artist William Blake who said that 'every kindness to another

is but a little death in the divine image.' In Christian thinking, when you give of yourself in kindness, you die a little death; that is how selfless an act of kindness is.

On one of my late-afternoon walks in Oslo, I found myself at the church-yard surrounding a beautiful white church. The light was low and the street lights were already on. There was a blanket of untouched snow around the church. The odd tree trunk cast a long shadow on the white ground and the street lights threw their light onto the walls of the building, where the tall, narrow windows stood black against the whitewashed walls. The barren trees rose above the roof and there was a beaten trail to the big brown front door. The gravestones were shrouded in a dim evening haze and the pine trees were loaded down with the weight of the snow.

I walked up to the door and opened it. One does not just walk into a church in this country. Unlike Catholic churches, these Lutheran churches are closed except for designated occasions. Ris Church is some-times used for audio recordings, though, and all the pews are removed to make way for recording equipment because the acoustics are excep-tional. The ceiling is high and held with wooden beams.

When I entered, there was a cluster of people in the front. They were talking. When they saw me, they started to wave me over to join them, or just to come inside, in a welcoming way. I felt the space was heavy and sombre in its whiteness. There were long rows of hard wooden benches leading up to the altar with its stage and its candles. I might as easily have been in the Santa Maria del Popolo in Rome. I would not have been more struck by a feeling of weightiness and magnetism had I been there instead of here in Ris.

The church building is in the Romanesque Revival style and I later learned it was built in 1932. It has a north-south orientation, which is unusual. The stained glass, I found out, is by Per Vigeland, another well-known artist. The altarpiece of Christ and small children was painted by Hugo Lous Mohr. There are three church bells, which I could hear from home when they were rung. I found out the largest bell, among

the largest ever cast in Norway at the time it was made in 1930, is tuned in D#. The middle bell is tuned in F# and the smallest in A♭. That is what I heard in the evenings at home, all of them together.

It was not an accident I walked into that church in the middle of the week one evening at dusk. Something took me there. Something inspired me to open the door and walk in and look inside. Some pull I could feel in an almost material sensation.

As it turned out, after everything was said and done, after many twists and turns along the way, this church is where we ended up having the most beautiful memorial service I can remember. It was not an accident that the church was near the university and all his former colleagues could walk down and attend, so that the church was packed with listeners on another dark, snowy day that had suddenly burst into sunshine.

It may have been a beautiful service – singing choir, speeches by colleagues, candles lit – but I hardly heard any of it. For some reason, after these months of sickness, isolation, loss, the hard work of being on call and vigilant all the time, I was not as relieved it was over as I thought I would be. I thought I would finally have time to let everything sink in and start looking after myself.

Instead I felt emptied out. My life was going away, along with the coffin that was being driven down the street away from us at the very end, and we all stood watching it go. I had the strange feeling that my life was leaving me. Like Galatea riding along the waves in her sea-chariot, my life was floating soundlessly away. The seashell she stands on is pulled forward by a herd of grey dolphins. Tritons are hovering in the waves and putti are flying overhead under the clouds with their bows and arrows pointed who knows where.

And in my own sense of where I fit in this scene, I am fleeing. So fast that the winter coat I am wearing is nearly falling off my shoulders.

In Buddhist circles it is common to hear the phrase 'Life is suffering.' To my ears, this is no different from saying 'Life is easy.' Life is difficult, life is a breeze. It is not something you need to get away from. Nor is it something you need to be attached to.

Life just is. Things are what they are. To some this statement seems inane. But there is a lot of philosophy behind the notion of 'thusness.' The 'I am that.' When you get to the end of it, you find how difficult it really is to accept things as they are. To let them be what they are, either good or bad. They just are.

I had to remind myself of these thoughts because it is so easy, especially for people in our position, to wish things were different. We could try to see the things we were going through, each of us in our own way, as unwanted, undesirable, and not the way it should be. We should be living our lives in our home with the eagles and foxes and bears and hummingbirds and robins, fir trees, cedar trees, hydrangeas in pots all over the porch. We should be laughing and walking and out on our kayaks, paddling in the summer breeze.

All the shoulds are screaming out as we go from one room to another, from home to hospital to palliative care facility, to nurses and doctors and medicine cabinets. But they are just 'shoulds.' You cannot dictate what will happen as you live your life. It is an altogether different thing to say 'This is' rather than 'This should be.'

To let everything be so simple. As simple as saying, 'The snow is fresh in winter.'

Maybe Edvard Munch painted a picture of a person holding his face in his hands and letting out a scream of despair. He is on a bridge and behind him the sunset is blood red and weird. Perhaps the painter wanted to scream but just painted it instead.

It is notable how those who talk about the work of Edvard Munch invariably end up trying to find its 'meaning.' Munch's paintings invite

the search for meaning. Why was this painted? What was he trying to say? But looking for meaning may be a futile search. Maybe there is no meaning. Maybe, as the French writer Albert Camus might say, the universe is simply absurd. Or else the 'meaning' of works and events is somewhere else, somewhere no one wants to look. Behind the screen. Behind the canvas. Why is he screaming on the bridge? Maybe he is just screaming.

The British painter Tracey Emin did let out a scream. She screamed in her studio while she was painting: she let out a loud, angry, frustrated scream and slapped the paint onto the canvas with her brush as if she were fending off a swarm of demons.

That young man from the Netherlands, Janwillem van de Wetering, who took off on a ship bound for Japan because the idea that life was hard and there was no way to make it less hard had begun to bother him too much, wanted to know why there was so much suffering attached to the mere business of living, no matter where or how you were living.

As he put it, he went to Japan to find what he said was 'not a spiritual door I could knock on, but a real door, made of wood, with a live man behind it who would say something I could hear.' He did knock on the door of a monastery once he got to Tokyo. An actual door and it was opened by an actual monk.

They invited him in and listened to his request. They let him stay and learn. He lived among the monks for a couple of years. He wrote his book about what he learned and I read this book and I found he learned but it did not change anything. He was not much happier when he left on a ship going back to the Netherlands than he was on the way there. In fact, the first thing he did when he got on board the ship going back, after two years in a monastery, was head to the bar for a beer.

That is a reality many refuse to accept. Buddhism, if you take it on, is not going to make you happy or even contented or immune from life's difficulties. That is simply not going to happen. What is more, once you

have gone there, then there is no going back to normal life. That is the burden you will bear: you have become far too realistic.

Once you go there, you become another person. That becoming cannot be stopped.

In fact, what that young man did learn was that his options were limited. Human liberty is quite small, after all. Somehow, in a way that is still mysterious to us all, our lives are fixed before we know it.

The British travel writer Pico Iyer wrote a book called *The Half Known Life: In Search of Paradise*. Being a travel writer, Iyer was looking for a Paradise that was earthly, not conceptual. Where is Paradise? He went to Iran, Kashmir, Sri Lanka, Nepal, Israel – places where the earthly Paradise was purported to have been found. But while the beauty was still there in all those places, and the spiritual magnetism could still be found, far too often they had been ruined by politics, corruption, war, feuding, modernity, industry, and tourism.

He often heard along the way what is repeated all over: that the different religions of the world are all searching for the same God. They just go about it differently. But I do not think this is so. I think different religions have different conceptions of God, a god, or no god. They are not the same. They are perhaps all searching for answers to certain crucial questions, and solutions to specific problems of existence. Certain conditions we face.

Those were the very same conditions we – he and I – were facing in our small apartment in a country in the north of the world all by ourselves: life and death, loss and separation, disappointment and dashed hopes, length of life and brevity of life, pain and sickness, loneliness, emptiness. The unknown.

Andri Snær Magnason has a different notion of earthly Paradise. He writes that Paradise is everywhere. All places on earth are extraordinarily beautiful. Thinking about climate change, however, he says that we were handed Paradise and we ruined it. He calls us 'the children of the black sun.'

As for Pico Iyer's book on the search for Paradise, for some reason he writes a lot about death instead of life in any kind of paradise. Maybe they are one and the same.

Iyer relates a comment made by the Dalai Lama during a visit to a holy mountain in Japan. The Tibetan leader said, 'Death is part of our life. So long as you understand that, it won't be a shock.' Iyer also tells of the ninth-century Japanese sage Kōbō Daishi, for whom 'death means simply a journey to an adjoining room.'

In Japan it is customary to keep the lanterns lit so the dead can find their way back to earth and visit their loved ones.

The Pāli Canon talks about death as being lost. There will be a long series of rebirths, which is called *samsāra* in Pāli, and this is a wandering without direction. You cannot trace the rebirths back to their beginning either. There is no first point. No beginning. Maybe there is hardly ever an end either.

And it was a surprise to me to read that you may go to heaven, but your stay there will also be finite. Everything is finite, even Paradise.

In fact, in the discourses of the Buddha related in the Pāli Canon, Gautama says rebirth, different lives that are lived by one person, is really like someone going from one village to another village. That person goes to a third village and then many villages, and then comes back to the first village again.

PART EIGHTEEN

In all my years as a student of literature, I have seen that Dante Alighieri's *La Divina Commedia* is a prototype for all the narratives and stories we tell. The writer is taking the reader on a journey, through the *Inferno*, the *Purgatorio*, and the *Paradiso*. If it is the *Inferno*, we are washed out, exhausted, and drained by the end. We have met characters and situations too grizzly to bear and we are loaded with fears and anxieties. If it is the *Purgatorio*, we see so many troubles, but we can still hope. Damnation has not happened, and redemption is still possible. If it is the *Paradiso*, we are lost and alone but we receive messages and guidance through a mysterious landscape, and the outcome is transcendent. The result of our journey is transformative.

Sometimes the journey we take is not fictional at all, but is real life. And it is probable, as Thoreau said, that '[n]ot till we are lost, in other words not till we have lost the world, do we begin to find ourselves and realize where we are.'

Thoreau also said we should '[r]ise free from care before the dawn, and seek adventures.' And to what end? To no end, except the doing of it and the being: 'The true harvest of my daily life is somewhat as intangible and indescribable as the tints of morning or evening. It is a little star-dust caught, a segment of the rainbow which I have clutched.'

The thought of rising and ascending was always there whenever I accompanied him to the airport in Vancouver so he could take a plane back to Oslo. We were still commuting this way. I drove us to Vancouver International and he checked in. We had a last-minute coffee before he boarded and then I went back to the car. There was an unpaved parking area near the terminal that they called the Cellphone Waiting Area. It was a place people could park for free and wait for their passengers to

either arrive or depart. I would invariably park there and watch his plane take off.

It was a quiet parking area where people drove in, parked, and then eventually left one by one as if by clockwork. I would go out and lean against the car, taking in the rays of sunshine that bathed that open area, and I could clearly see the plane taxi along the runway, slowly raise its nose, and lift off. Then it soared higher, ascending into the ethereal sky with arms wide open as if to embrace the thinning air. The white plane, wrapped in its coat of aluminum and steel, ascended on and on, just like Jesus on the third day, into the sky full of clouds like small cherubim with white wings and fluffy, curly hair. I would think about him looking down at where I was, just as I was looking up to where he was, the distance between us growing wider every second.

When I thought about this later, I began to see this was a repeated practice for the forlornness that eventually encompassed me as somehow the last plane that went up never came down again.

Taking leave at the airport repeatedly over the years was practice for this final departure. At least that is what I think now. I sometimes also think of a segment from *The Duino Elegies* of the Austrian poet Rainer Maria Rilke – or René Karl Wilhelm Johann Josef Maria Rilke, as was his true name. It is the last line of the final verse of the eighth elegy: *so we live, and are always taking leave.*

As Pico Iyer took it upon himself to ask where on earth is Paradise, journeying far and wide in his quest, so also I think no one ever goes out in search of an earthly Hell. No one asks: Where on earth is Hell? Let me find it!

The question seems absurd. Many people describe their horrid experiences as a 'living hell,' which is now a common expression. There are probably many levels of Hell that you could experience: the hell of

war, chaos, starvation, destruction, torture, and all the minutiae of these experiences you can view on the daily news. But there are also quiet hells, where nothing happens but you know this is it.

Such a thought did occur to me. I looked around the spartan hospital room he ended up in, the machines blinking beside his bed, the tubes carrying fluids into his arm, the waiting, the quiet, the way the world had come to a standstill. How I was in fact trapped there myself. Unable to go forward, unable to backtrack. Not free to leave and hardly able to stay. Then I thought: This is Hell, then.

Hell seems to be any situation you are in that is unpleasant or even unendurable and that you cannot get out of. There is a 'No Exit' sign on it. The No Exit sign is blinking bright red above every door in this place.

What people say in common parlance is that when one door closes another one opens. The opening door may be even greater than the closing one.

The Italian philosopher Franco Berardi once said that 'even in Hell there are nice people and places you can relax and smoke a joint.'

I did not know it during those months in Oslo, but while he was deteriorating physically, I was experiencing the same in my mind. I tried to keep calm and steady, but a real sense of nightmare was creeping in. I did realize that if this kind of time, the time we were in, went on too long, I might somehow lose my mind, as they say. I did not know how that would happen, but I thought it just might.

After he died in the care home where he was living the last few weeks, the staff came in and took over. They asked us to leave the room. They would take him somewhere. I stood out in the hall, disoriented, not knowing where to go except home. Home to nothing and for nothing.

Next day I came back, as if I needed to keep visiting. Except there was no one to visit. The act of coming to spend the day with him was so ingrained that I could not stop. When I got there I asked where they

had taken him. To the chapel, they said. There was apparently a chapel in the place. It was downstairs, they told me.

Like a ghost that was unable to detach from its person, I headed down the stairs. I did not know where the stairs would lead, but so long as they went down I followed them. At the bottom there was a door to somewhere. I opened it and went inside.

I found myself in a large foyer of some kind and it was full of people. Persons were somehow swarming about, some rather aimlessly, some full of purpose. It was as if each one of them was acting a part in a different play, many theatrical scenes going on all at once. They stood still or they walked, rehearsing lines for an invisible script, each in their own imagined costumes, holding invisible books or staring at a sky that was not there or standing guard over nothing.

I looked across the room and saw another door with a sign on it that said 'Chapel.' I tried to open the door, but it was locked. After several tries I realized I could not get in, so I went back across the room, through the strange throng of people, intending to go back upstairs again. But that door too was locked and I could not get out.

I looked around. I was in a room in the basement, without windows and only one door out, surrounded by what I now realized were extreme cases of dementia, Alzheimer's, and just plain insanity. Suddenly I panicked. The staff would think I was one of the patients. No matter what I said, they would think it was nonsense. They would wrap me in one of those blue gowns; I would try to plead with them, my hair hanging down, my arms extended as they would be if I were pleading to God for mercy. But they would not listen. They would just take me somewhere and keep me.

In my panic I started to try to shake the door open. The more I shook it the more it would not open. Finally a nurse came and looked at me strangely. I tried to tell her I wandered in here by mistake and now I could not get out. She opened the door for me, which seemed miraculous at the time. I dashed out and up the stairs as if I had escaped a hell that

was intended just for me. The hell of trying to explain something true to people who would not be able to hear it because they were not in the same world.

As the weeks went by during our stay in that small apartment, I remembered it was worth thinking about my time among the Buddhists because there the idea of no exit is an illusion. One of the most important perceptions to be aware of, they urged, is the perception of impermanence.

The idea of impermanence is not something that you deal with in a flash and then move on. That notion is something you have to think about for a while before it sinks in. As they say, you need to meditate on it. The gist of it is, if nothing is permanent, no more than the Earth is flat or time stands still, then all things are transient. Even this. You feel trapped but in fact this will end and you will no longer be trapped.

No situation in life is forever. That is the teaching. If there is no permanence, then, it stands to reason there is no hell. Suffering itself will end. There is no such thing as 'no exit.' This must be what they mean when they tell us that the awareness of impermanence will lead to your emancipation. This was true even for him, who really was in a no-exit situation. His suffering, too, was bound to end.

These thoughts made me remember a book I happened upon in a rather serendipitous way in a bookstore in Seattle, Washington, called Open Books. I was accompanying my family who were meeting the poet Anne Carson at the only bookstore I had ever been in that held only poetry books. I had been looking for a collection of poems by the Irish poet William Butler Yeats for a project, and when we entered the bookstore the first thing I saw was a newly opened box of poetry by Yeats.

In the book *The Winding Stair and Other Poems*, Yeats included a very short poem titled 'Gratitude to the Unknown Instructors':

What they undertook to do
They brought to pass;
All things hang like a drop of dew
Upon a blade of grass.

Much later, after several years had passed, I was driving in southern British Columbia between Vancouver and the U.S. border. I often drove that route, along Highway 99 going south or north. This is an agricultural area full of verdant fields, blueberry and cranberry farms, and orchards stretching east and west.

To go into the city of Vancouver, you drive through a tunnel at one point. It is the George Massey Tunnel and it goes under the Fraser River for a stretch of over six hundred metres. Sometimes it is referred to by its former name of Deas Island Tunnel. The Fraser River that flows overhead is the longest river in the province, emerging from the Fraser Pass at Black Rock Mountain in the Rocky Mountains and flowing into the Strait of Georgia. The name of the river for Halkomelem-speaking people is Sto:lo; and in the Dakelh language Lhtakoh; and the Tsilhqot'in name for it is ?Elhdaqoz, or as they say, Sturgeon River.

One time as I was approaching the tunnel from the north I met with a strange sight. Normally the highway going into the tunnel is nondescript and busy and people just want to get through it as quickly as possible. But this time as I neared the tunnel, a large freight-carrying ship was moving slowly across the highway. The ship was so large that it dwarfed the tiny cars underneath that were going into the mouth of the cavernous underground entrance on one side and emerging with their lights on like fireflies on the other side.

The ship on top of the highway was a surreal sight and suddenly the weight of it all concerned me. How could the tunnel hold up that enormous weight? At the same time, the mass floated soundlessly, as if levitating across the fields. The ship was gliding on air, like the Sistine Madonna in her red-and-blue robe, levitating, her feet never touching the ground, looking directly at you as she went along at her glacial pace,

holding an infant in her arms who is also looking at you as if to say: What are you going to do now?

There is a story of four boys in fifteenth-century Japan who embark on a journey to Rome to meet with the Pope. This is when the Jesuits were conducting missions into Japan to convert Buddhists to Christianity.

The four boys travel to Rome on sailing ships and overland in horse-drawn carriages, and it takes them several years. The journey is fraught with illness and accidents, and they see and experience things they are not prepared for.

They each have a question they wish to ask the Pope. One of them wants to know: What is it like to live without doubting yourself? It seems like a puzzling question until you consider how fundamental it is to the difference between the two world views. It is the difference between knowing and not knowing, between acceptance of what is and the need to change reality to make it fall in line with your beliefs.

A Japanese cinematic drama series was made of this story. In the end the drama acknowledges the many versions of this story that could be told. It all happened so long ago and it is not a fixed story, except for the fact that the four boys brought back some ideas and dedications that ended up having a big impact on Japanese culture and history.

I often think about that one question. I was never sure why I found it so hard to not doubt myself. Many people refer to Western psychology when they maintain we all need to be self-confident. But self-confidence can become a terrible trap, where you make yourself the standard of everything. The whole world has to measure up to your own personal notions.

I think it would be exhausting to be so centred on oneself. But it is also exhausting to never be sure of the rightness of where one stands. That is like being lost at sea on a frail vessel attempting to reach a Vatican of certainty with questions that will never be answered.

Where I live now there is an urban forest behind my house. The trees grow wild there and nothing is maintained except a walking path through the dense jungle. There is enough forest to remind you that if this province were left alone, it would quickly be overgrown by numerous species of trees and bushes, plants and flowers. Here we come on cedar, juniper, pine, ponderosa, larch, tamarack, spruce; fir, hemlock, yew, dogwood, maple, arbutus, hawthorn, oak, crabapple, cherry, alder, birch, cottonwood.

One time I walked this path and read into a video the beginning of Dante's *Paradiso*. This segment of his *Divine Comedy* begins with the narrator being lost in the woods and starting to panic until a guide finds him and leads him the right way – a way that ends in Paradise. When I am in the woods I often think of all the things we do not know about our surroundings. What are the trees saying to each other as they rustle their leaves and ponder loomingly over the shade and darkness? What is the message of the leaves when they are transparent with sunlight?

Pico Iyer once mentioned a comment made by the American psychologist William James: that we humans are like dogs in a library, surrounded by untold knowledge and wisdom we are entirely unable to decipher.

That person, the one who is like a dog in a library full of wisdom he cannot read, is what the Pāli Canon calls an 'uninstructed worldling.' The one who can read the volumes in the library, by contrast, is called an 'instructed noble disciple' of the Buddha.

Uninstructed worldlings are those who have 'dust in their eyes.'

I have read about the Jain belief that you gather dust as you live your life. The dust clings to your soul and weighs you down. Every time you do something, the dust comes in. It is almost impossible to be alive and not be weighted down.

I began to understand, as the weeks and months wore on during our time in Oslo, that my own eyes were accumulating dust. The dust of the world that Buddhist writings talk about. I thought in the end it was about somehow losing my mind or losing my grip. But it was something else – clearly, something else.

Or, only clearly somewhat later on. After our story was over and I was back home, and after wandering through the maze of my conflicting emotions and thoughts and turning over a hundred new leaves, only then did I get an inkling of what I was looking at. There was a sense of gaslighting, but that did not seem right to me. I went about trying to understand such a phenomenon.

To understand my inklings, I knew I had to go to the source of where the idea of gaslighting comes from. It is from a movie, one that has been remade more than once. The first rendition of the American film titled *Angel Street* was released in 1940, and the British version was titled *Gaslight*, directed by Thorold Dickinson and acted by Anton Walbrook and Diana Wynyard. The story is based on a play by Patrick Hamilton called *Gas Light* from 1938. I set about to watch the British film version one evening in the late winter when snow was again falling, but this time in British Columbia.

Roughly, a husband and wife move into a townhome and soon the wife becomes confused about her own behaviour. She thinks she misremembers things and forgets where she put things. But it is clear from the beginning that it is her husband who is confusing her. He moves things, takes things away, and tells her she forgot and accuses her. She believes him because she has no reason not to. Eventually, with the help of a neighbour, she discovers his ruse, recovers her composure, and takes her revenge on him.

Most people know this basic story. But this form of misdirection can happen at the hands of anybody and anything, not necessarily a husband. An institution, a firm, a state, a politician, a lawyer, anything really, can set out to confuse you until you no longer trust your own senses.

The husband also makes the light in the gas lamp flicker and dim in order to terrify her.

In an essay titled 'Naughty Orators: Negation of Voice in *Gaslight*,' Stanley Cavell talks about the gaslight story as a 'melodrama of the unknown woman.' There is a certain genre of films that fall under this heading. He writes that there is embedded in these stories an 'elsewhere'; things are happening, but they are happening elsewhere. You do not know where they are happening, or how. But you have inklings: in the dimming of the lights and the footsteps you hear from the attic above. This kind of world is what he terms 'the world of women.' It is where women have traditionally lived.

The objective in such a story is to see how the protagonist works out 'the problematic of self-reliance and conformity, or of hope and despair.' This may be very much like a theme in a story by Franz Kafka, but here there is an explanation. It just has to be found. The panic that sets in is about not finding what so evidently ought to be discovered.

This is about doubt: when doubt becomes excessive, it is melodramatic. It is about how skepticism invades ordinary life and threatens it. We do not know where the danger is coming from; we only know it exists somewhere. In the process, the whole idea of reality is being destroyed. This is sometimes called 'controlled amentia,' which is the creation of an intellectual disability. But such a disability is created out of nothing, out of thin air.

What you know is what you do not know. What you know is removed from you and hidden away.

The psychology at work, Cavell explains, begins with Sigmund Freud and the idea of talk therapy. Psychoanalysis is precipitated by 'the theft of women's knowledge.' Most if not all of Freud's early patients, from whom he gained his insights, were women. What he learned in psycho-

therapy sessions with them is what he based his theories of depth psychology on. But that knowledge was acquired by force: 'psycho-analysis ... coerces the confessions it claims as its evidence.'

In legal circles, ill-gotten information is not admissible in court. It is not reliable information because the informant is under coercion, pressured to give responses that will appease the listener. The listener takes advantage of the informant's need to fit in, to conform. This is what might be called 'social and psychological violence.'

What we are left with, apparently, is simply 'a house of horror.'

The horror Cavell is talking about is the horror of not being able to speak. Of being deprived of voice. When you are responded to by the world as if you are not part of the world you are in, then you lose your ability to speak. When every fact you encounter takes on an accusatory aspect, you become deprived of words. It is not that you cannot say words; you can. But you have lost your level reason. You can say words but you cannot be heard.

Jacques Derrida declared that 'the land of thought is fully occupied.' It is a land where, from the point of view of the *Gaslight* story, women can only be visitors, or else immigrants. The women are there from else-where, from another world of thought. They have thoughts of their own, but these thoughts are secret. They have inklings, but they occur as shifts of lightning in a night sky that disappear quickly. Everything is wrong side out.

Such a position is impossible, so Stanley Cavell has called it 'the long coastline of madness.' We have come from the mountains behind the town. What is before us is the sea. I heard this spoken of as the long evening drawing to a close; what is before us is mostly night.

PART NINETEEN

For several years after this story and after I returned home to Canada, I traversed this 'long coastline' as best I could. At one point I started watching films that were essentially Italian soap operas. A form of Harlequin romance, but Italian and set in Rome, which put a different tenor to the genre.

These romances are quite formulaic. There is usually a handsome, desirable man who has had lady friends and even wives before, but is now divorced and has parted with former loves. He finds a new love and they are affianced, but he does not tell her the whole story. She has to either trust him blindly or try to uncover the story of his past. Generally, she has no choice but to simply trust him.

The former lady friend or wife is unable to accept the appearance of this new fiancée, so she sets out on a path of revenge. Her ambition becomes to destroy them both. She will destroy the new fiancée by maligning her character and attempting to render her worthless. She will destroy her former partner by disassembling his career, his reputation, and his business, until he is quite ruined. Then she will step in as his saviour and get him back.

Meanwhile the new fiancée does not understand what is happening because she does not have all the information. If she knew everything, she would probably not be his new fiancée any longer. But I never found out who wins in these films because I never watched them to the end. I tired of the melodrama and the sheer volume of psychological manipulation on display.

Even at great remove of time, place, and language, jealous people are exhausting. People who withhold information for purposes of control are exhausting. Even if it's just a film. Even if it's just a fiction devised by some third-rate writer, those themes are exhausting.

Franco Berardi theorized that in today's version of corporate capitalism, the *final product* is in fact our exhaustion. When everything we do and think becomes a consumer commodity: our interests, hobbies, desires, emotions, inclinations, activities, our work, leisure, food, creativity. These are consumable commodities, or else they are commodities that can be 'harvested' by other entities and turned into consumables. So we end up drained and we do not know why.

When we are viewing a film, we are victims. Film makes us see things that are not there; 'we are present to things to which we are not present'; the light in film drives us mad. We become mad, if only for the duration of the viewing.

But perhaps the same can be said about accompanying another person to the end of life, someone who has to go where you cannot go. In the process, you are drained. You are hypnotized by the oncoming cloud. That cloud will eat you but you will stay alive.

Your situation is the opposite of self-reliance. You cannot act from your own light. So everything is dark. It is the opposite of transparency. You are in a cloud where you do not know anything.

Because of the possibility of this state of being, American transcendentalist philosopher Ralph Waldo Emerson said that we do not actually exist. We are here as ghosts of ourselves, and we haunt the world.

Buddhist scholars might agree.

We were scholars. Our work consisted of reading scholarly books and articles, doing research in libraries and in the field, writing academic articles on the subjects of our research. But more than that, we were scholars together. We were students of the same field; we knew the same writers and academics and source material; and we attended the same conferences. Sometimes we both gave papers, sometimes only one of us did and the other came along out of interest.

We travelled in this capacity to many different cities and universities, and when we were there we invariably took the time to explore the area we were in. I had, in the end, a blur of memories where so many of these seminars and conferences melted into each other. Memories of wandering in the landscape outside of Tromsø, Norway, and seeing the clearest ocean water I had ever seen in the lagoons and tidal pools. Of having breakfast on the Left Bank in Paris after a strange previous day at the Sorbonne vivisection room, listening to a full day of academic papers.

Memories of having dinner in a glass-blowing factory in Umeå in Sweden, eating dinner with broken glass all over the floor. Sometimes the experience was frustrating. Sometimes downright disturbing, depending on the discussions going on. But we had so much to talk about, and being there together gave us a background we could always refer to.

The way that part of our life together has melted into a huge diorama in my mind is like having a constant view of the Stanza della Segnatura in the Vatican Palace at my private disposal. There is a crowd of academics from all over; they stand around holding papers in their hands, waiting to go onstage and hold forth. Or they are standing and sitting in groups, arguing and gesticulating, sometimes laughing but usually as serious as if they were debating the eucharist or some fundamental aspect of religious scripture.

There is even, in my mind, a pantheon of holies hovering above the restless scholarly crowd, waving their arms and holding their coats and jackets like minor Napoleons. Above all this is a bank of golden clouds and the image of an alabaster-coloured Christ with his arms up in blessing of the event below, with all his disciples around engaged in a disputation of their own. And even above that there are the angels descending from the sun rays, and they are bringing their little scrolls and telling each other with knowing eyes all this is good.

Sometimes during our earlier life in Oslo I would go with him to work at the university. While he taught courses and conducted his meetings,

which were many because he was head of the department, I spent much of the day in the university library. It is a beautiful building of large glass panels and simple, modernist architecture designed by Are Telje. It is the largest academic library in Norway and it opened in 1999, so it was fairly new.

This library, which is wrapped in light brown wooden furniture of fir and beech and shelving and flooring with green-helmeted brass table lamps, has around two thousand study places, and arrangements were made so I could use a study carrel for myself. But another attraction was the many events that took place there every day. There were science seminars in the science library, writing workshops, book launches by Norwegian and international authors, a book club with author readings, a language café where you could practice languages, art exhibits, and noon-hour classical concerts.

It was a favourite event for me to attend the concerts. They were always excellent musicians and the atmosphere was gentle and serene. The concerts took place in the foyer with the large windows facing the noonday light and trees wafting in the breeze in summer. Those times, in the brightly sunlit space with music dancing in the air, I did not think of anything that might possibly serve as a warning to anyone about anything.

It occurred to me that places where books are kept have been spaces I have ended up in since the beginning of my independent life. I worked in libraries as an undergraduate and also through graduate school. It was not something I was aiming for; it just happened that this is where I was employed. At first I was in the backrooms ironing call numbers onto book spines, and in the stacks shelving books. Later I was in the archives organizing writers' fonds, gifts from writers to libraries. At one point I was employed by the chief of the National Library of Iceland as a translator and I came every day to the beautiful old reading room in Reykjavik and translated the book he wrote, page by page, all by hand in those pre-computer days.

I sometimes thought of the Argentinian writer with the long name Jorge Francisco Isidoro Luis Borges Acevedo, whose stories I was fond of reading. I thought about how he was appointed director of the National Public Library of Argentina, even though he was quite blind by the age of fifty-five. Sometimes the sense and the ability you need most is what is removed from you.

There is a fresco in Rome by Melozzo da Forli showing Pope Sixtus IV appointing Platina as prefect of the Vatican Library. This fresco was at one point transferred to canvas. It is meticulously composed in shape, balance, colour. The pope is sitting in his leather and brass-studded chair, in his white robe and scarlet collar and papal cap, conferring the contract to Platina, who holds a piece of folded paper in his hand and stands in his scarlet robe facing the pope while another is kneeling on the ground behind him. They are surrounded by the columns and pillars of the Vatican building, in harmonious proportions.

Then I thought of the new Library of Alexandria in Egypt. The Great Library of Alexandria was the most important library in the ancient world and it contained as many as 400,000 papyrus scrolls. That significant centre of learning was burned down in 48 BCE by Julius Caesar. A new library was built in 2002, and was designed by the Norwegian architectural firm Snøhetta. Inside the library, there is a bust of the Norwegian writer Henrik Ibsen. At first that surprised me, but somehow it also made perfect sense.

The Pāli Canon, significantly enough, contains a warning about the consequences of not recognizing the 'divine messengers' among us.

Who could a messenger be, in what form, what would it consist of? Accidental synchronicities? Surprises you stumble upon inadvertently? Forgotten memories that unexpectedly reappear? Signs you did not see? Something somebody says unwittingly?

Or perhaps there are people around, in our midst, who serve that function and do not always know it.

The teaching around this thought is that we need to be silent so we can hear, and we need to be still so we can see what emerges. It is necessary to listen attentively.

When I thought of this note about divine messengers scattered about in Buddhist scripture, I was reminded by the American novelist Teju Cole, in his novel *Open City*, of the same thought that appeared in medieval Christendom. Cole writes that the Creator of all Creation also scattered clues everywhere telling us how to use it all – how to 'read' the herbs and plants and stars in the sky.

It seems to be a commonly held thought that synchronicities are meaningful. Patrick Modiano wrote, for example, in *Paris Nocturne*, that things hardly ever occur by chance. Instead, things and events and sights and experiences happen again and again; they keep coming back to us as if to remind us of something.

One afternoon where I live now, on a darkly grey day, I went out to fetch the mail. It had been raining and the roads and stairs were wet. To get to the mailbox I had to walk around a complex of houses, each with its own front door, and each door had a tall staircase leading up to it. Everyone there had to walk up a flight of outdoor stairs to get inside the front door.

I saw a young man wearing a puffer vest and a bright blue turban delivering packages for UPS. He waltzed up the stairs to one of the front doors, deposited the package, turned around to go back down. At the top of the stairs, on the very first step, he slipped and fell, tumbling down the whole staircase on his back.

I was about to run over to assist when he got up looking alarmed, and then he retreated behind a bush. Later I saw him walk away as jauntily as he arrived. I guessed he got off lightly this time, but I thought: This is just how it is with us. One false move is all it takes. One false step and the whole landscape changes.

In the mailbox I found a Christmas card from my sister in Iceland. 'I have really nothing to report,' it said on the card, 'the same as usual, there have been about a hundred earthquakes since last month, the magma is piling up on the Reykjanes peninsula, it will probably erupt, I guess the town of Grindavík has been evacuated, but in general it's still the same old here, same old everyday.'

It appears that Cook trees all lean toward the equator, regardless of where they are in the world. In the past, Cook pines – a type of conifer that looks like a column and grows to as much as sixty metres – were not that numerous, and they were found only in New Caledonia. But they have proliferated through cultivation in different parts of the world, and only recently have people begun to notice the way they lean over. They lean at twice the gradient of the Tower of Pisa, south in the northern range and north in the southern range, and the further from the equator they are, the further they lean.

In the latest analysis of the leaning pine, it is thought the lean has something to do with the Earth's magnetism.

The Danish artist Erik Steffensen photographs a certain oak tree near his studio and then paints over the photograph. Always the same oak tree. He talks about reading a tree. To read a tree as you would a book.

It is remarkable that one tree, standing on his property not far from his studio, can provide him with the subject matter of a whole lifetime.

It was Jacques Rancière who said that 'the dignity of art does not depend on the dignity of its subjects.' You can paint an old boot and it can have the same aesthetic dignity as a painting of the Last Judgment. A painting of one tree can be as impactful as a painting of the resurrection of Christ.

The painting by Michelangelo in the Sistine Chapel of the Vatican in Rome of the Last Judgement is an example of a painter trying to depict an 'important subject' in as overwhelming a way as possible and still be in a sacred setting. The fresco is crowded with twisted and agitated bodies of people, some rising from the grave, some ascending to heaven, some already in the heavenly spheres, and some being ferried by Charon to the entrance to Hell. In the upper middle of the whole fresco is Christ passing judgment on everyone with upraised arm, as if to show his wound, and asking: *Have you earned your place in eternity?*

This whole scene has rightly been called a colossal nightmare. The picture is an unbelievably sad image of fear and dread: what I would now think of as evidence of straightforward collective historical trauma.

There was one moment that stayed with me as time went on during those final months in Oslo. As it turned out, I eventually did manage to get into that chapel at the palliative care home where he died. A couple of days after I had wandered into the basement ward and panicked beside the locked door, we got the call that we could visit him one last time in the chapel before they closed the coffin and took him to a funeral home.

We went back to the facility and entered the chapel by way of a driveway. When we got to the door, no one wanted to go in, so I went in to say goodbye alone. It was a barren, birchwood-panelled room with simple wooden benches and an altar over which a simple cross was hung. In front of that they had placed his coffin and he lay there like a stranger with folded hands.

My first thought was that this was not him. They must have made a mistake and put someone else there in his place. It seemed clear to me that wherever he was at that moment, it was not here.

In Catholic tradition the cross is a crucifix, the Christ figure suspended with nails through his hands. But in Protestant churches and chapels, the cross is just a cross and no figure is on it. I suddenly felt the significance of the empty cross. Of course he would not be there. Only a ghost is there.

I looked at that cross and had what seemed like an illegitimate thought. I almost spoke it out loud. Now would be a good time, my mind was saying, now would be a good time for that miracle you call the raising of Lazarus to happen. Just this once. *No one needs to know, we're all alone here. Just us two.*

We could both then walk out of the barren room together, through the tunnel that was the driveway and into the sunlit open air.

I suddenly felt I was inside an Edward Munch painting: *Death in the Sickroom* or *The Sick Child* or *Love and Pain*. It would be a dark room with no windows and closed doors, and if a resurrection of some sort did not happen we would never get out of there.

PART TWENTY

'Are you shovelling sand to live, or are you living to shovel sand?' This is a question posed in the Japanese director Hiroshi Teshigahara's movie *Woman in the Dunes*.

I first saw the movie when I was an undergraduate, and I have often thought of it over the decades since. The film was released in 1964 and was based on a novel titled *Sand Woman* by the Japanese novelist Kobo Abe.

A teacher of entomology has three days off and spends them in the sand dunes looking for sand beetles to show to his students. He misses the last bus home and is invited to spend the night in a shack in a village in the dunes. The shack is at the bottom of a deep dune and they need a rope ladder to get down and up.

He is hosted by a young widow who spends the night shovelling sand into crates, which are hauled up by the villagers. Every night the same. When the teacher prepares to leave the next morning, he finds the ladder has been removed and he cannot get out. He realizes he has been trapped and he has to help the woman shovel sand. All night, every night.

A so-called New Wave film shot in black and white, the cinematography of *Woman in the Dunes* conflates human skin and the curves of the body with sand and the curvatures of the dunes. Sometimes it is uncertain whether what we see is a sand dune or a shoulder. Sand is shown falling, sliding, collapsing, breaking down – sand edifices built by nature are crumbling disastrously all the time. There is only one woman in the film, and the visitor is required to abuse her before a gang of watching men wearing masks and beating drums.

She is herself trapped in her shack, and if she does not shovel sand every night, the dunes will cover up the house, and then the next house.

She is beating away the elements for the whole village. Then they sell the sand she collects to cement factories, which is how the village survives. She is therefore being used as slave labour for the village.

In the end the visiting teacher has made her pregnant and she is lifted out in a medical emergency after a few months. The ladder is left down and the visitor can now go away if he wants. But he decides to delay his departure because he has discovered a new passion. He noticed that the sand acts as a sponge that soaks up groundwater through capillary action. He wants to work on perfecting a technique for collecting water and then share it with the village.

Someday, he says, he will leave this place. But that day does not come. He remains in the shack in the dunes, having removed himself from society. Once gone, he sees no reason to return to Tokyo. Not just yet.

He has entrapped himself. There is a psychological truth in that: sometimes it is easier, when you are forced to live a certain life, to tell yourself this is what you want.

Or perhaps he is simply being loyal. The question 'Are you shovelling sand to live or are you living to shovel sand?' is a koan. The answer is not going to come to you for a long time. Maybe never.

A related question, which has often come up as I pursued a career in the arts, is almost like a mantra for serious artists. It is said that to be an artist, you must throw everything else overboard. The mantra is 'Everything for art.'

A singular focus that jettisons everything else in life is very difficult to maintain. Only the most dedicated can do so. But it is also thought to be the only way. Not just for art, but for life itself. For love. Also for a true Buddhist practice. 'Everything for this.'

I was reminded of the idea of total dedication to a practice very much later, many years later, when I observed a master painter work on a

painting in our communal studio. Where I live now we have an artists' guild with its own studio and gallery, and we gather regularly for painting together, for social time, for dinners, for lectures and talks, watching of videos, and enjoying the presence of master artists who visit and show how they work.

Our visitor set up his camera tripod easel, his paint box and water jars and array of brushes that stood up like Danish wooden soldiers with high, hairy hats. The painter showed up with a deep tan, wearing white shorts, sandals, and a Hawaiian shirt that said *Waikiki* all over it. Around his neck he had an animal tooth, a kind of amulet. His hair was coiffed Elvis Presley–style. I was not sure, when we all sat down around him, what this man might be able to teach me.

But his whole character changed when he started to work. He applied the wet paint onto the Arches paper as carefully and meticulously as if he were in fact performing the 'surgery' that Jacques Derrida talked about. He was clearly a 'professional,' which is not always understood as a concept. He tilted the paper on the tripod, dropped a minute amount of watery paint onto it, and rotated the paper to allow the paint to spread in a controlled way in each direction.

I was suddenly transported to the time I attended an academic lecture in the vivisection room at the Sorbonne in Paris. We sat in a circular amphitheatre and the lecturer was down below where the vivisectionist used to be. We were in what was formerly the medical school. It was difficult to get rid of the sensation that death had been in that room hundreds of times.

But here in our studio, the vivisectionist was a painter, and he was delineating an imaginary world of trees, grass, red barn, blue sky, and little birds flickering above. At one point he looked up and said to us: *Be bold, be brave, and don't be too precious.*

What would happen if we gained the wisdom that is hidden from us on our daily Path? When the Buddha received enlightenment under a Bodhi tree, suddenly the whole universe flowered, as the story goes. The trees

all blossomed and they were full of fruit at the same time; even the trunks were blooming. Lotus wreaths were suddenly hanging from the sky; lilies burst up from the ground, even out of the rocks; and the sea became sweet drinking water.

The Buddha began to teach what he learned. In a story retold by Daniel Capper, an elephant named Erāvana heard the teachings and announced everywhere that they were good teachings. Since then the elephant has been a special animal, known as 'the Immaculate Tusker,' and it is said that all Buddhist saints have that 'elephant look' because they move their whole bodies when turning to see what is behind them.

To illustrate the fact that elephants can respond to Buddhist meditation, there is a special meditation practice found in some holy palm-leaf manuscripts explaining how to tame an elephant. To pacify a rampaging elephant, the meditator concentrates on the word *buddho* and directs attention to the spirit that is guiding the elephant. Once the focus on the elephant spirit is strong enough, the animal will calm down.

Actually, as Phra Ajaan Thate Desaransi said, in the Thai language, translated by Thānissaro Bhikkhu, 'If you go to a teacher experienced in meditating on *buddho*, he'll have you repeat *buddho, buddho, buddho,* and have you keep the mind firmly in that meditation word until you're fully skilled at it. Then he'll have you contemplate *buddho* and what it is that's saying *buddho*. Once you see that they are two separate things, focus on what's saying *buddho*.

'As for the word *buddho*, it will disappear, leaving only what it is that was saying *buddho*. You then focus on what it is that was saying *buddho* as your object.'

I was reminded, when I read this, how the much-reviled postmodernists of the late twentieth century also liked to separate the word from the speaker. Here you would end up focusing on the spirit speaking rather than what was spoken, because the spoken word has disappeared and the elephant is now calm.

For some reason, when life is at a crisis and there seems no way out, it is comforting to dwell on the magical stories that have made the rounds in various cultures over the centuries. The magic in them is necessary, it seems. I was thinking of a certain mountain in Sri Lanka that Pico Iyer talks about that is considered sacred. One of its many names is 'the mountain of the butterflies,' but it is mostly referred to as Śrī Pāda.

What is curious about this mountain is that somehow the Buddha managed to fly over to Sri Lanka, and when he did he landed on this mountain. A certain Mahāsumana, who was an advanced practitioner of Buddhism, asked the Buddha if he could leave something behind when he left, something that could be an object of devotion. So the Buddha left his footprints in the rock on the crest of the mountain Śrī Pāda.

He left his footprints, imprinted on a rock face. What can one leave behind, after all, other than magical footprints in the illusory landscape of the imagination that we can call the mountain of the butterflies?

A holy mountain may have a protective spirit. The mountain spirit has been seen in various guises, as I have read in books on the life of mountains. Sometimes that mountain spirit appears as a leopard or a bee or an alligator. It can also be a tiger or a person holding two snakes.

Even Thoreau, writing in *Walden* in 1854, thought that the fog might have a spirit. As he was surveying the site of his cabin in the woods, it was a very foggy day: 'I heard a stray goose groping about over the pond and crackling as if lost, or like the spirit of the fog.'

I have heard that Tibetan mountain spirits love the smoke from burning juniper wood. So it is not uncommon to burn juniper sticks simply in order to make the mountain gods happy.

The need to look after the welfare of the mountain gods in Tibet is not an idle thought. The plateau of Tibet is the highest place on earth, and most of the important rivers of Asia have their origin on that plateau. It is supposed that at least 40 percent of all humanity relies on the water pouring forth from those heights and feeding the rivers of Asia. The mountains of Tibet and the snowy cover on those peaks are a critical source of water reserves. When the glaciers melt, as is noted by Andri Snær Magnason, who tells about glaciers in Iceland, when the glaciers melt, the waters that come from them dry up.

We cannot exist without water. Nothing can.

My understanding is that in China there are four very holy mountains, one in each of the four directions. There is Putuoshan in the east, mountain of compassion; Jiuhushan in the south, home of the Bodhisattva Ksitigarbha; Emeishan in the west, home of the Bodhisattva Samanta-bhadra; and Wutaishan in the north, mountain of wisdom.

On Wutaishan, the Bodhisattva Mañjuśrī is said to ride a blue lion with a green mane and a loud roar. The roaring of the lion awakens those who are spiritually lazy. This Bodhisattva still appears to those with seeing eyes as small points of luminous lights floating through the air. These are 'the fireballs of light.'

Fireflies, phosphorescence, glinting dust. Diamond snow.

Light reflecting in every raindrop.

When the rain falls, it is one rain and it falls on every single thing: plants, animals, houses, trees, people, trains, roads, cars, chimneys, statues, park benches. All separate things. But the rain that falls on them all is one rain.

One of the more alarming aspects of his illness was that as the weeks went by, he became thinner and thinner until he was quite unrecognizable. Along with changes in personality, which happened almost instantly at the beginning, his body changed rapidly over a longer period of time. I tried to remain acquainted with him, but he was not the same. So I tried to get to know the new him. I could do it myself, but others found it much harder.

When I observed him in his ever-new aspects, it was almost necessary to remember what is said about the body in Buddhist circles. Your body is this clumsy thing that you feed continually and look after endlessly. You get it to sleep, rest, walk, exercise. And when you are sick like this, your body is more and more of an aggravation. But really the body is just another cloud: this cloud is changing shape all the time and it is passing through the atmosphere at its own pace.

In the end the winds will dissipate this cloud and it will be somewhere else entirely. It will be blown away by the wind horse over time, like the prayers on the little flags hanging on a string under the great cedars.

I was reminded of something the Belgian artist Walter Swennen said about the body and the observer. He was talking about the act of painting. Painting is a physical act where all these thoughts and things pass through your body and become a visual image, to which the eye is an observer.

And the eye, according to Gautama Buddha, has its own intelligence. There is talk of the 'eye mind' and also the 'ear mind' and the mind of the sense of touch. As though every part of our bodies has a mind of its own.

Jacques Rancière also said, in his essay 'Seeing Things Through Things,' on the Russian filmmaker Dziga Vertov, that Vertov explained he created his films in the assurance that the eye not only has a mind, but it also has its own language. He developed a movement called Kino-Eye, where the film does not show exactly what we think the eye 'sees,' but rather shows a montage of things the overt eye has overlooked. The eye did see this, but the thinker behind the eye did not register that vision.

Kino-Eye was not based on entertainment film, but on the newsreel. The newsreel was based on the newspaper. On what was necessary in a time of scarcity. Perhaps it is always true that necessity is the most certain door to discovery. The discovery that the eye has its own mind and speaks its own language, whether or not we understand it.

Just as the eye has its own language, I have read that in Chinese brush painting, the brush itself has its own language. If you are a painter of Chinese ink and brushes, you will first have to learn the language of the brush.

If you know the language of the brush, you can read the painting the brush has made.

It has often been said that we play different roles as we go through life. There is a theatre production going on everywhere and we have parts in it. Many parts, it turns out. Sometimes we play them well, sometimes not so well.

But all the parts we play are just that: roles. None of them are real. What is real is hidden deep in your heart and it may not show itself. Perhaps not ever. Perhaps only when you get older and begin to realize what things are about. Or perhaps at the moment you are slipping away and there are no more roles for you in this production. Then you need to pack up and go home.

We get to a place of nothing. Of no. Of emptiness. A denial of everything. The word for this is *Mu* and it is the answer to one of the big koans in Japanese Zen. I was reminded of this koan by Janwillem van de Wetering.

Show me the face you had before your parents were born. Show me your original face.

The Korean-German philosopher Byung-Chul Han once said that without emptiness, neither philosophy nor art are possible.

Emptiness is something sacred in itself.

I thought a lot about things like 'emptiness,' 'nothingness,' 'purposelessness,' while we were in Oslo during those months, but also and perhaps even more so later. After I returned to British Columbia and tried to continue with my life. Things seemed to happen without purpose and without meaning. Not only just then, but endlessly later, as time went on. Looking for signs from somewhere about what is going on returns no information. There is no news from elsewhere. Not ever.

One evening in my new home, many years later, a storm came rolling in from the south, from Washington and Oregon. The dark clouds spread themselves over the southern sky and then over everything, carrying electricity that burst in peals of thunder and rain that shattered in torrents on the patio, the grass, the trees, the streets.

I watched the storm ravage the trees in the forest through my window. The branches swayed and jerked out of control and whole trees leaned to the ground under the force of the wind. The sky lit up in a flash of blue electric light that seared through the sky and then was gone, followed by a roaring cry from some deep and desperate place in the universe.

I remembered I had forgotten to take down the garden umbrella on the patio. When I looked out I saw it had been dislodged and was clinging to the fence and the house as if ready for takeoff into space at the next gust, the wings wide open like a huge sail. I went outside to close the umbrella and get it out of the way of the wind, but it was stuck in position.

I did battle with this huge sail of an open garden umbrella while the storm roared and the rain pelted down. Soaking wet, I finally loosened the umbrella, stood it up, and managed with difficulty to lower the sails

in the hefty wind. I could have been a crew member on a sailing ship with the sea splashing overboard. When I had the umbrella folded up finally, I put it down on the ground, where it lay like a fallen soldier.

It is often advised that, in order to be clear-minded and focused, you should not try to do two things at the same time. Focus only on the one thing you are doing.

But at this juncture in our lives, while we were struggling through the last three months in Oslo, there was no way I could be that single-minded. I had to think of a variety of things simultaneously: to think both for him and me, to think for two people, and maybe for four. Or even six people. I had to think for them all, the closest relatives as well as us two. In order to do that I had to try to be inside the head of each one, to preempt their thoughts and know what they needed an answer to before they themselves knew what the question was. I had to make things run smoothly.

This situation is not unknown to women all over the place.

PART TWENTY-ONE

In the Kiyoshi Kurosawa film *Wife of a Spy*, the wife Satoko ends up in a mental hospital during the Second World War. A friend from Imperial University, Dr. Nozaki, offers to have her released and take care of her at his home instead. She looks at him quietly and says, 'I have something to confess to you. I am not crazy at all. That makes me the only "crazy" person in this country.'

In this same film, Satoko discovers her husband Yūsaku's disloyalty to the Japanese regime of the time. She is against his dangerous actions until she sees the evidence of the system's wrongdoing herself. Then she says: 'If you are a spy, then I will be the wife of a spy.' She throws her lot in with his. Because she is his wife.

If you are a spy, then I will be the wife of a spy. Sometimes the political or economic system we live in is unjust or inhumane. Even the health care system can be inhumane. I felt I had already acquired a glimpse of that possibility.

We sometimes talked about the injustices inherent in the global economic system, especially after the 2008 crash. But now, so many years later, what is still called the 'neoliberal' regime has had strange consequences. For example, the *North Shore News* reported that a gardener named Sonia had weekly errands to run to the North Vancouver dump and she saw 'a mountain of ripe mandarin oranges.' She came back three days later and saw another such mountain, and next time again another mountain of oranges. One dump truck load of oranges every day.

The piles of hundreds of oranges, maybe thousands of oranges each day, were dumped in what is called the food waste of present-day capitalism. Ten tons every day was a minimum number they gave. The

oranges ripened too early for Christmas; they were substandard; the national inspection agency has rules about colour, firmness, decay, surface defects, and bruising that the oranges did not meet; they could not be offloaded at port because of the port workers' strike; they missed their delivery dates. Excuses given. But Sonia ate some she found at the dump and said they were delicious.

It is obvious to everyone, I thought, that here is an insanity of wastefulness while so many are without food, cannot afford food, beg on the streets for food. Then there are those, like him, who wanted to eat but simply are unable to eat at all. Instead he had to have nutrition pumped into him in liquid form in the end. And it was also true that I myself no longer had any appetite. I forced myself to eat those shrimp once a day, as they were the only food I could imagine.

I must have thought, without knowing it at the time, *I will throw my lot in with yours.*

Having to make things run smoothly all the time was also a difficult ambition for me to have. The more I tried, the harder it was.

I was reminded of something I heard a Buddhist nun say: Venerable Jetsunma Tenzin Palmo. She had a choice in life, which was to either retreat and live a life of meditation or to start a nunnery. Since it was felt Buddhist nuns were not equal and they had no temples of their own, she saw she was in a position to start changing that. But starting a nunnery was a journey full of pitfalls and aggravations, difficulties and hardship. Negotiating, planning, consulting, interacting, even physically building structures. Dealing with surveyors, carpenters, money. Retreating into meditation was so much easier.

She asked a Catholic priest what he thought she should do. The priest said she should build a nunnery. For a smooth outcome, it will not work if you stroke yourself with velvet all the time, he said. What you need is sandpaper.

The Taktser Rinpoche, whose name was Thubten Jigme Norbu and who was the oldest brother of the fourteenth Dalai Lama, came from Taktser, the village of the 'roaring tiger.' He tells a story of the fish in the nearby stream, which is repeated by Daniel Capper.

One day he came to the stream and found it had dried up in the recent drought, and the fish were trapped in a small pool they could not get out of. In an effort to save them, he scooped them out of the pool and carried them home, where he deposited them in the family drinking urn. But he missed his footing and overturned the urn, which broke, and all the water spilled out with the fish spread on the ground.

Now he had made a big mistake. Not only did he not save the fish, but the family's supply of drinking water was also lost.

It is possible that all our efforts end in disaster.

Perhaps all fish stories end in catastrophe. That is the life of the fish, you might say.

We had a goldfish in a tank at home in British Columbia once. One day when I came home I found the glass had cracked and most of the water had spilled out onto the floor. The goldfish was swimming around in the bottom of the tank in very shallow water.

To rescue the fish, I took it outside and put it in a koi pond we had among the rocks in the yard. There were no koi in there at the time. The goldfish now had a lot of space and swam around in its new environs for a few days. But not entirely new, because it was in the pond first when we got it, along with two brothers. But the brothers were eaten by a snake, so we took the remaining one inside.

Now it seemed to remember the pond it had once been in. I thought it would be lonely, so I went and procured nine little goldfish to keep it company. The big fish adopted all nine babies and began to protect them; she showed them how to live in the pond and how to hide from predators. Every morning I looked out the big window of the living room at the pond and saw nine pairs of eyes in a row peering out from under a rock while mother fish was out scouting the area. When it was

safe to come out, she went and told them to go find their food.

I was struck by the organized behaviour the goldfish exhibited. I could see how the big fish was schooling and teaching the small ones. But as might have been expected, one morning I discovered the pond had been ransacked by a gang of raccoons in the night. The rocks in the pond were strewn all over the yard and all the fish were gone. Only one small one was left, swimming in frantic confusion.

We had made a mistake. It was not a good idea to let them live out there. Not a good idea at all. We had a little ceremony for all the lost fish. We walked down the hill to the marina and sat down on a bench at the end of the dock. Our ceremony for the fish consisted of sitting in silence and watching the still, blank dark water at our feet. A lone kayaker came sailing by, gliding along peacefully.

The Vietnamese-American writer Ocean Vuong said that a work's vulnerability is its greatest asset.

The Irish-American artist Sean Scully said that a work has no obligation to explain itself.

The British artist Ian McKeever said that a work has no need to find closure.

The work should pull you in and push you away at the same time.

In his famous essay 'How to Avoid Speaking,' Jacques Derrida says he had been ruminating about *negative theology* for a long time but kept putting off talking about it. Then he made a promise: 'One day I would have to stop deferring, one day I would have to try to explain myself directly … '

It is true, some things are hard to talk about. Then even when you set out to finally talk about it, you still keep deferring. You find you are still going in circles around the one thing you do not want to confront.

At the same time you wonder why you might need to explain anything to anyone after all.

But Derrida makes another notation on speaking and not speaking. The moment you say you will not speak of it, you are already speaking of it: 'At the moment of promising to speak of negative theology, I already started to do it.' This is how you are trapped in an unalterable vulnerability. Somehow, 'language has started without us.'

But then: 'To avoid speaking, to delay the moment when one will have to say something and perhaps acknowledge, surrender, impart a secret, one amplifies the digressions.'

The same goes for people, it would seem. In other words, you are strongest when you are most vulnerable. You do not need to explain yourself to anyone. Ever. You do not have to understand everything. Sometimes it is better to not understand. And you do not need to please others. These are simple thoughts, but for some reason most people find it hard to adhere to them. Most people, it seems, go for raw strength and being right about things, and also being liked. Those needs are not helpful.

He had been a victim of those kinds of mistakes much of his life, but eventually he dropped them all. Especially in these final months, there was no need for any of that paraphernalia, which only obscures things.

So many busy people end up acknowledging that in being so busy, they have simply been exploiting themselves. The Korean film director Park Chan-wook phrased this as always carrying a labour camp around with oneself.

In one of the Sutras in the Pāli Canon, Gautama Buddha suggests a metaphor for how to understand things. Suppose you are walking along an ancient path and you come upon the ruins of an abandoned, ancient city. The buildings and streets are there, the towers and sidewalks, but it is in a neglected, decrepit state.

You realize you can revive this city. You go to the authorities and make a case for revitalizing the city. This is done and soon it is a newly renovated city and life is back in its houses and on its streets. The new life is teeming and glowing.

That is what happens to you when you decide to live in the right way, after neglecting things for so long. You revive the ruins of the abandoned city of yourself and bring life back to it by turning to the right way.

The right way of living has eight parts. The eight folds to the noble Path in Buddhism are really no different from the right Path in other religions or cultures, but here it is called 'the eightfold Path.' The eight folds are: right understanding, right intention, right speech, right actions, right means of livelihood, right effort, right awareness, right meditation.

In so many words, there is a right way and there is a not-right way. We can choose either one at any time.

The not-right way is easy to take. It happens almost automatically that the blind follow the blind. Or, as Gautama Buddha phrased it in his teaching so long ago, we can be 'like a file of blind persons: the first one does not see, the middle one does not see, and the last one does not see.'

What the 'right' is, however, that is in the details.

There may also be 'right attitude,' such as the perception that you are wearing your body the way an actor wears a costume. When the time comes and the play is over, you will have to take it off.

Even in our strictly concentrated universe of those months in Oslo, when one of us was declining and preparing to depart, and the other of us was in a waiting space that was full and empty at the same time – even in this universe there was a right way to go and a wrong way, and we had that choice when we set out and headed to Oslo in the first place. There was a right attitude to have, and it was thrust upon us by

circumstance. It seemed to me we had no choice, given who we were, but to try to take the right Path.

You may wake up one day and realize *you are in the wrong world*. It may have been a series of mistakes or even an accident that you should find yourself in a place you do not recognize as belonging to your life, or what you thought was your life. It is most certainly not your 'fate' or your 'karma,' as people sometimes say. Most likely you did this all on your own, except you no longer remember how.

It is like being lost in the forest. You try to retrace your path to get back to where you started, but you do not recognize any of the markers. You have taken a wrong turn.

I often had that concern when I walked in the woods, especially if I was by myself. I always made sure I knew exactly where I was. But life is not a forest. I felt I had taken the wrong turn and I no longer remembered where the intersection was. The fork in the road. The junction. It was maybe in my inability to put a stop to what other people were doing. I let them in.

This is what was happening as the weeks wore on in Oslo. I knew it somehow, but I was not sure what it was I knew. I looked around at the small apartment and the unfamiliar furniture, the green sofa and the Ikea dining table. The windows with white windowsills and snow outside. Cars going by, people walking home from work. It was becoming clear to me, especially in the early evening hours, that blue hour when dusk was falling, that I was in the wrong world.

It was not especially comforting to me to think, as Buddhist thought teaches, that there is no 'wrong world.' That it is beneficial to abandon the idea of home in the traditional sense. You are at home anywhere. Everywhere. The world is your home. If you are an artist, the teachers of art have told me, then the world is your audience. These ideas seem

counterintuitive. It is natural for us to think locally and to locate our home in a precise spot on the map.

We are like birds in a swarm or in a murmuration: we can only see the seven birds next to us in either direction. It is very hard to think in terms of the whole world or the whole sky. .

Birds, like starlings, can swarm and murmurate by the thousands, and crows seem to fly by the hundreds. Many birds congregate in huge flocks. But then there are the loners, like eagles, whom you usually see only one by one or sometimes in twos.

Where I live now there are nesting grounds for eagles nearby and they are, according to the information I have, the largest eagle nesting grounds in the world. You often see eagles overhead when travelling along Highway 99. But one day I was travelling north on 200 Street and a bird was flying just above in the same direction. The wingspan was too large for a crow or a raven or a seagull; it was not a hawk either, though sometimes you see a hawk coming out of the woods. When it doubled back in front of me and flew over again, I saw the white head and the yellow crooked beak and black feathers of an eagle, and it was hovering above my car.

I lost sight of this eagle down the road, but then suddenly, a mile or so later, it appeared again, still flying in the direction I was moving. It swooped down low and created a shadow with its broad wings, then wheeled upward and around again.

I am not sure why it is so easy to attach significance to this kind of incident: when a large bird, like the albatross in the English poet Samuel Taylor Coleridge's *The Rime of The Ancient Mariner*, decides to travel along with you for great distances, we tend to think there is something to it. That the eagle or the albatross overhead is communicating something. Anything.

The whole world never did stop being magical after all. So many years later. It seems like a magical kingdom every time I go on my way for whatever reason I have at that moment to go somewhere. Around me there is always that same scene: the parchment-coloured sand; the lime-green fields; the amethyst mountains behind, with white veils over their peaks.

That backdrop of nature becomes for me like the Three Graces – joy, beauty, and creativity – displayed in real life. They are always there like great mothers in the pearlescent sky, always together, always watchful.

PART TWENTY-TWO

During those months in Oslo, there were many lonely hours. I sometimes felt like a shipwreck lying on its side on a black beach. Cold waves are crashing behind me. A blustery wind is whining in front of me. I wondered if he sometimes felt the same way, but I could not tell.

When I took time to think about this loneliness that had descended on us like an alien spaceship on a dark moon, happening even though we were still together in the same space, I could still see there was something completely natural in our circumstance. I remembered a quote from Thoreau's *Walden* where he talks about being lonely in his cabin by the pond. And yet he was not lonely at the same time: 'I am no more lonely than a single mullein or dandelion in a pasture, or a bean leaf or sorrel, or a horse-fly, or a bumble-bee. I am no more lonely than the Mill Brook, or a weathercock, or the north star, or the south wind, or an April shower, or a January thaw or the first spider in a new house.'

When you know there is something you have to do, your own loneliness takes on miniature proportions. There is a reason for everything, even though that reason may be hiding behind a black cloud covering the sky.

The reality of loneliness for us was compounded by something we knew was a strange feature in Buddhism, an aspect of Buddhist thinking not many people seem to know.

We think the practitioner should be in seclusion, concentrating in solitude. We think that is the only way to achieve what they call liberation. Or, liberation of mind. That the spiritual life is a life of solitude.

But the Buddha said this is not so. The spiritual life, the whole entirety of it, consists of 'good friendship, good companionship, good

comradeship.' The path you walk is something you do together. It does not have to be a cluster of monks. It can also be a husband and wife. Good friends, good companions, who understand each other and what they are going through.

The loneliness I felt was a future loneliness. It was a loneliness about to come that I was already feeling. No longer would we be walking together in this place or in any other place. I would, in reality, become the one going wherever I went in solitude.

But there seemed to be many different kinds of loneliness, as I now discovered. There is a loneliness two people can feel together, and another loneliness you feel by yourself, alone. There is the loneliness of being alone with no one to talk to, and also a loneliness of anticipating being alone later, even though you are not yet alone. A future loneliness. There is a loneliness about the past, either because it is gone forever or because it never was. There is a loneliness when you are with your friends, or with a lot of people, when you feel set apart from them. I think there is even a loneliness from yourself, because you are no longer with yourself. You have lost yourself.

I realized I was already feeling future feelings. What I knew I would go through was happening already in an anticipatory way. Because I knew I would have to go home alone at the end of this journey, and the emptiness of the future soared like a shadow over the days and nights even while we were still together.

It seemed to me I had come into an awkward stage without being aware of it. Whenever I went out and walked in town, I felt like an alien who had recently landed and was trying to be like humans. Trying to learn the ways of humans and everything they were doing seemed strange and unfamiliar. Drinking coffee in coffee shops, jumping onto the tram, serving others behind counters. It was all strange. And what I did not realize is that this feeling of estrangement would stay with me for years.

Where I live now the ocean is nearby and I walk on the beach as often as I can. The sand is white and black, pebbles scattered about, shells and stones and rivulets and estuaries. It is a good place to feel the wind and watch the sea and sky change colour as the day progresses. I walk on a path above the beach to the end of the promontory where there is a small bird sanctuary with the unattractive name Blackie Spit. There is a bench where you can sit and wait for various marsh birds to appear out of the sky and land in their nesting ground there.

But one day it was not a bird. A small plane came whirling out of the sky with a sputtering engine and crashed into the marshy ground ringed by trees and ocean. The plane burst into flames. The pilot emerged from the wreckage and sat down on the bench, watching his plane burn. Fire crews appeared along with an ambulance. They wanted him to lie down on a stretcher, but he said he wanted to walk to the ambulance.

Sometimes this is what happens. In a strange way, you can be a spectator to your own disaster. You can sit on a bench in a bird sanctuary and see your whole life go up in flames while you yourself, unaccountably, are the survivor of your own life.

The Korean painter Kim Yong-Ik paints abstract expressionist backgrounds with very precise circles overlaid. It is as if he is trying to create a confrontation between chaos and order. More recently he has turned to a very light palette of shades of white and beige. To account for this use of analogous and even monochromatic colours, he talks about 'the aesthetic of shadows.'

His reasoning is that a strong sense of emotional shading can only be had by *not* releasing your emotions. If you let your difficult emotions build up inside you for a while, you may be able to come across a system of shadows that is generative and creatively moving.

The shadow is a very negative force in Western psychology. We deride the shadow. The shadow is the enemy within. Even the Buddhist sages of India and China and Japan and Korea and Thailand see the

shadow as the entanglement the worldling has to be removed from, like a fish caught in a net.

But thinking of Yong-Ik's sense that the shadow is a creative friend, deep in wisdom and knowledge and sensitivity, I was considering an alternate view of things. It was about introspection. About a deeper shadow, the shadow behind the shadow.

As you move on in your life journey, I was thinking, you may eventually discover that *everything you have been trying to do comes to nothing.*

And yet, you may also find that precisely because it is wrong, it is true. Incalculably, the wrong note, the mistake, the wrong move, is what is going to lead to a greater truth than what you had before.

There is a lot of trust involved.

When our story of those months in Oslo came to an end, as stories inevitably must, and I went back to our home in British Columbia, the house nestled in among the trees of the forest, I tried to make life work again. I spent several months rearranging everything and reconfiguring spaces. But eventually I realized I would not be able to clear the air. I had come back distressed and I remained that way.

To try to snap out of the state I was in, I decided to move. I found another house closer to the village, set high on a hill with a view over the ocean inlet, the mountains forested top to bottom with thick, dark green cedars and firs and hemlocks and alders. It was a completely Zen experience to live there. The morning with hazy sunrise, evening with deep red sunset, even the nighttime with blazing stars and moon, were almost unbelievable.

But as if to mirror my own mind, the first summer I was there was also one of the first of what now happens every summer: forest fires break out and ravage the hillsides, mountainsides, valleys, charring the beautiful

trees and emanating smoke you cannot breathe. The world I lived in was suddenly filled with dark beige, almost mauve, smoke that stayed in the air permanently. It was hot but you could not open the window or else the smoke would fill the house, so the heat inside built up. Life could become unlivable.

I watched the flames across the inlet jump and dance in the forest. Every day I kept an eye on the raging phenomenon to which I now had a front-row view. Any day there could be an evacuation order, and people were told to keep a getaway bag ready. A bag with basic necessities, some clothes, personal papers – something you could grab when the alarm sounded to leave. I thought of all the evacuations already underway elsewhere in Canada: people who scrambled to collect their bewildered children; young, strong men who had to carry their aged fathers on their backs; families filling their cars with household things: jugs and jars, clothing and sheets. All the while the flames growled and seared in the background, threatening to move in closer all the time and eventually eating up your own house.

For some reason I began to feel this was not just a fitting scene for my own life at that moment, but that I was witnessing something historic, something that could be depicted in a fresco like Raphael's *Fire in the Borgo,* where there are hundreds of incongruities and everything is unrealistic.

And it is so strange, so strange. We have discovered that life on Earth did not actually come about because the environment for it was perfect. But what is so strange is the discovery that it is life in its many forms – the living things that exist in the terrestrial zone – who create the environment they need to survive in. They create oxygen and channel water, store it and distribute it along with a multitude of microorganisms and fungi, for them to exist and carry on. So without life, there is no environment for living.

You have to wonder which came first: life or the environment that generates life. And even more so, what is life? If life did not emerge from the environment, where did it come from?

When Gautama Buddha was asked this same question, he had poetic answers to give, according to the Pāli Canon.

Life is a dew drop on the tip of a blade of grass at sunrise.

Life is a line drawn with a stick on the surface of water.

Life is a mountain stream rushing downhill.

I had been thinking about the British artist Cornelia Parker, whose ideas reach in so many directions. She likes things that are exploded, burnt, charred, or destroyed, then she puts them back together in some altered form in a gallery.

I was intrigued by her idea that there was a meteor that fell to earth, somewhere in Namibia, I think, and she was trying to get it sent back into space. She involved NASA but could not get funding because she was not American.

She wanted to put a rock from the moon onto Mars, and put another rock from Mars onto the moon. Shift rocks between planets and moons. If it could not be done, at least the artwork is in the telling of the story. Whoever tells the story is exhibiting the conceptual artwork.

On some weird level I enjoyed thinking about those meteorites. I spent a lot of time looking at the moon in Oslo. In the darkness, through the window of the small apartment. If you could send a meteorite back into space from where it came, there would be a sense of justice.

If I could send the alien force that had visited us, interrupted us, if I could send it back to where it came from, I would.

Where I live now, there is a time in spring and early summer when there are white butterflies conspicuously busy in the bushes. They fly among the leaves and branches continuously, zigzagging and making small circles in the air, going from one bush to the other. It does not seem to

matter what kind of bush it is, blackberry or juniper. The white butterfly is testing them all.

When I am out walking, the white butterfly is there, hovering and dancing among the leaves. But it follows me. When I move forward the butterfly comes along. We go side by side for a long time and I begin to wonder, *Is it following me? Are we out walking together? Is it trying to tell me something?*

I think it is called a California White or Spring White. Or Cabbage White. I know there is a lot of folklore about this particular butterfly. They say it has symbolic value, about purity and good fortune. Or else it is a sign there is an angel nearby. In Indigenous traditions it is a sign of transformation. I know a lot of people attribute symbolic value to this butterfly. They think it is a lost one communicating from somewhere else.

It is an enjoyable thought. Most likely an inner projection. But without our small wishes, where would we be? What would the mystery of living be? We cannot deprive ourselves of the sense of awe and magic, even though there is always someone who wants to come and explain it all away. I do not want the explanation. I do not want to have to provide one either. It just is. Beauty just is.

There is also empathy with nature. I have read that one time the fourth-century Chinese Taoist sage Zhuangzi, or Master Zhuang as he is called, one time he was not sure whether he was a butterfly or not.

I have also read that the Japanese teacher Dōgen Kigen, who lived in the thirteenth century and founded the Sōtō school of Japanese Zen Buddhism, was influenced by Daoist writings. Dōgen taught that everything is sentient. He also taught that mountains walk. They do not walk like humans do: they walk like mountains do.

On that score, I have heard many times that trees also walk. They walk, but slowly. Like trees.

Nature preaches, except we cannot hear the sermons. Dōgen advised we should listen with the body first, and only last with the mind. This also needs to happen from a place before all places. Then maybe something will be transmitted.

The American Buddhist Stephanie Kaza has said in her book *The Attentive Heart: Conversations with Trees* that she would be able to hear the tree if she was attentive enough. She sat with the tree and tried to let go of her preconceptions and thoughts and just commune with the tree as it was.

Another American Buddhist, the 'deep ecologist' Gary Snyder, also had conversations with trees. One of his advisers was a cedar tree.

It is not the ears that hear when the call comes. The attentive listener waits in silence and then hears with the heart.

For a long while in our years together, we had as a daily routine to stop the day in the evening before dusk and spend the sunset hour seated side by side on the lower deck of the house, facing west. We could see the sun setting over the waters of the Pacific: at first it was hazy orange, then deeper orange, then pink, then red, then maroon as it came down to ground level. We saw the ball of sun and the light that emanated from it through the trees of the forests down below. The filtered light showed up in occasional bursts of brightness, then it went behind a branch, then it came flashing out again further down.

There were usually birds ducking from branch to branch getting ready for the night. Squirrels running up and down the tree trunks in mad pursuit of something unknown. And butterflies flitting from leaf to leaf.

One time a butterfly was flying between the trees and its transparent wings caught the red light of the setting sun as it flashed between tree limbs. The wings of the butterfly suddenly took on a light of their own, shining like angels' wings glowing from within. Just for a moment. Then it was gone.

Pico Iyer tells of a certain question the Dalai Lama is invariably asked when there are questions from the audience after an event: *When something you wished for or dreamed would happen does not and you are disappointed, how do you deal with the disappointment?*

The answer will always be: *Wrong dream.* Whatever happens or does not happen is neither good nor bad, not fortunate or unfortunate. It is you who have created all kinds of wishful desires in your imagination. When you have wishes that do not happen, you are simply not attuned to reality. Reality has nothing to do with your dreams. Better not be attached to those dreams because you will always be disappointed.

Like so much else in the Buddhist world, those are harsh words when the thing you wish for is life itself and it is for someone else. But even that will not be able to obey your demands. You cannot demand anything of reality. How things come to be and why they occur is not even something you can fully know.

Wrong dream. Toward the end of those days in Oslo I was having such wrong dreams, they had become nightmares. When the city lights were down and the firmament was entirely black like a sheet of black velvet and all the traffic was gone, not even a tram could be heard. I attempted to sleep in the strange bed in our apartment. The bed was too big for the room and you could only get out of bed on either side because the foot of the bed touched the opposite wall.

I dreamed that it had become necessary for me to do whatever anyone asked me to do, and quickly. I had to be at everyone's beck and call: not to obey the orders of just one or two people, but of everyone. I was not allowed to speak, but if I spoke I was before a jury and judge who were sitting passively and judging what I said. The judgment was going to be negative. It was always negative.

In my dream I had no idea how to be alive under these circumstances. Or how to get out of such abject servitude and perpetual, permanent

conviction. When I woke up again, I did not feel rested. I felt exhausted and the day had not even begun. I looked at the white painted ceiling in the early dawn light. I tried to think, to remember, where this nightmare had come from. I could not see its origin, but it came from somewhere. The dream had stopped and the day started, but the feeling of despair over something I did not recognize or know never went away.

Suddenly I seemed to be in a story by Franz Kafka. Except the story could never end and I was in it.

PART TWENTY-THREE

We lived in two places for over a decade and a half, one home in Norway and the other in Canada; we were settled in the way we divided our time between continents and we each had our own pursuits in both places. But now, in this small rental apartment in Oslo, we had become entirely nomadic.

Nomadic especially because we were now just going between this apartment and the hospital in Ullevål. That hospital was once a municipal hospital but eventually became the Oslo University Hospital, and it was a teaching and training hospital, with a helipad on top of the parking garage. To me it was a most confusingly large place, and every time we came back it seemed like a different place.

As time went by, his dwelling places became smaller and smaller, until he lived in just a room. We could have seen this as a shrinking environment, as a closing in of everything, but somehow we did not. There is a branch of knowledge described as an 'ontology of dwelling,' which looks at how we think of 'dwelling' in the first place. Your dwelling is not your home or your house and garden or your estate or farm. If you pull back further, you see your dwelling is actually Earth, Planet Earth. And more importantly, your dwelling is, beyond that, the universe.

We are always dwelling in the universe, which is where we belong. Seen in that light, whether your home is large or small makes no difference. Whatever the case may be, your dwelling is always enormous.

He spent a few weeks in a palliative care facility, before he was confined to his bed. We went for walks in the hallways and he exercised on the way. The place was quite homey and he was comfortable there. During his stay there his birthday came up and he had permission to borrow the dining lounge for private use. We, his immediate family members,

told him he could order whatever he wanted for his birthday and we would deliver on it.

He wanted to cater a dinner for myself, his son, daughter, and son-in-law. It should be a fancy dinner, even though he himself could not eat. He would watch us eat. Then he wanted a performance from each of us. We were to present whatever we wanted, just something we were able to do. So we prepared our performances. His daughter gave a speech, his son played the guitar and sang one of his songs, his son-in-law gave a formal speech, and I read a poem. We worked on these performances for days beforehand, as if we were to present before King Olav at the Operahuset, or the Oslo Opera House.

We each had our turn to perform, and I was nervous. We stood up at the table and delivered our recital while he sat at the head of the table like Pope Julius, the catered spiced meatballs and red cabbage and parsley-and-lemon-coated small potatoes in dishes on the white tablecloth, his elbows leaning on the armrests of the decoratively carved wooden chair, a scarlet blanket covering his shoulders, and his face in sad and silent contemplation as we worked our hardest to make him happy.

Of all the different realms we might find ourselves living in – and there are six of them, according to Pāli scriptures – we are in a favourable one. We could be in a god realm, or an animal or ghost realm, and we could even be in a hell realm of some sort. But we are in a human realm, and we are the only ones who can achieve a 'spacious mind' that is able to see the very big picture and feel blessed by it. Some call this kind of mind 'Nirvana,' but as soon as you apply such terms you have lost the meaning again. The core of this thinking, as I have gathered, is simply that to be a human being is to be in a good space.

It is hard not to think of traditional anthropocentric views that have been held by Christianity over the ages and see the similarity. But we can start to shrink our minds that way and forget that everything in the Buddhist universe is connected. They call it 'dependent arising,' which

simply means that the world is a network of connections that cannot stand alone. If one strand breaks, it all breaks.

The way the stories go, when the Buddha was alive he received expressions of devotion from trees and cobras and birds and bulls as well as people. He offered teachings to a parrot and an elephant. All were in the same network and he knew it.

Not only Buddhists speculate there is a 'ghost realm.' The idea of ghosts can be found in every culture. Maybe the naturalness of the idea of ghosts is very simple. Thoreau, for example, in observing the mist rise from the pond in the morning, said 'the mists, like ghosts, were stealthily withdrawing in every direction into the woods, as at the breaking up of some nocturnal conventicle.'

It was only incidentally, and more recently, that I took up the book *On Time and Water* by Andri Snær Magnason. I was looking for books to put on a reading list for a course in environmentalist literature I was teaching at the University of Iceland, and this book seemed close to home and useful. However, as with most discussions of the destruction of the environment in Iceland, I soon felt acute emotional pain.

Magnason talks about the building of the Kárahnjúkar dam, wherein fifty square kilometres of pristine landscape were flooded to create a dam that would make electricity far in excess of what was needed by the country. I recalled that at the time the engineers of the dam asked my father, who was a geophysicist as well as a mathematician and engineer, to come and assess the project. He went to Iceland, toured the place, met with the engineers, and discussed the project.

They asked him to stay and help build the thing. He said no and came back home. I asked him how his trip went. He told me they wanted him to help build the dam. I asked if he was going to. He looked me straight in the face and said with a sadness I had not heard from him

before, 'No.' He would not touch it. Now, so much later, what I remember best is the horror I saw in his eyes.

It is Magnason who wrote that some things are too difficult to write about. You cannot write about certain things directly any more than you can stare directly at the sun. We can comprehend the smaller tragedies, the personal disasters and mistakes. But when it comes to the whole world, our minds are not equipped to grasp what we are talking about. If that is the case, then how do we talk about big things like the environment of the whole earth?

Magnason writes that you can only write about a difficult subject obliquely. In fact, he says, 'I need to write about things by *not* writing about them.'

The same thing goes for the subject of dying. How do you write about such a thing? All we experience is a kind of disappearance. We experience a sense of loss. But we are not looking at the real subject. Perhaps that is not possible.

I was reminded of something Jacques Derrida said: that experience, when we try to remember it, can only be a ruin. Experience itself is a ruin even while it is being lived.

That book by Magnason had a little unexpected gift in it, and I noticed it only while I was writing these words about our experience in Oslo.

One time, rather long ago, I read the autobiography of the Dalai Lama, *Freedom in Exile*. It was a long book, several hundred pages long, but once I started reading it one afternoon, I could not stop. I read all night long and into the morning. It was the story of a most extraordinary life – by any standards, a life that covers vast ranges of time and change. A little bit like the incredible story of the Last Emperor of China.

After reading, I was propelled to write a letter to the Dalai Lama and say this was the most incredible book I had ever read. I addressed

it with the name and the town and the country, but had no specific address. In spite of that, the letter was received and I got a reply, written by his assistant.

I said in my letter that since Tibet is 'the Land of Snows,' then Tibet and Iceland had something in common because before it was named 'Iceland' in the Viking era, my country briefly had the name 'Snæland,' which also is 'the Land of Snows.' His Holiness said in return that 'Iceland and Tibet have a lot in common.'

When Magnason interviewed His Holiness, who came to visit Iceland in 2009, the Dalai Lama said to him: Iceland and Tibet have a lot in common because they are both the land of snows.

This felt like an event of synchronicity. When accidental things happen at strangely appropriate times.

I am told we should be watchful of synchronous events. They happen for a reason.

Synchronicities were studied by the Swiss psychiatrist Carl Gustav Jung. Breaking down this phenomenon, there appear to be at least five or six types of synchronicity you can experience. There is a warning or *alert synchronicity*, where what you are experiencing or seeing is dangerous but is keeping something even worse from happening later. There is a type of *confirmation synchronicity*, where you seem to get signs that assure you what you are doing is the right thing. There are *prophetic synchronicities* as well, where you may encounter something that seems like a signal about the future. Then there are also *manifestation synchronicities*, where what you wish for or are thinking about a lot appears before you in real life. And then there are *opportunity synchronicities*, which act like a door to something you could do or be, or somehow an opportunity opens up that you were previously unaware of.

I do not know the intricacies of these things. But most people I have talked to on this subject say even though they do not understand it, things have happened to them that seem too meaningful to have been just 'chance.' But then, chance itself is not really chaos or random.

I often thought about these impossible things. Perhaps I was trying to find meaning in what we were going through. I do not know why we need to have meaning all the time. Maybe meaning is like salvation. Later I read in a book of literary criticism about the work of the Italian writer Claudio Magris that the only salvation we need is salvation from salvation.

In the Buddha's third sermon to the monks, the Fire Sermon, the Buddha declares, '*Everything, O monks, is on fire.*'

There is a 'blazing mass of suffering.' This bonfire, he said, will only be extinguished when we stop feeding it the fuel it needs.

All that burning is really the fire of hatred, he said. And delusion. Delusion is when you do not see the world as it is. You only see it as you imagine it to be.

To extinguish that kind of burning, it is necessary to remove hatred from your mind. And it is necessary to practice seeing things as they are.

In another context, fire can also be seen as sacred. Sometimes I wondered how to interpret this dichotomy. Does it mean that suffering is also sacred? Does it mean that what he was going through, he who was sick and had so little time, that his unhappiness and pain was really a sacred experience?

In fact, so certain was Gautama Buddha that suffering is a major part of living that he told the thirty monks who were listening to him that there is more water in the tears you shed in all your lifetimes than there is in all the oceans of the world.

His final weeks were spent in a palliative care facility in Grefsen in Oslo. It was called Lillohjemmet, on Kapellveien. A nondescript whitewashed building with a long hallway and large private rooms. There was a cafeteria and a family meeting room and a nurses' station. I did not like the place but I went there every day. The room they gave him was barren and nondescript, rather institutional, so I tried to liven it up for him. I put one of the paintings I had created on the floor at home up on the chest of drawers where he could see it.

He felt safe there so he was content with it. He got to see his grown children often and the people who worked there were kind. I often took walks in the neighbourhood when he was visiting with his children.

But even though he was content with the place, for me it was a lonely, sad, pale white building in an empty neighbourhood. There were homes there along the street, but I never saw any people around. No one walking or in the garden or coming and going. There was a bit of a fence, the windows were shuttered to the outside, and there was no life around the building, which sat there on the hillside flat and squat. A road sign here and there, a car parked on the street, a street light operating for no apparent reason.

When he was at this facility he was already quite ill and he slept a lot. We took turns sitting with him, but I was there most of the time each day. There was a lot of downtime when he was asleep, and during those times I rested my mind, closed my eyes, or looked out the window at the garden. The yard in the back was a barren, unappealing place since it was February and there was snow on the ground, trees were barren, and the place was not attended to. The garden was fenced off with high wooden walls, and the dreary aspect of it was unfortunate. I thought of how in Iran, people have walled-off courtyard gardens they tend carefully to make them so beautiful they will remind you of the Paradise to come. It is 'a world in love.'

As I was observing the formation of clouds and the occasional falling of snow, I saw there was a pair of magpies starting to build a

nest immediately outside, under the building overhang. As the days wore on, I watched them build, slowly and methodically. The female stayed on the site and put sticks and objects into place around a mud cup they had made, while the male went off all the time, finding twigs and sticks and bringing them back.

This went on in a diligent way every day. I began to think there was some symbolic relevance to this sight. That they were building a big, bulky nest, taking their time, and doing it right in front of us for a reason. Maybe to show us that life goes on. I started to attach a great deal of significance to those large black-and-white birds. They were telling us things. Nature was talking.

Later I thought about the eggs in the nest, the pale blue, speckled eggs, and how they would hatch. Baby magpies would appear and after a month they would leave the nest and sit on a branch nearby.

Magpies mate for life, I had read, and they socialize in pairs with other magpies. Sometimes the offspring stay with the parents for a long time too, and they help them build next year's nest. But eventually they will go.

In Buddhism it is said that you are never really free until you leave the place you came from. When we stay in our place of origin, we are in a bubble that we mistake for the ocean.

If you have to remain in one place, you can try to cultivate what Tibetans call 'a spacious mind.' If you are able to, wander away, go, and roam free as a deer the way many Buddhist adepts do. It is also said that when you leave the conditions of your birth, you will not be alone. Others will be there: fellow travellers you did not know before.

'Life gone forth,' said the Buddha, 'is wide open,' while household life is 'crowded and dusty.' You cannot avoid 'household life' but you know it is difficult. If you want to light a fire and the sticks you are using are wet,

there will be no sparks. Conditions for clarity of thought have to be created; they do not happen on their own. The fire sticks have to be dried. The metaphors in the Pāli Canon are old and by now overused, yet they continue to resonate.

Sometimes you need to remove yourself from the hassle of daily life to clear your mind. In a way, our present situation was in itself a removal from daily life. For us, daily life as we knew it had ceased. But this was a 'retreat' no one expected. It was not a retreat anyone wanted. It was the darkest of days and in its closedness it was also 'wide open.' I had the strange impression in those final days that it was he who was being allowed to wander forth, as the Buddha said. The rest of us would have to stay behind in the dusty world.

PART TWENTY-FOUR

One time we were all three there and his condition had deteriorated so much that we were getting ready for the end. We were at his bedside hour after hour, eight hours, ten hours. He seemed to be asleep but we could not be sure. After so many hours keeping vigil, I said I would take a short walk. I grabbed my coat and went outside, so glad to feel the fresh, cold air.

I walked in a different direction from my usual route: up Kapellveien, then up Kirkegårdsbakken and further along Glads Vei. Suddenly I found myself at a gate to a green space I had never seen. I peered through the grille and saw it was a cemetery, the Grefsen Kirkegård. I did not know it was there. I stepped through the gate, went inside, and stopped to view the scene, but my eyes were fixed on one spot for some reason, over to the northwest. Then I turned and went back to the care home, where I found the children, although they were adults already, in a bit of a commotion because they had been alone.

But I was unusually calm. I had a strange feeling when I was out walking that, even though he was asleep in this building, he had come out for a walk with me. This impression became much stronger after he had been designated a burial place, which is decided by the state, and the family has no say in it. We were told he would be placed in that very spot my eyes had fixated on.

Even though I had that strong impression that I was not alone on what was my final walk while he was alive, because he died about an hour after I got back, I did not know how such a thing could be possible. How you could somehow leave your body and come along for a journey and then return.

But later I learned something peculiar about the belief system in Tibet, which has a story in it about what they call the 'wandering soul.' It is said the wandering soul can leave a body and share itself with another's soul for a while. When the soul is wandering, though, it is very vulnerable, so it stays with another where it can be safe.

I began to think I was that other who provided the safe haven for him to come with me. There was no other effective explanation.

I knew it was true, even without any special teaching about it, that if there is the slightest hint of life in a person, that person has within him, at every single moment, three thousand realms of existence and experience.

He seemed to know everything. He was suddenly communicative and awake. It was as if Thomas Merton had been writing of him when he wrote of the smiling Buddhas of Sri Lanka, as Pico Iyer pointed out, that they were 'filled with every possibility, questioning nothing, knowing everything, rejecting nothing.'

He looked me in the eye and said his final words. Then he left us. He just left us. We were alone and abandoned in a dark and empty room.

He left to live the life of a holy man among the trees in the forest.

In the temple a bell was rung, and somewhere else a gong boomed.

I know it is true, in the larger sense true, that we have rights, but not when they infringe on the rights of another. In this case, as I sat by his bed not knowing whether he was awake or now asleep or even unconscious but still breathing erratically: it is his right to go. If someone wants to go, you do not have a right to force him to stay. You do not have the right to try to keep him.

When you let go, it is possible you will have a frightening sense of being abandoned in space. You are floating without direction and the bond that kept you tethered to your world has now been severed.

Then it is good to think that we need to open the curtain that stands between us and the universe, but to open the curtain we need to conquer the fear of death, and when we open the curtain we will be able to see with our own eyes the most beautiful and maybe the only universe.

I read about Buddhism in the West, which is an altered way of thinking from the ancient Eastern traditions. Because it is a different world now. Although some things remain the same no matter what age you are in. Birth and death are still the same. To get past this, they say we must be 'dead to death.'

Maybe Western Buddhism has more Western psychologies in it. Maybe it is influenced by Christianity. There is probably more gender equity and fewer hierarchies than in the East. There is also probably more focus on meditation and on retreats. So scholars have suggested. But I am not sure they are right. Although Jetsunma Tenzin Palmo fought for the rights of women in Tibetan Buddhism for a long time. She has said that gender inequity in Buddhism is very strong and unfair.

Already back in the 1860s, Thoreau said that the 'retreat' has been commodified. The retreat is a product bought and sold: an idea, a dream. Then, I wonder, what is a real retreat? Is there even such a thing? I often think, no matter where you are or what you are doing, for however long, this is still your life. You cannot retreat from your life until the end of it.

The Norwegian painter Olav Christopher Jenssen said that he likes to stop working on a painting just before it is finished. 'I want to stop the painting just before it becomes perfect,' he said. Now I wonder: Does life do the same thing? Take us just before we become perfect?

At what point can you say what the fully realized person in the Buddhist world can say, the one who says he or she has laid down the burden and has 'done what had to be done'?

When can you say something is finished? Or something has ended? Maybe there is no such thing as an end; there is only mutation. Change. Metamorphosis.

Ed Ruscha, who is a typesetter and printer-bookmaker as well as a painter, has a sign in his studio. It is a big sign on the far side, hanging from the ceiling. You notice it as soon as you walk in: old-fashioned in design, oval in shape, two words in big letters that say 'The End.'

It is always the end. It was the end already at the beginning; as we entered, the end was present. It was permanent and continuous, there all the time whether we chose to look at it or not: The End.

Yet the end is always wrong. Things never turn out the way you want them to.

Thoreau said that time is just the stream he goes fishing in. The stream is the surface of things, and when you look deeper, you see the bottom. Time is rushing by fast but eternity remains.

He also said, 'To be awake is to be alive.' But hardly anyone is truly 'awake' in that sense: 'I have never yet met a man who was quite awake,' he said. The insinuation is that being *alive* is very hard and can be accomplished by few people. Living requires great focus – it requires 'an infinite expectation of the dawn.'

Many years later it occurred to me to look at the file of pictures from that time. I took photos in passing back then, but with a bit of trepidation. Now I was surprised to find how poor the photos were. They were dark,

so dark you could almost not see the outline of his face. They were blurry, so it was unclear where they were taken. Just a black background with a number of spots of light that I was unable to identify.

It was as if his image refused to be visible. His image was fading the same way he was. It occurred to me this was the best way to photograph things at the time. With 'nonphotography,' where what you see is completely unclear. Yet you have a memory of the moment somewhere – a tinge, a flavour. A small sound in the distance. It is like trying to see through the windshield of a car saturated with rain. The image on the other side of the glass is always disappearing, fading into the watery distance.

But in the back of my mind was a thought that came from the English writer and philosopher John Ruskin about the purpose of something like photography, which he apparently disliked, according to Jacques Rancière, because photography is unable to 'condemn itself.' The photo is always positivistic, perhaps.

It may not be possible to achieve success in any ultimate sense with photography, which can depict only one moment of time among an endless number of moments. Photographs need to be seen as a whole, all of them together as one picture – all photographs everywhere. What Ruskin also said was: 'Not with the skill of an hour, nor of a life, nor of a century, but with the help of numberless souls, a beautiful thing must be done.'

It is often said that we are inundated with images at this point in history. We see too many pictures. Perfect and seductive photographs are shoved at us every day, all the time, in the digital worlds we inhabit. But imperfect and dilapidated images are also in our faces all the time, except they are transgressed pictures that are edited, remixed, and used for purposes other than what they were intended for in the first place. We have, in fact, a tumultuous relationship to images: They frighten us, move us, manipulate us. Take us away. Remove us.

So I do not like looking at old photographs. They are full of ghosts that have lost their anchor.

In the story of loss and grief that accompanied our life together, what I did not know during those months in Oslo and could not possibly know, and what no one knows, is that it would take another twelve years before the actual grief set in. I came out of our unfortunate story still functioning well even though I was sad. I went on with things, carried old projects forward, made some changes, moved to a new house, took up the practice of writing again.

But my writing projects were like a malfunctioning vehicle that kept breaking down. Stories ended before they even began. Poems panicked and went in circles madly like the fish off the coast of Florida suffering from some new and unknown disease. My art projects were seeping out like the air from a tire held in by a rusty nail that would soon fall out and the tire would go flat.

I did not realize what it was until it happened. Like a slow leak in the roof of your house because some of the shingles have moved in a storm that came and went a long time ago. The water from the rains that were always falling in torrents gathered under the roof shingles and slowly trickled down the long chimney of the wood-burning stove inside. There were puddles on the stove and rust was gathering. One day the roof would give in. You who are inside are not aware of how compromised the roof and the ceiling of your house actually are.

Then one morning it just happens. It caves in. It comes down like the Twin Towers in New York, imploding on themselves from the impact of something that arrived from far away.

But there is another side to being what they call the 'survivor' that I realized only much later. When you accompany someone on his last journey in life, there is an end to it. In the end he goes away and you

remain. You do not know where he has gone, but you know you will never meet again.

The story is over, but it is not over for you. The experience you went through has changed you and you are a stranger to the new person you now have become. You go back to your life, but it is someone else's life. In a strange way, you are now an imposter and you are impersonating your former self.

Strangely, I felt like an alien who had to learn the ways of humans from scratch. My decisions were strange; my thoughts were not connected to the world of others. My emotions were flying like a murder of crows from one landscape to another.

Even though the details are not clear, you know that *something has happened*. There is a 'before' and an 'after.'

I was reminded of two separate portraits of Pope Clement VI painted by Sebastiano del Piombo I. Before and after portraits. In the first, painted with oil on canvas in 1526, the pope sits in his armchair wearing a white dress and scarlet cloak with a scarlet hat covering his hair. He has a look of arrogant serenity, as if nothing and no one can touch him. The buttons on the front of his cloak are lined up like soldier ants to fight on his behalf. His hand is grasping the armrest in secure confidence.

The second portrait, painted five years later with oil on slate this time, shows the same pope who is now different. He still has his white dress, red cloak and hat, and the armchair is still there. But his hands are hanging loose over the armrest, not clutching anything, as if listless and unsure. His face is deep in distressed, introspective thought, his eyes fixed on some hazy distance. He has grown a voluminous beard, which was said to be a symbol for loss or penitence.

What happened in the meantime was what is known as the Sack of Rome in 1527. The city walls could not be defended from the imperial army that laid siege to the city. Pope Clement fled into hiding in the Castel Sant'Angelo, but the churches, monasteries, and palaces were being pillaged and trashed everywhere around him. The Sack of Rome

was considered divine punishment for the excess worldliness of the Church. Excess arrogance and excessive greed.

Since the story was not over for me and I had to continue living my life, I took solace in books. I read one book after another, and when I finished a book I almost panicked if I did not have another volume on hand to start reading right away. Days and weeks were spent in a reading chair, holding a book before my eyes.

I felt like a young Nahshon: someone who has just come from wandering in the wilderness, the first one, the only one, to wade into the Red Sea when it would not part. The one who walked into the water until it came up to the middle of his face, until he could no longer breathe.

I do not know what happened. It was as if the seas parted, the air came back to my lungs, people rushed from one side to the other and went on, but I did not. I was outside the weight of history suddenly. Alone, reading a book.

There seemed to be one question that came out of everything we had experienced together: How should one live? You have a life given to you – how should it be lived?

In the Pāli Canon it is said people asked Gautama Buddha this same question because their concern was the same. How do we live our lives? Gautama had very detailed answers to give.

Instead of a high bed, lay a simple mat on the floor to sleep on. Instead of scurrying for food all the time, eat only one meal a day. Anything that is alive, help it to stay alive. Respect the integrity of others – their lives, their worlds, their things. Say only what you know is true, otherwise keep silent.

As to the nature of life itself, the Buddhist Canon simply asserts that life is, from beginning to end, a crossing of the flood.

Crossing the flood.

The Buddha also said that the most important thing in life and the highest goal in life – more important than giving to charity 84,000 bowls of gold filled with silver, or 84,000 bowls of silver filled with gold – more important than any good or charitable deed is to develop a mind of loving-kindness.

How to develop a mind of loving-kindness is what the Buddha's instructions are all about. It is a matter of refinement. To possess loving-kindness, you first need to accept things as they are. You need to be able to see clearly.

There is a simile for this in the Buddhist Canon and it is the simile of a bowl of water. A bowl of water when it is clear is like a mirror and in it you can see yourself the way you really are. But if the bowl of water is mixed with dye – red, yellow, blue, or any other colour – it is not possible to see your image clearly.

The dye could be lingering feelings of ill will. The same is true if the water in the bowl is boiling and bubbling. You cannot see your image there either, and the heat that made the water boil could be harsh feelings that overwhelm you.

If the bowl of water is covered with water plants and algae, you cannot see your image at all. That is a simile for how restlessness and remorse are obstructing your vision of what is true. Also, if your mind is full of doubt, the bowl of water will be whipped up by the wind and it will be churning and swirling. Also, if the bowl of water is muddy and dark, you will not be able to see at all.

Doubt, remorse, restlessness, ill will, harsh feelings, all make you blind.

*

There is another simile for the process of getting rid of harsh thoughts. Imagine you have a bowl with gold in it. But the gold has many impurities, like sand, earth, gravel, and grit from the ground where it was found.

The dirt and gravel in the gold are your bad conduct, which prevents you from seeing your way clearly. So you wash the gold, but many impurities still remain. You wash it again, and it is not yet clear. You give it another wash, and again and again, until the gold is free of dirt and gravel.

It is not just anything you are washing. What you are cleaning is gold. Gold is a symbol of the divine all over the world. In Buddhist thought, that gold is your mind.

PART TWENTY-FIVE

Franco Berardi talks about our time in history in a way that made sense to me after all was said and done, and made me feel that there was more going on than simply personal grief and recovery of mind after a difficult experience. I was not alone, after all.

Berardi says we are not really living in a state of capitalism. What we have is semiocapitalism. A semiotic capitalism. He calls our time an era of semiocapitalist transformation.

The material of semiocapitalism is subjectivity. This is subjective capitalism, which runs on the production, consumption, and exhaustion of subjectivity. Everyone is exhausted.

There is, somehow, an acceleration in nervous stimulation all around. This overstimulation produces panic. There is a rupture between the subject and reality; we lose the desire to be in contact with reality at all. This condition produces depression.

We live in what Berardi calls a 'third dimension of the unconscious,' which amounts to a third psychosphere. In fact, he makes a point of saying we are all forced to be witnesses to the destruction of the future.

I felt these were not simply intellectual arguments that could be ignored as life went on. There was something recognizable here. It was not just my own future that was blown up like a bomb that falls on a city and levels buildings and leaves rubble all over the streets. Not simply my own personal problem.

This grief is everyone's problem now.

It was something I read in a Turkish poem somewhere, what they say about the dead:

> *some become stars in the sky*
> *some become sparkles in the sea*
>
> *and some become the invisible people of the wise.*

In the temple a bell was rung, and somewhere else a gong boomed.

It was true. What Francis Fernández Carvajal said in *Conversations with God*:

> *We have so little time to love.*

One evening in our small apartment in Oslo we had ended the day and put away the book and laptop and glass and he had gone to bed since he was very tired. But for some reason, he lost consciousness. I tried to wake him but he stayed asleep. Eventually, after calling his brother and trying what I could, I called for an ambulance. I dressed and we waited for the ambulance to arrive, but it did not come for another four hours. During that time he just lay there and I waited. When the ambulance finally came, they collected him in a stretcher and we went to the University Hospital where they installed him in a private room, put in an IV, and made him comfortable. By this time he was somewhat revived but needed to sleep.

I needed to go home but it was 2 a.m. I went down the complicated stairway, almost getting lost two times, and ended up at the front door. There was no one in the lobby and the place was for some reason

emptied of people. I stepped outside. It was dark and snowing heavily and as deserted as the moon. There was no one to be seen and no cars driving through. I had no cellphone and no car and suddenly realized I had no way of getting home. There were no buses and I could not get back inside because the front door locked behind me. At least I had furry winter boots and a long winter coat with a furry hood, so I was not cold. I looked around. The streets were deserted. There was no car parked anywhere. It was pitch dark with only one street light that I could see.

Snow was falling thick and heavy from a starless night sky. The flakes came down velvety and large and stuck to any surface they touched. Everything was dead quiet and it felt like the scene of an abandoned city after a nuclear attack.

It would be a long walk if I tried to walk home. I was caught outside in my winter coat and boots with velvety snow all over me. In the single street light the colour of the falling flakes turned brown and orange, and where the light caught individual snow crystals, small explosions of light glinted. When that happened the air under the street light suddenly seemed bathed in diamonds. I watched them glint in the night and I pondered my predicament. I had no idea how to get home.

It was always a mystery to me what it is to believe in rebirth. It is possible that the idea of rebirth has something to do with a reality that is observable. Anyone who has witnessed the death of a living being knows about this. All the *pietàs* that have ever been created – sculptures, drawings, paintings – are about this one observation, which is that when someone dies, they are also lighter and a little smaller. Some weight is lifted from them; some substance is gone. It is sometimes slight, but sometimes very evident: this body is lighter and smaller than it was before. That substance that made it heavy, where did it go?

When you come back, you will come back in the rain. The form in which you return will be the rain.

I thought of this later, much later. There were days on end with heavy rain on the West Coast of Canada. The rainforest has its name from the incessant downpours. Even though in later years the summers have been dry and the forests have caught fire, there is still a deluge of rain in the colder months.

And when it is very cold, the rain becomes snow. The white snow falls gently on a silent world and covers everything. That is when I think those who are returning are able to stay awhile on the ground and in the tree branches. They linger awhile. They enjoy the fresh, cold air and the quiet of the snow-white world.

In what ought to be an epilogue to all these musings and remembrances, time itself allows one to step back and survey the entire landscape as if one were in a balloon hovering and gliding over the hills and valleys of one's own life.

In another serendipitous incident, and there are many such in the course of a lifetime – incidents where you accidentally come upon the very thing you needed to find just when you needed it – I was looking for a way to learn more about Chinese brush painting in a stubborn refusal to accept that I was not good at it. I wanted to learn the techniques.

One day I agreed to staff the front desk of the gallery of our artists' guild, and I found there was a book auction going on in the backroom. I wandered in and immediately saw a book titled *Chinese Painting in Four Seasons*. I took this book home and in it I found a poem by the fifth-century poet Bao Linghui, who lived during the Liu Song Dynasty. The poem is called 'The Call of Spring' and the theme is that after cold winter, there is bound to be spring.

> *The blossoms are open*
> *On the cassia tree*
> *And the orchid has unfolded*
> *Its first green leaves.*

In vain the happy wind of Spring
Will laugh,
If you do not keep your promise
To return.

BIBLIOGRAPHY

Abrahms-Kavunenko, Saskia. *Enlightenment and the Gasping City: Mongolian Buddhism at a Time of Environmental Disarray.* Ithaca, NY: Cornell University Press, 2019.

Agamben, Giorgio. *Studiolo.* Trans. Alberto Toscano. Calcutta: Seagull Books, 2022.

Baldinger, Tizian and Timon R. Böse with N.N. *Everything For Art: How to be a Successful Artist.* Trans. Ruth Butterfield. Berlin: Timon R. Böse Onlineverlag, 2021.

Beck, Ulrich. *World at Risk.* Trans. Ciaran Cronin. Cambridge: Polity Press, 2009.

Birus, Hendrik. 'Adorno's "Negative Aesthetics"?' In *Languages of the Unsayable: The Play of Negativity in Literature and Literary Theory,* ed. Sanford Budick and Wolfgang Iser. Stanford: Stanford University Press, 1987 (140–165).

Capper, Daniel. *Roaming Free Like a Deer: Buddhism and the Natural World.* Ithaca, NY: Cornell University Press, 2022.

Cavell, Stanley. 'Naughty Orators: Negation of Voice in *Gaslight.*' In *Languages of the Unsayable: The Play of Negativity in Literature and Literary Theory,* ed. Sanford Budick and Wolfgang Iser. Stanford: Stanford University Press, 1987 (340–377).

Cole, Teju. *Open City.* New York: Random House, 2011.

Culler, Jonathan. 'On the Negativity of Modern Poetry: Friedrich, Baudelaire, and the Critical Tradition.' In *Languages of the Unsayable: The Play of Negativity in Literature and Literary Theory,* ed. Sanford Budick and Wolfgang Iser. Stanford: Stanford University Press, 1987 (189–200).

Derrida, Jacques. 'How to Avoid Speaking: Denials.' In *Languages of the Unsayable: The Play of Negativity in Literature and Literary Theory,* ed. Sanford Budick and Wolfgang Iser. Stanford: Stanford University Press, 1987 (3–70).

Derrida, Jacques. *Memoirs of the Blind: The Self-Portrait and Other Ruins.* Trans. Pascale-Anne Brault and Michael Naas. Chicago: University of Chicago Press, 1993.

Gombrich, Richard. 'The Buddha's Thought.' *Revue Internationale de philosophy,* 2010. Vol. 64, No. 253 (3). Buddhist Philosophy (2010), pp. 315–339.

Grimms' Fairy Tales. 'The Golden Bird.' https://www.grimmstories.com/ grimm-fairy-tales/the-golden-bird. 2024-08-29.

Haider, Arwa. 'In *The Fraud,* Zadie Smith Takes Her Beloved London Back in Time.' *Montecristo:* Autumn 2023 (49–51).

Haraway, Donna. *Staying With the Trouble: Making Kin in the Cthulucene.* Durham, North Carolina: Duke University Press, 2016.

In the Buddha's Words: An Anthology of Discourses from the Pāli Canon (Teachings of the Buddha). Edited and introduced by Bhikku Bodhi. Somerville, MA: Wisdom Publications, 2005.

Iyer, Pico. *The Half Known Life: In Search of Paradise.* New York: Riverhead Books, 2023.

Laba, Nick. 'Truck Loads of Oranges Dumped at North Vancouver Waste Centre.' North Vancouver: *North Shore News,* Dec. 9, 2023.

Le Guin, Ursula. *The Carrier Bag Theory of Fiction.* Ill. Lee But, introduction by Donna Haraway. London: Cosmogenesis, 2024.

Lewis, Sara E. *Spacious Minds: Trauma and Resilience in Tibetan Buddhism.* Ithaca, NY: Cornell University Press, 2019.

Magnason, Andri Snær. *On Time and Water.* Trans. Lytton Smith. Windsor, Ontario: Biblioasis, 2021.

Maté, Gabor, and Daniel Maté. *The Myth of Normal: Trauma, Illness and Healing in a Toxic Culture.* Toronto, Canada: Knopf Canada, 2022.

Modiano, Patrick. *Paris Nocturne.* Trans. Phoebe Weston-Evans. London: Yale University Press, 2015.

Rancière, Jacques. *Aisthesis: Scenes from the Aesthetic Regime of Art.* Trans. Zakir Paul. London: Verso, 2013.

Ross, Andrew. *Real Love: In Pursuit of Cultural Justice.* New York: New York University Press, 1998.

Šarotar, Dušan. *Panorama.* London: Peter Owen Publishers, 2014.

Steyerl, Hito. 'In Defense of the Poor Image.' *e-flux journal* # 10, November 2009 (NP).

Wetering, Janwillem van de. *The Empty Mirror: Experiences in a Japanese Zen Monastery*. New York: Ballantine Books, 1987.

White, Curtis. *Transcendent: Art and Dharma in a Time of Collapse*. New York: Melville House, 2023.

White Jr., Lynn. 'The Historical Roots of Our Ecologic Crisis.' In *The Ecocriticism Reader: Landmarks in Literary Ecology*, ed. Cheryll Glotfelty and Harold Fromm. Athens, Georgia: University of Georgia Press, 1996 (3–14).

Whitman, Walt. *Leaves of Grass*. Ill. Wharton Esherick. Rye Brook, NY: Peter Pauper Press, 2023.

Kristjana Gunnars was born in Iceland and has lived in Canada since 1969. She served as Professor of English and Film Studies at the University of Alberta, and as Guest Professor at the University of Trier in Germany and the University of Iceland. She lived on the Sunshine Coast of B.C. for twenty years while pursuing a career in the arts (painting), as well as writing. She is the author of numerous books (see websites kristjanagunnars.com and kristjanagunnarswritings.com for details). Her latest books are *The Scent of Light* (Coach House Books, Toronto) and *Ruins of the Heart* (Angelico, New York). She has published a number of chapbooks, the latest being *112th Street Notebook* (akinoga, Baltimore) and *At Home in the Mountains* (Junction, Toronto). Her work has appeared in numerous anthologies and journals in Canada, the U.S., and Europe.

Typeset in Arno and Domaine Sans.

Printed at the Coach House on bpNichol Lane in Toronto, Ontario, on FSC-certified Sustana recycled paper, which was manufactured in Saint-Jérôme, Quebec. This book was printed with vegetable-based ink on a 1973 Heidelberg KORD offset litho press. Its pages were folded on a Baumfolder, gathered by hand, bound on a Sulby Auto-Minabinda, and trimmed on a Polar single-knife cutter.

Coach House Books is situated on occupied land, which is the traditional territory of several Indigenous nations, including the Mississaugas of the Credit (an Anishnabek people), the Haudenosaunee Confederacy, and the Wendat and Petun nations, and is now home to many First Nations, Inuit, and Métis people. This land is covered by the Dish With One Spoon Covenant, an agreement between different First Nations communities to share resources peacefully and equitably, and by the Two-Row Wampum, a covenant of mutual respect and non-interference between early settlers and the Haudenosaunee. The land is also subject to Treaty 13, sometimes called the Toronto Purchase, signed between the settler colonists and the Mississaugas of the Credit.

As a settler organization, we acknowledge that we have violated these treaties and agreements. We acknowledge the grievous and ongoing harm of colonialism, and we strive to work toward a future of justice and reconciliation.

Edited by Alana Wilcox
Cover and interior design by Crystal Sikma
Cover art *scree* by Kristjana Gunnars, ink on paper
Author photo by Charles Marxer

Coach House Books
80 bpNichol Lane
Toronto ON M5S 3J4
Canada

mail@chbooks.com
www.chbooks.com